ROBIN WILLIAMS

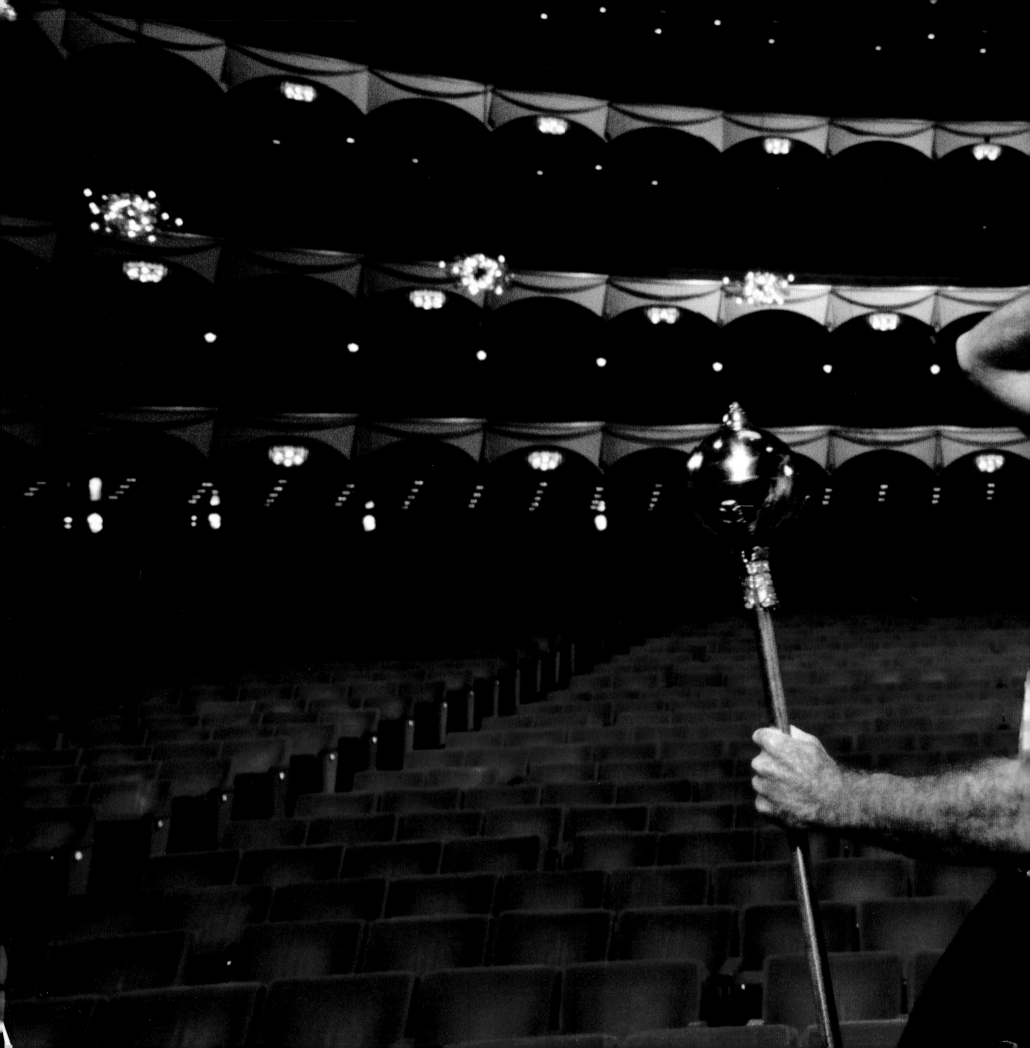

ROBIN WILLIAMS

A SINGULAR PORTRAIT, 1986-2002

PHOTOGRAPHS
by ARTHUR GRACE

COUNTERPOINT

BERKELEY

previous spread: ROBIN ON STAGE OF THE METROPOLITAN OPERA HOUSE
DURING PUBLICITY SHOOT, NEW YORK, 1986

Design by Debbie Berne
Photo Editor: James Gilbert

ISBN 978-1-61902-727-5

COUNTERPOINT
2560 Ninth Street, Suite 318
Berkeley, CA 94710
www.counterpointpress.com

Printed in China

Distributed by Publishers Group West

10 9 8 7 6 5 4 3 2 1

To Zak, Zelda, and Cody Williams
who were always the heart of Robin's life

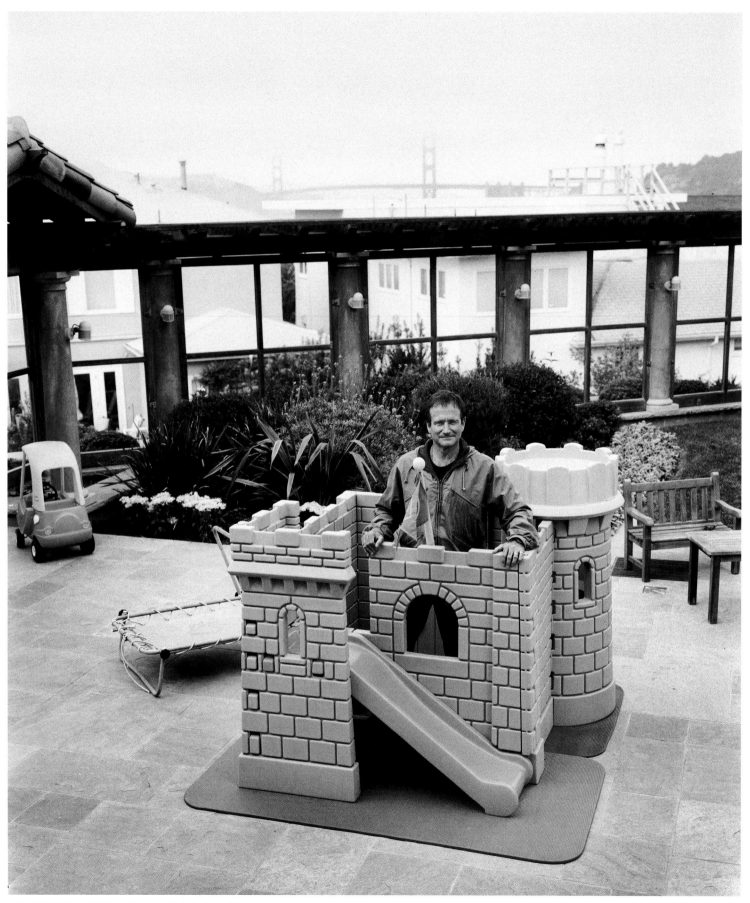

AT HOME, SAN FRANCISCO, 1995

CONTENTS

INTRODUCTION

The first time I ever heard the name Robin Williams was in September 1978 while I was on assignment for *Time* magazine in Thurmont, Maryland covering the historic peace meetings at Camp David with President Carter, Israeli Premier Menachem Begin, and Egyptian President Anwar Sadat.

During the endless waiting around for a photo op, one of the photographers started talking about this crazy guy, Robin Williams, who was in a new TV show called *Mork and Mindy*. He kept raving about how funny this character Mork was and how he did this "nanu-nanu" thing and kept saying the most off-the-wall stuff. Another photographer quickly seconded the motion, telling everyone that it was the funniest program he had ever watched. Being a huge fan of comedy who had enjoyed a brief moment doing stand-up during my "formative" years (that would be the hazy days of the late '60s), I made sure I was in front of my television the next week to catch the show. It had me laughing almost the entire time and I became a major Robin Williams fan. I had never seen anyone like him before and had never laughed so hard in my life.

Eight years later, in 1986, I found myself standing at the curb of the US Airways passenger pickup area at the Pittsburgh Airport waiting to meet Robin Williams. *Newsweek* had sent me on assignment to shoot photographs for a cover story by their film critic, David Ansen, titled "Funny Man: The Comic Genius of Robin Williams." I didn't know it at the time, but Robin's brilliant performance co-hosting the Oscars that year was the catalyst for the story.

Right on time, the car I was looking for pulled up to the curb, and there, sitting on the passenger side riding shotgun, was a smiling Robin Williams. I threw my bags into the empty trunk of the rental car and hopped into the backseat. Both Robin and David Steinberg, his manager, quickly turned around to shake hands and say hello. As we pulled away into the traffic, it seemed completely surreal that I was now "on tour" with Robin Williams.

A few moments later, David glanced at Robin and asked if he had heard that a certain show-biz acquaintance of theirs had died the day before. Robin looked straight ahead and said in a deadpan tone, "Ahhh death . . . nature's way of saying, 'check please!'" I immediately burst out laughing, as much by his delivery as by the joke itself. Robin turned around and smiled, apparently pleased that he had me laughing. A while later, I said something completely inane about Ronald Reagan and Robin let out that staccato, protracted laugh which I soon learned is what he always did when he found something really funny. I figured we were off to a good start, but I knew better than to push my luck on the comedic front. I kept hearing in my head the standard admonition from countless TV shows and ads before something dangerous was about to be shown: "Don't try this at home, folks."

As we drove toward the hotel on that day thirty years ago, I never could have guessed that it was the beginning of a ride that would span three decades and become the most extraordinary trip of my life. Looking back, it was one of those rare times when a chance

meeting unexpectedly grows into a real friendship. Robin and I simply hit it off from the start and everything progressed from there. We were always comfortable in each other's company, and even when months would go by without us seeing each other, the minute we met up again, we picked up right where we had left off.

I was never one of Robin's closest friends like Billy Crystal, Bobcat Goldthwait, or Eric Idle. However, over the years, when not laughing about something or other, Robin and I did manage to get in quite a few serious, in-depth conversations about his business and my business, family, politics, friends, and the state of the world. To be sure, if Robin and Marsha hadn't respected my work and trusted me as a friend, this book would never exist. I will always be grateful to them for letting me hitch a ride on Robin's fascinating, roller-coaster life and, most importantly, for giving me the opportunity to photograph it without restriction.

I'm not a reporter in the conventional sense. As a photojournalist, I am a self-proclaimed "trained professional observer." What I have written about in this book comes from personal observations and shared experiences with Robin.

Anyone who knew Robin will tell you that the first question someone would usually ask if they found out you were Robin's friend was something like: "Is he 'on' all the time?" or "Is he always that wound up (crazy, manic, etc.)?" The answer, of course, is a definite no, as the photographs in these pages make clear.

Robin was like anybody else who works hard at what they do. He needed time for rest, relaxation, and recuperation. The only difference was that he needed it more than most. The amount of energy he expended performing was often otherworldly, as anyone could attest after watching his HBO specials or attending his stand-up shows or comedy club surprise appearances (or even having a long dinner with him).

On stage there was always a small table with a stack of white hand towels and rows of bottled water to keep Robin semi-dry and hydrated. After he finished a live performance, he would come offstage totally drenched, his shirt clinging to his skin. He would immediately grab a towel and started drying himself as he drank bottled water and headed straight for his dressing room. The first thing he did when he walked in was to deposit his soaked shirt into a plastic bag held open for him by his longtime personal assistant Rebecca Erwin Spencer. The shirt would later be sent out to the dry cleaner (but not before Rebecca tossed it in the shower).

For Robin's downtime, he had private spaces in his home in San Francisco and at his ranch in Napa where he could completely withdraw from everything and everyone. In San Francisco his retreat was a hidden room behind a movable bookcase, while in Napa, it was a separate watchtower with its own staircase. Inside were computers, monster models, Star Wars spaceships, rows and rows of toy soldiers, and stacks of video games. There was also invariably a pile of scripts.

of penetrating his air space on more than one occasion and got scorched.

Robin had an incredible number of friends who were highly accomplished in a wide variety of fields, not just in the entertainment business. He knew glassblowers and painters, politicians and authors, scientists and scholars, athletes and musicians. Whenever I would meet up with Robin in New York, San Francisco, Los Angeles, or just about anywhere, I would be introduced to an array of fascinating and intriguing people, a lot of them famous, but many I had never heard of.

That's how I wound up meeting Oliver Sacks for dinner one night in Robin's suite at the Carlyle while Robin was shooting *Awakenings*. I had no idea who he was, but by the end of the meal I was as captivated by Oliver Sacks as Robin, who was playing him in the movie. Another time at a studio shoot in New York for a *Premiere* cover to coincide with the release of *Good Morning Vietnam*, Robin introduced me to a petite, older woman named Lillian Ross, who had a reporter's notepad and pen in hand. I wasn't familiar with her, but during a break, Robin informed me of her legendary status and stellar reputation as a writer. She was doing a piece on him for *The New Yorker*. As the years passed, I would see Lillian with Robin at various events and family gatherings, and they became good friends. She found him fascinating, but she also liked to laugh, and Robin never disappointed in that department.

That was the thing about Robin that seemed so obvious, but most everybody took for granted, including me. You were really lucky to be around him because at some point you knew you were going to laugh your ass off. And that was a real gift from him. When Robin was riffing, it became a transcendent experience for anyone lucky enough to be within earshot. Even from long distance Robin could throw you a good laugh, especially if something was going south in your life. Right after he heard about my divorce in 1999, he gave me a call and proceeded to tell me in an earnest voice how sorry he was for me and also for my wife. Then he paused a beat and asked, "Would it be OK if I slept with her?"

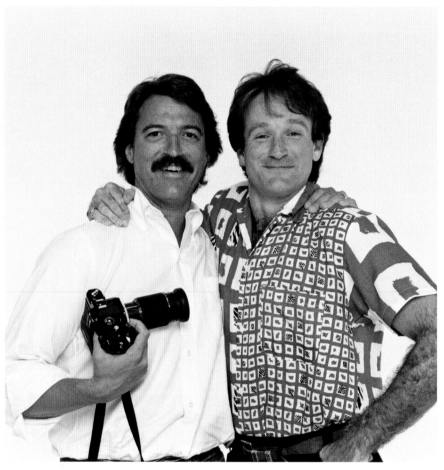

NEWSWEEK COVER SHOOT, LOS ANGELES, 1986

On one visit in 1993, I walked into his lair in San Francisco and saw a military video game on his computer screen. He explained that it was a new air-to-air combat game with the latest US and Soviet fighter jets and that he had just finished an aerial dogfight with Steven Spielberg, who was in Los Angeles. Robin smiled, and proudly said he'd smoked him.

As long as I knew him, Robin was in love with video games, and took them seriously. Sometimes he would even drive over to Electronic Arts and meet his friend Bing Gordon, the Chief Creative Officer, to beta test new products (pages 178–179). When Robin was engrossed in any action video game, you quickly learned that the area around him became a "no-fly" zone. I made the mistake

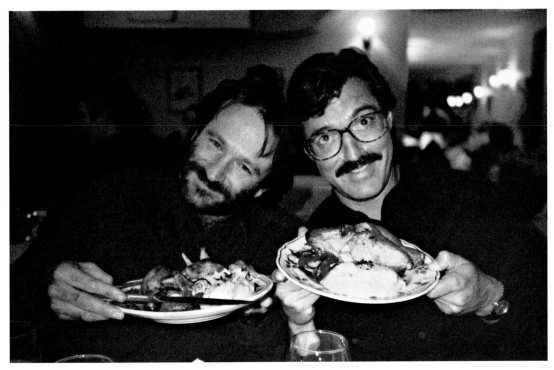

Everybody knows that Robin was an incredibly generous man who gave both his time and his money to various public causes and charities. I also saw the small ways he showed his generosity. There never was a time when I was with Robin that he didn't stop for a panhandler or a homeless person and hand them some money. When a mutual friend of ours came down with a tropical disease while traveling in Asia, Robin flew her first class back to San Francisco where she could get the proper treatment. When a good friend of his from Julliard needed money to finish his feature film, Robin lent a financial hand. When a local teaching hospital was in need of a piece of medical equipment, Robin and his wife Marsha quietly bought it for them. He once offered to charter a jet for me so I could get home in time to be with a terminally ill family member. The list goes on and on.

ELOPEMENT DINNER PARTY, NEW YORK, 1988

As private a person as Robin could be, out in public or in private settings, he was always approachable. He had a well-deserved reputation for being down to earth and nice to everyone regardless of their economic or social status and ethnicity. I never saw him say no to anyone who asked him for an autograph, except one time in a restaurant when he had a fork full of food halfway into his mouth and was interrupted by a fan who wanted his autograph. Robin put down his fork and politely told the lady that he couldn't do it just then because he was eating (in case she hadn't noticed), but promised to do it before he left, which he did.

Every professional photographer I ever spoke to who had worked with Robin always said the same thing: how easy he was to get along with and what a great guy he was. And of course they all had fun hanging with him. Robin liked photographers, and from time to time on a studio shoot, he would entertain everyone by putting on his best Annie Leibovitz impersonation, pretending to be asking him to go along with some crazy setup, like hanging by his legs nude from a tree branch with a banana in his mouth.

I'll never forget what Robin did for me when I eloped in October 1988. When I called him that afternoon from DC to tell him that I had just gone down to city hall and tied the knot, he immediately said I had to fly up to New York that afternoon so we could have a celebration dinner with some of my friends who lived in the city. The timing was perfect, he said, because it was a Monday night and the play he was doing with Steve Martin, *Waiting For Godot*, was dark. Amazingly, everything came together without a hitch. We had a rollicking dinner party for sixteen with Robin Williams as the entertainment. After dinner he and Marsha surprised my wife and me by putting us up at the Carlyle for the night with a great bottle of chilled champagne waiting in the room.

Less than a year later, I was able to repay Robin in a much smaller way. He and Marsha were getting married in Lake Tahoe in a private ceremony with only a small number of their good friends in attendance. I had a dual role as guest and wedding photographer and took the photographs of their late afternoon ceremony on a wooded path by the lake. Afterward, there was a fabulous dinner then gambling late into the night. I woke up early the next morning and was the first person in the door when the local one-hour

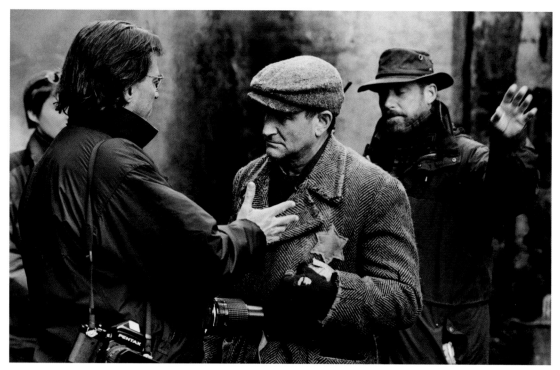

ON THE SET OF *JAKOB THE LIAR*, PIOTROKOV, POLAND, 1997
©ROBERT STALEY

The worst episode that I remember was in 1988 as Robin's film career was taking off. He told me the story right after it happened. He was sent a script that he absolutely had to read over the weekend to give the studio an up or down answer by Monday morning. He was also told that no other A-list actors would see the script until he weighed in on whether he wanted this highly coveted role. At the end of the weekend, Robin's answer was an enthusiastic yes, and he waited for confirmation. It never came. Unbeknownst to him, two other top-tier stars had also been given the script over the same weekend. The movie was *Batman* and the part was The Joker. Jack Nicholson got the role.

Sure, Robin was angry, but the hurt and bewilderment in his voice as he talked to me about it was palpable. He couldn't fathom that he'd been lied to and set up like that. I'm sure that episodes like this one help explain why Robin lived in San Francisco, putting a lot of distance between himself and Hollywood.

photo place opened. During the group breakfast, I hustled back to the photo store and picked up the envelope of color photos and negatives. When I said good-bye to Robin and Marsha a few minutes later, I handed them their wedding present. They were genuinely surprised and appreciative that I'd managed such a quick turnaround (this was way before the instant digital era). As my taxi pulled away, I watched them standing on the sidewalk looking animated as they checked out their one-hour wedding album.

It should not come as a surprise that artists like Robin are sensitive individuals. Behind all the projected stage and film confidence, there is always a degree of insecurity, and Robin was certainly no exception. There were times, especially having to do with the entertainment business side of his life, that I saw genuine disappointment, anger, or sadness over something that was going on in his career.

Whenever I was in San Francisco with Robin, I was amazed that he could walk around in public and no one bothered him, other than to wave or say hello. When he went to Bike Odyssey in Sausalito, the sales people and the mechanics all knew him and would come over to talk. He was always greeted warmly by the proprietor of Heroes Club: The Art of Toys on Clement, where Robin bought Star Wars models and Godzilla monsters among other toys that he collected. They knew him at The Cheese Steak Shop on Divisadero, where he would occasionally take me for a Philly cheesesteak. San Francisco was home to him. He loved the city and the city loved him back.

For Robin, the best part of being home in San Francisco was that he was able to spend time with his kids—Zak, Zelda, and Cody. Nothing lit up Robin's face more or gave him as much joy and relaxation as when he was around his children—whether it was putting

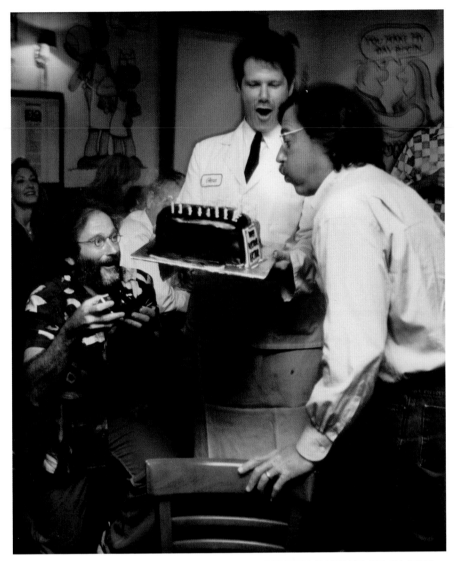

ROBIN PLAYS PHOTOJOURNALIST, FIFTIETH BIRTHDAY PARTY,
LOS ANGELES, 1997 ©DIRCK HALSTEAD

a puzzle together with Zelda at the kitchen table, playing video games with Cody in the kids' playroom, or snowboarding with Zak at Lake Tahoe. They relished their time with Robin, but unfortunately, his hectic schedule and location shoots on films meant he was away much more than he wanted. That's why he would lobby for his films to be shot in the Bay Area, which is what happened with *Mrs. Doubtfire*, *Bicentennial Man*, and *Flubber*, among others. Even though he was on set all day, he was home every night.

Gradually, as his kids grew older, they came to realize that they had to share their father with the rest of the world.

Robin was a lucky man in many ways. He was extraordinarily talented. He had the love of his family and friends. He reached the heights of his profession and was richly rewarded, both financially and with prestigious recognition. He traveled the world and was loved by millions. He lived to make people laugh and succeeded at it like no one before him.

I was lucky just to be his friend.

ENDNOTE

I had always thought that when I was eighty-four and Robin was eighty, we would sit down someplace and collaborate on a book about the golden years of his career. He would look at my photographs and then reminisce about the events and his feelings at the time. Unfortunately, that book was never to be.

It took me a long time after his death to decide what I should do with all the photographs I had of Robin, both public and private, many of them never published. It made no sense to sit on them given the millions of fans he had around the world who would love to see more of Robin, especially between two covers in a book they could pick up over and over and keep around for years.

I truly believe that Robin would have found this book to be an accurate and singularly realistic "portrait" of his life during some of his most productive and joyous years. Most importantly, I hope Robin would have found this book to be a worthy representation of himself—for his family, his many friends and admirers, and most of all for his millions of fans.

Arthur Grace
Los Angeles
February 2016

IN PERFORMANCE DURING
STAND-UP SHOW, ON TOUR,
1986

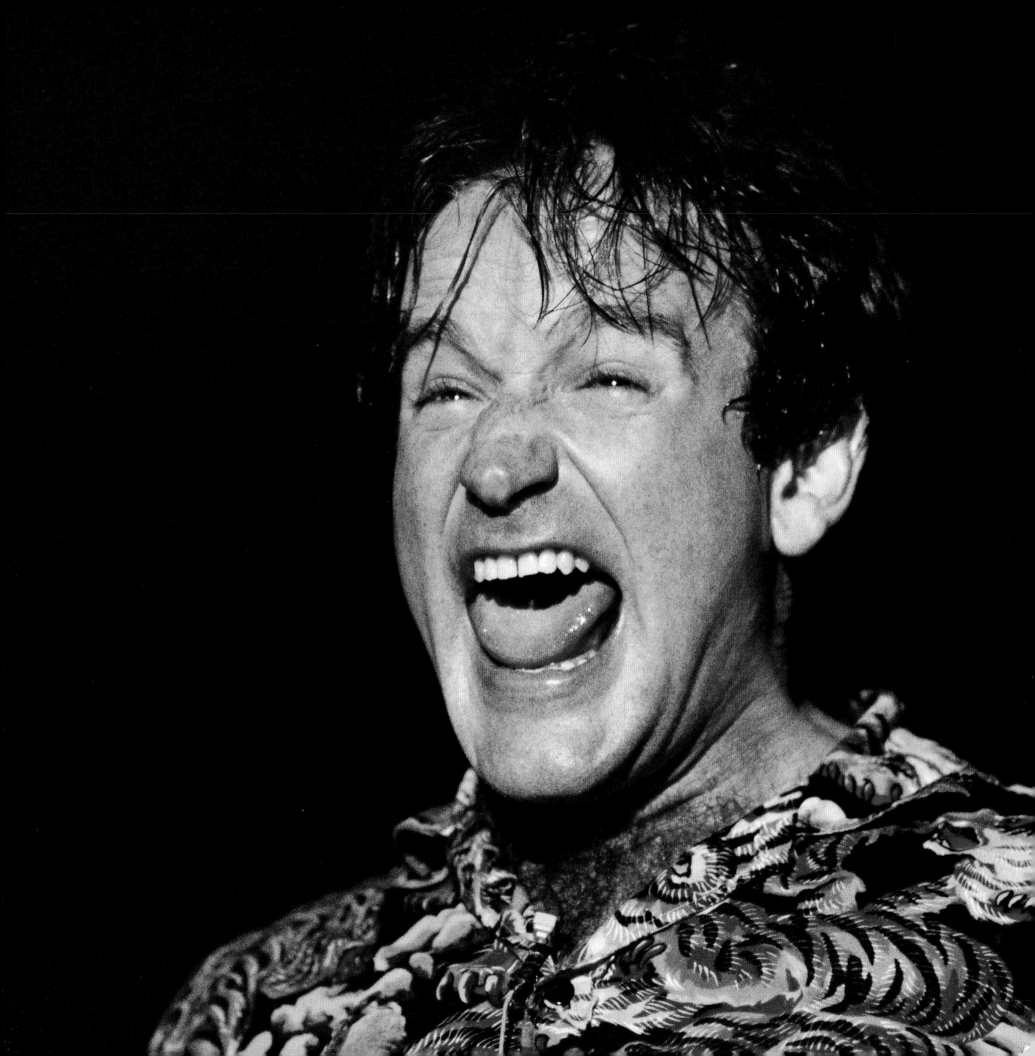

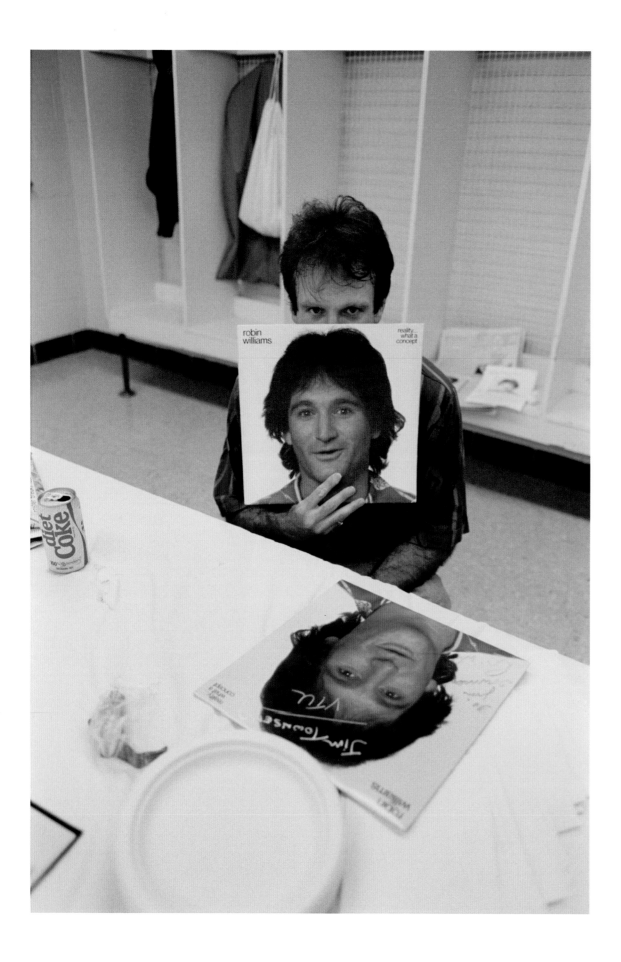

left and this page
MUGGING FOR THE CAMERA IN
HIS DRESSING ROOM BEFORE
STAND-UP SHOW, 1986

ALONE IN HIS DRESSING ROOM
BEFORE GETTING DRESSED
FOR HIS SHOW, 1986

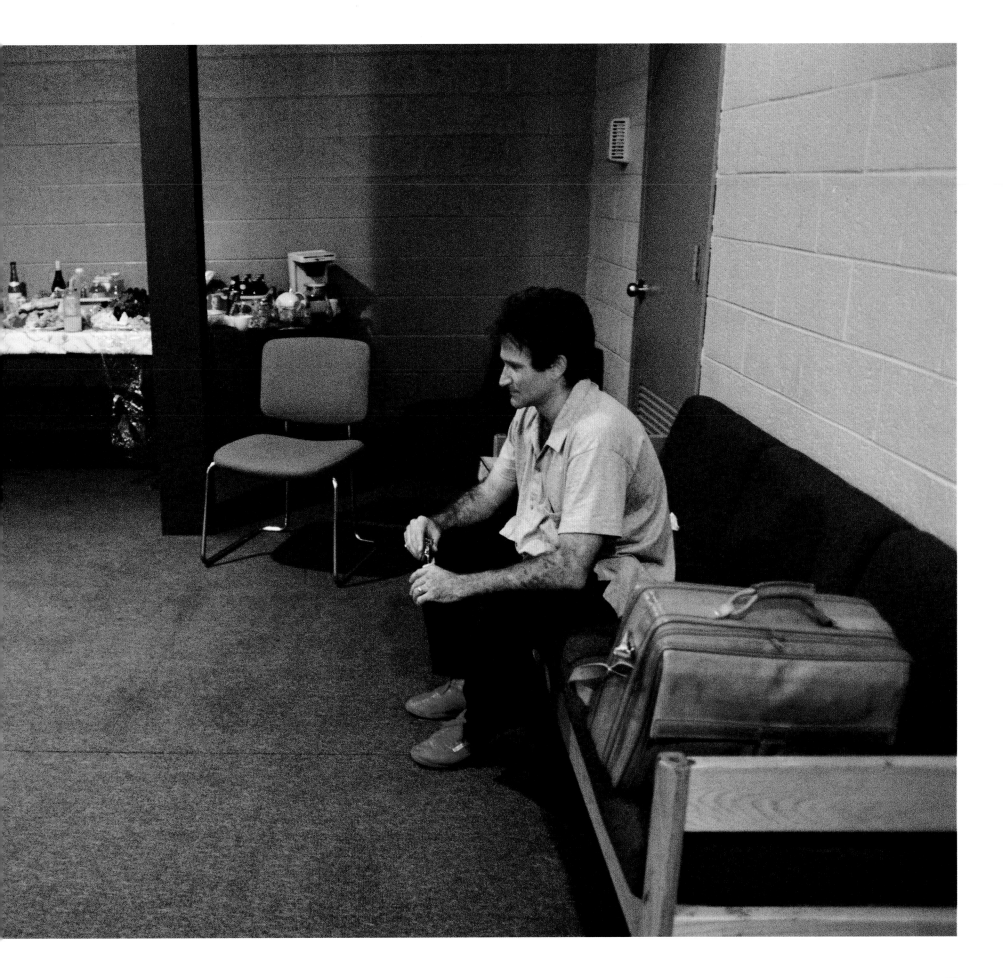

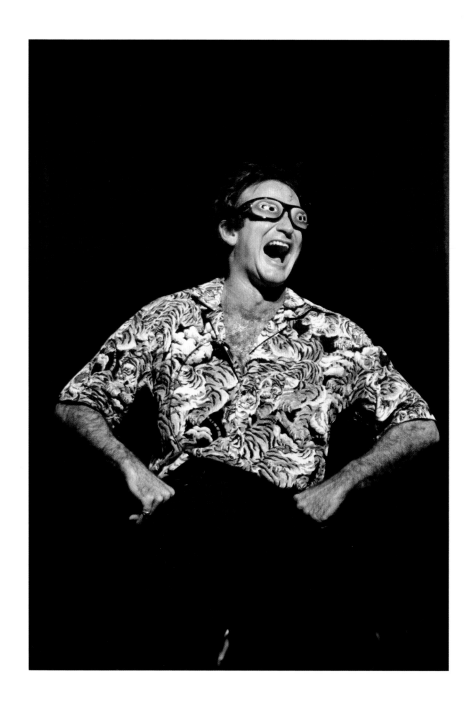 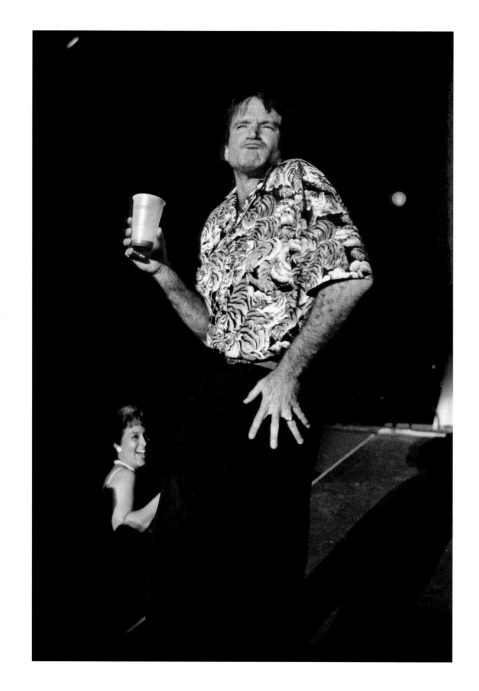

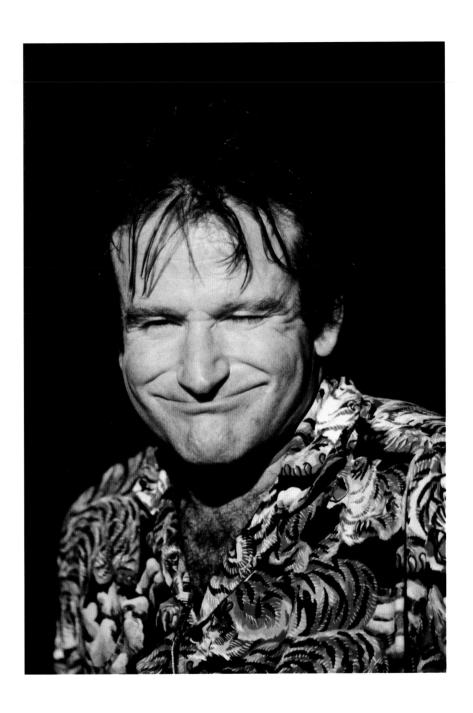
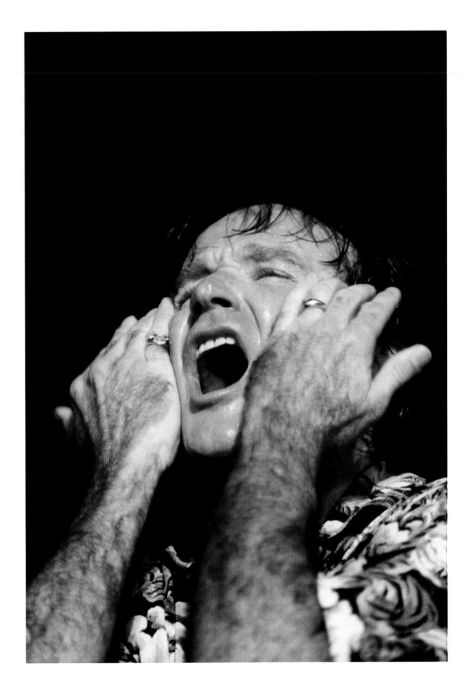

left and above
IN PERFORMANCE DURING
STAND-UP SHOW, 1986

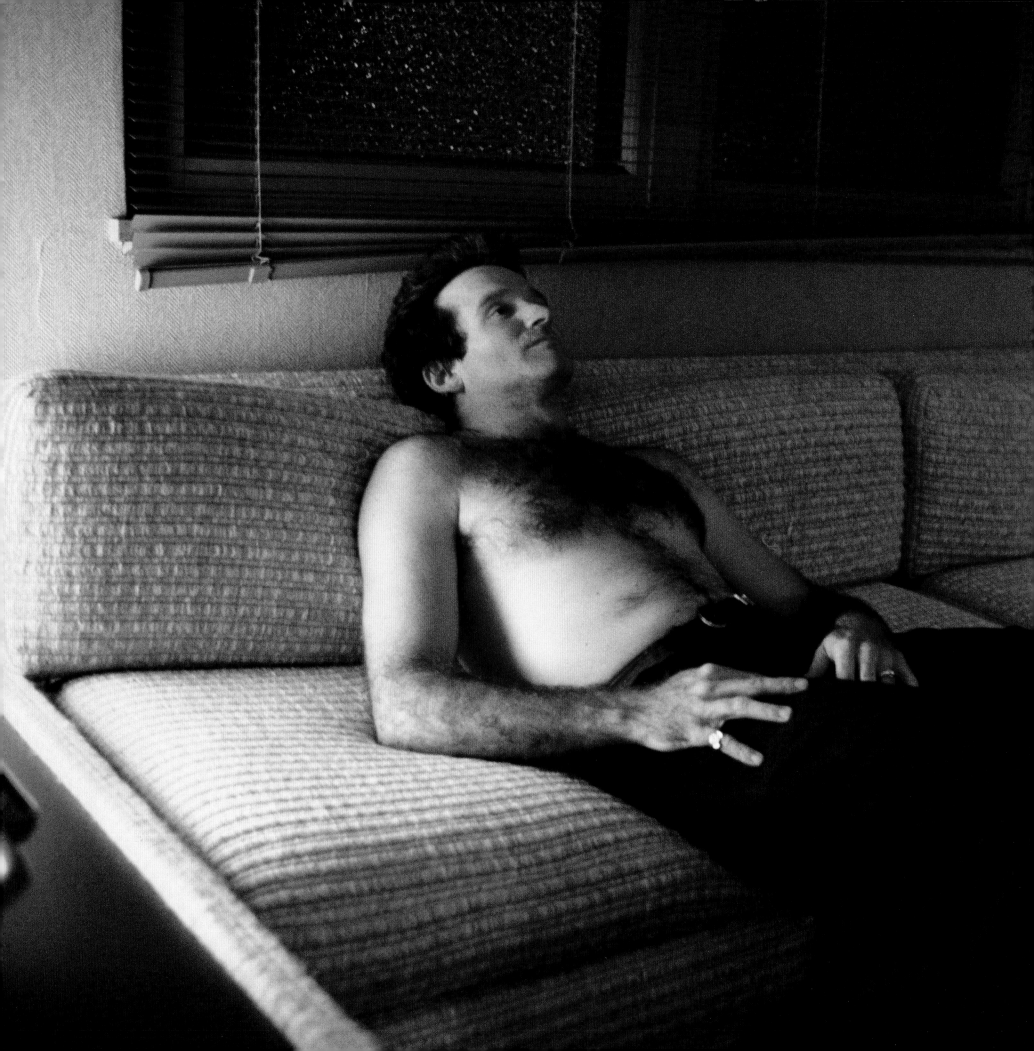

RESTING IN HIS DRESSING
ROOM MOMENTS AFTER
COMING OFF STAGE, 1986

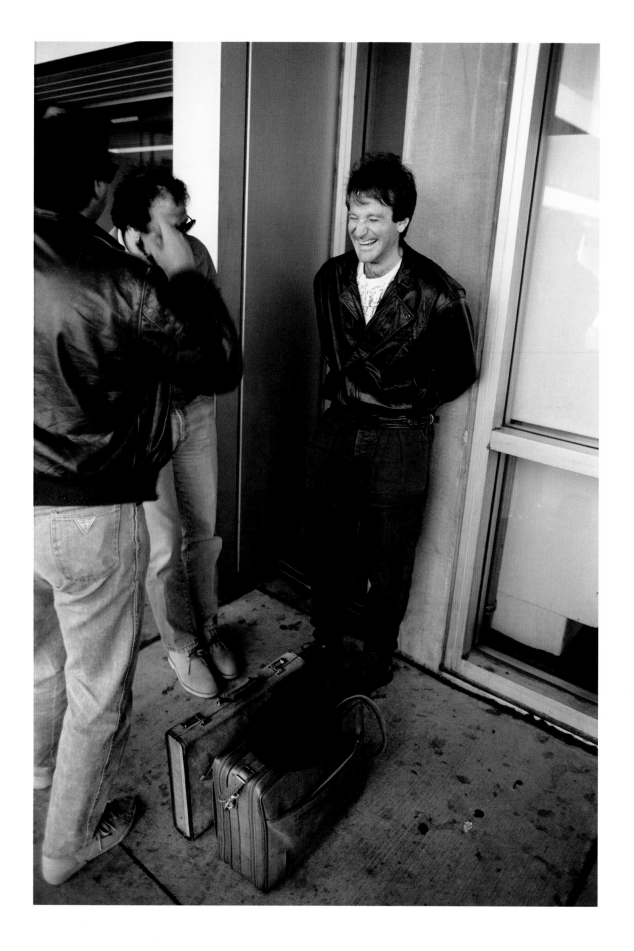

LAUGHING WITH MEMBERS OF
HIS ROAD ENTOURAGE OUTSIDE
AIRLINE TERMINAL, 1986

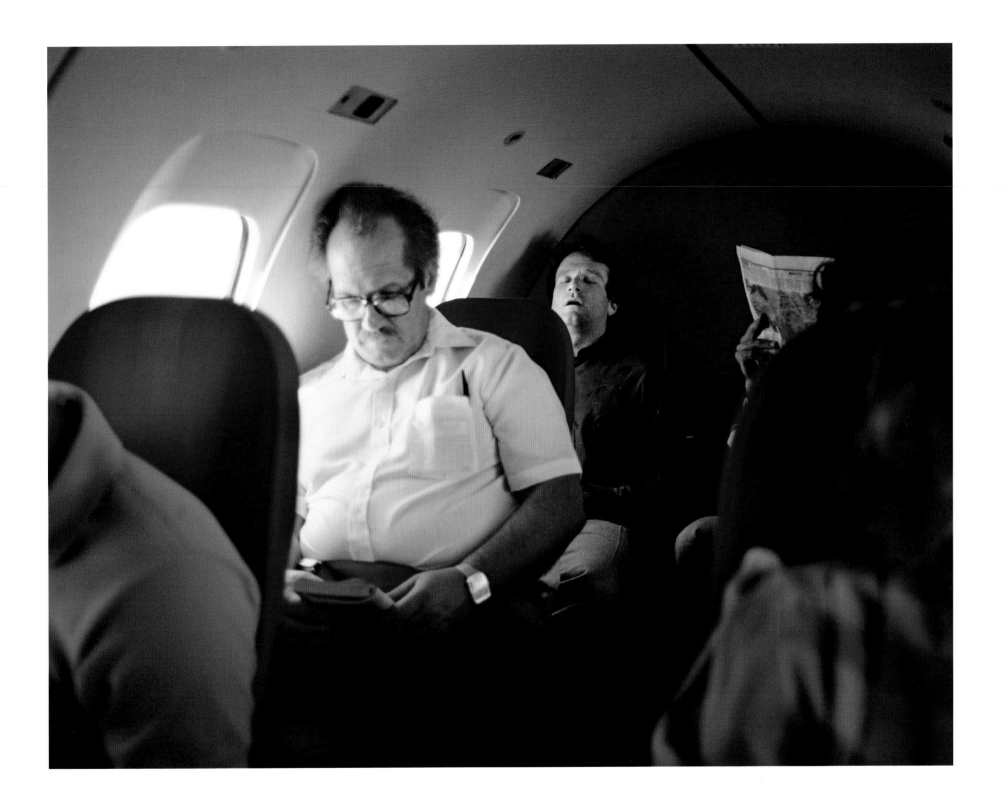

SLEEPING ON PROP PLANE
TO CHICAGO, 1986

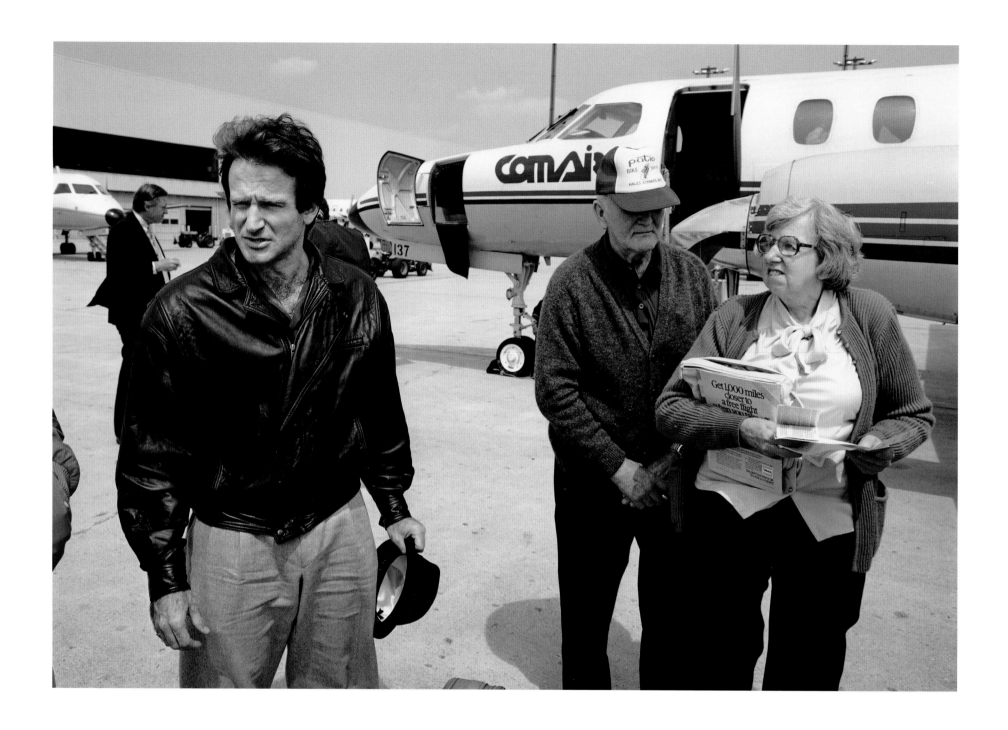

ON THE TARMAC IN CHICAGO WITH
FELLOW PASSENGERS, 1986

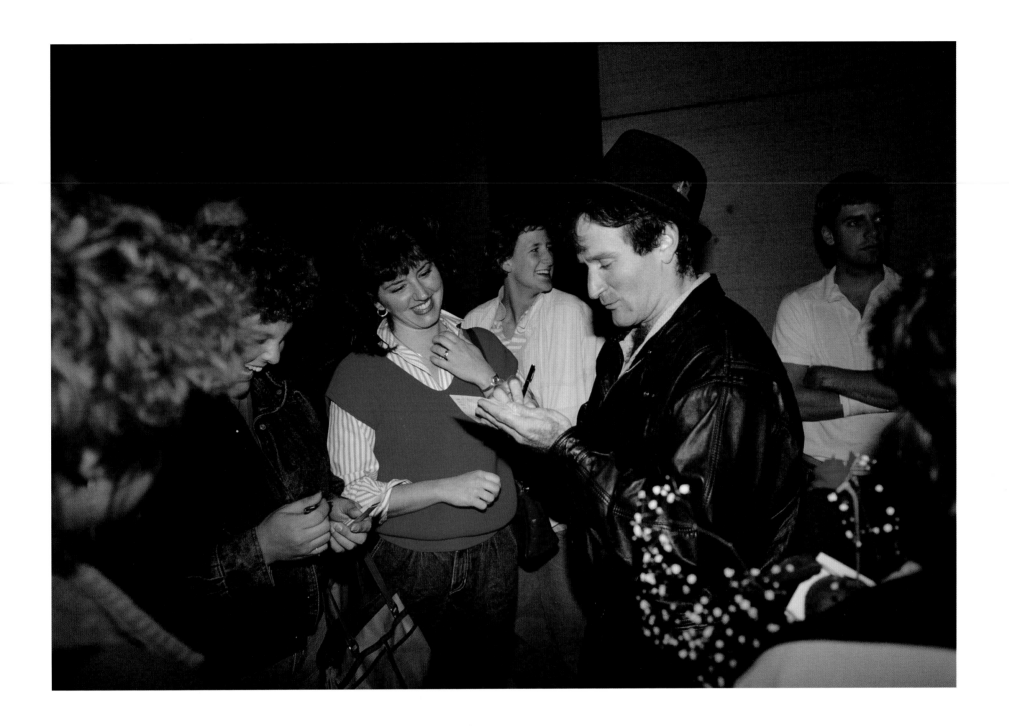

SIGNING AUTOGRAPHS AFTER
HIS SHOW, 1986

CHECKING HIMSELF OUT IN
HIS DRESSING ROOM PRIOR TO
PERFORMANCE, 1986

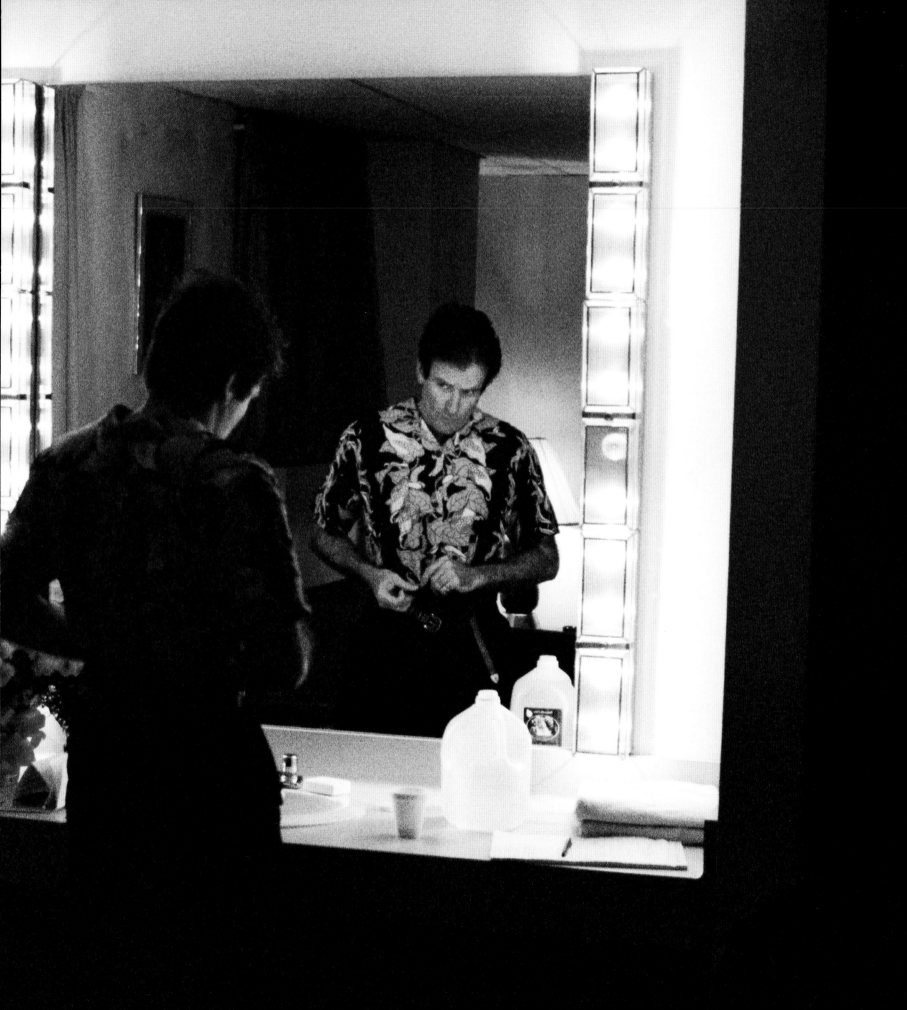

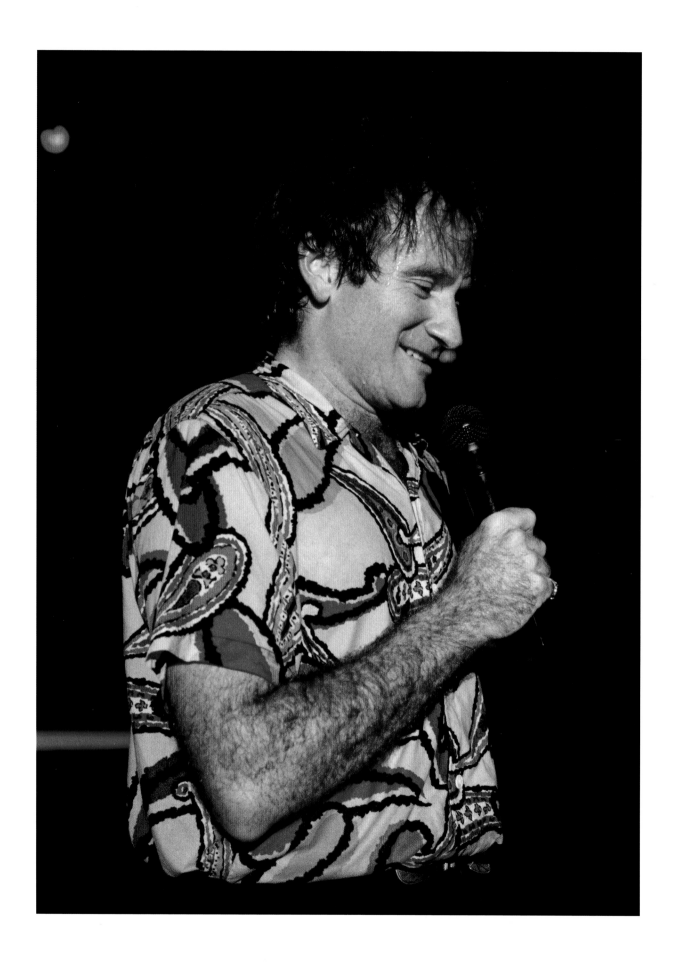

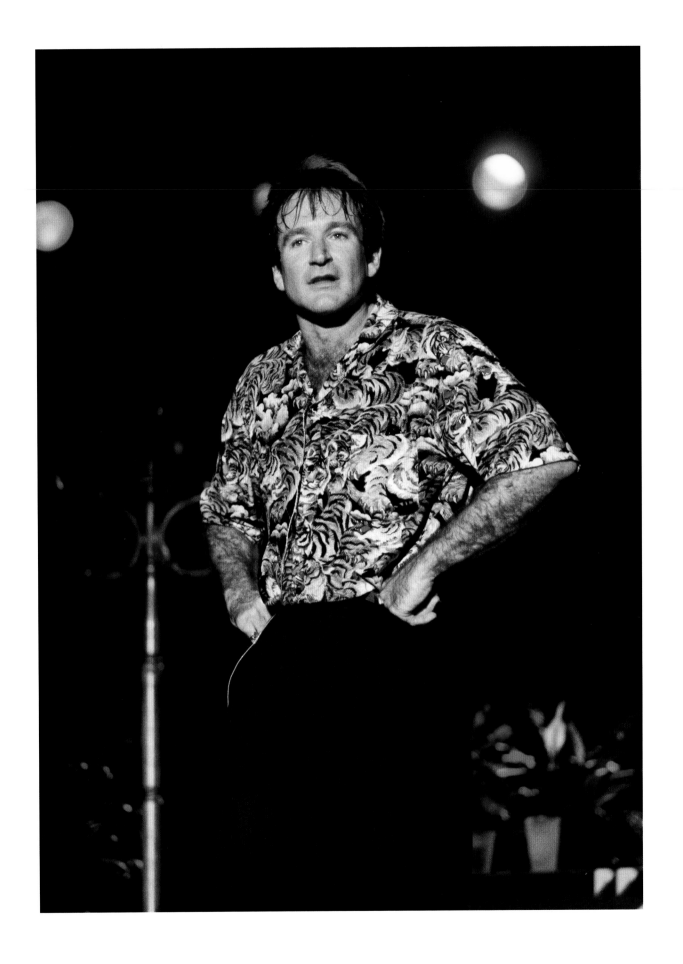

left and this page
IN PERFORMANCE, 1986

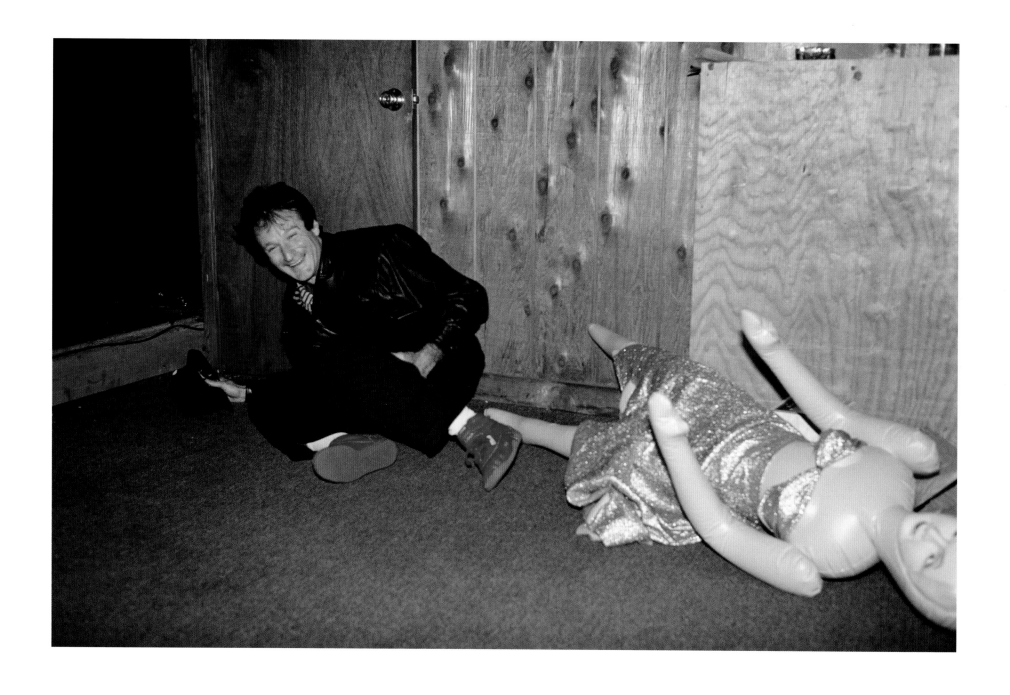

BACKSTAGE WITH SHOW PROP
AFTER PERFORMANCE, 1986

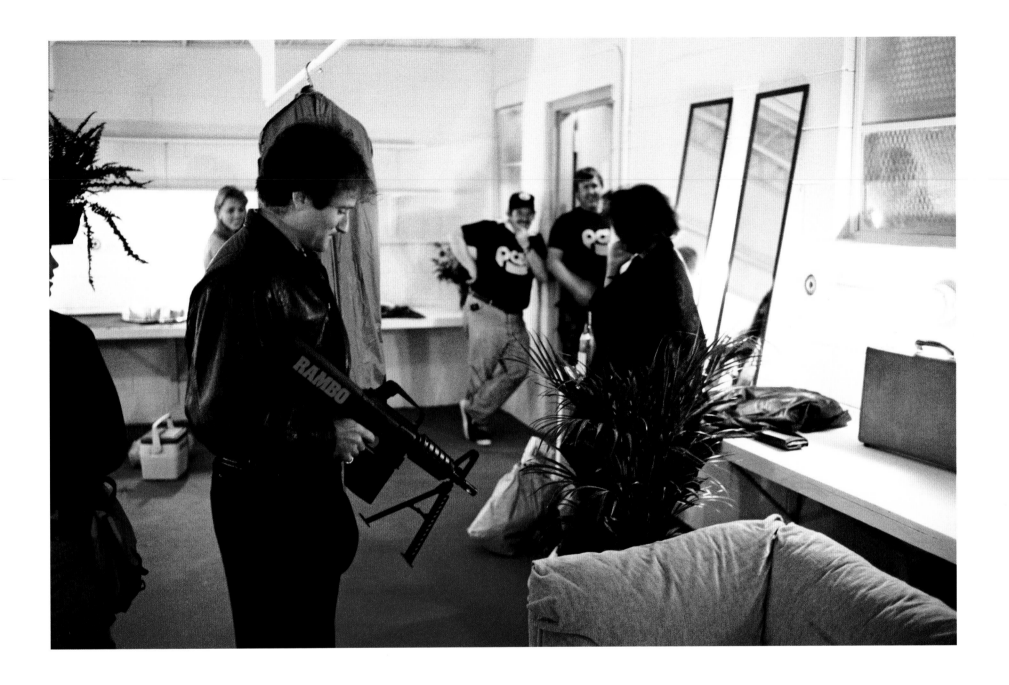

IN DRESSING ROOM WATERING A
POTTED PLANT WITH A SQUIRT
GUN AFTER HIS SHOW, 1986

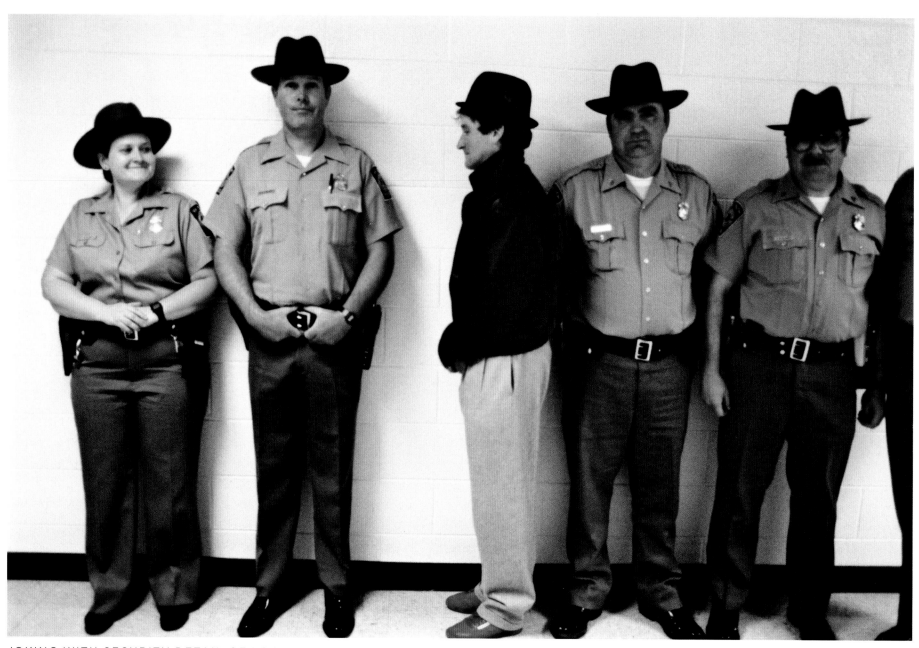

JOKING WITH SECURITY DETAIL OF LOCAL POLICE, 1986

ON TOUR 1986

Being on tour with Robin in the spring of 1986 was as exhilarating and carefree an assignment as I ever had, and easily the most fun. Within hours of linking up with Robin and his tight road entourage (manager David Steinberg, travel coordinator Marsha Garces, and sound man Martin DeMartino), I started to forget what I was there for, as the laughs just kept on coming, and I was welcomed into the group. From the very start, I was given total access, and all I had to do was not blow it. The photographic moments I was after were always right there in front of me.

Life on the road for Robin at this point in his career wasn't that glamorous or easy. It was a grind—a lot of performances had to be delivered in a short period of time and at different locations. We drove or flew from one city to the next, often with Robin grabbing some sleep whenever and wherever he could. There were tedious waits at airport lounges, cramped rental car rides, and one memorable bumpy flight in a cigar tube of a commuter prop plane going from Blacksburg, Virginia to Chicago (Robin slept through that one) and on to Madison, Wisconsin.

Regardless of the grueling itinerary, Robin, who was single at the time, always tried to find time to go out and do some local exploring. Once, after a nighttime drive from Pittsburgh to Philadelphia, we all checked into our hotel and then headed right out because Robin wasn't tired and wanted to burn off some energy after the long, cramped ride. That's how we wound up "unwinding" at a memorable after hours nightclub called The Black Banana with Robin engaged in animated dialogue with the local patrons.

Another time in Atlanta, Robin wanted a "wing man" for the night, and I signed on. Our first stop was at a club our driver had heard about that was a few minutes from the hotel. When we walked in we faced a crowded room bathed in dim blue light with music blaring. Without looking around we made straight for the bar at the far end of the floor and grabbed two seats. When the female bar tender finally came over, Robin ordered a shot of Jack Daniels, and then asked me what I wanted. I wasn't sure what was going on since I knew Robin had been on the wagon for years. When the drinks came, Robin pulled the shot glass to the edge of the bar, leaned over, and just smelled it. He never picked up the glass, never took a sip. Instead, he turned away to check out the action.

I kept looking straight ahead, weighing if I should say anything or keep my mouth shut about his drink. I heard Robin say to me, "Hey Artie, you notice anything strange about this place? Turn around." As I slid off my chair and started to look through the blue haze of the smoke-filled room, Robin answered his own question. "We're the only men in here, pappy." He immediately turned back toward the bar to pay the bill, whispering to me with feigned urgency, "What do you say we get outta here before we get punched out." We both started to laugh and headed straight for the door at flank speed before anyone recognized him. At the end of the night, after finding a heterosexual disco and hanging out for a while, Robin still gave our misguided driver a generous tip after we got back to the hotel.

One part of the business side of my road trip was, of course, taking photographs of Robin before, during, and after his performances. I

WAITING TO BEGIN INTERVIEW WITH LOCAL TV STATION, 1986

breathing slowly, his eyes looking down. (Robin once compared this sleepy state to narcolepsy). But as soon as he heard the words over the PA system, "Ladies and gentleman, Robin Williams!" he was off like a shot, bounding toward the bright lights. It was like he'd gone from zero to sixty in a matter of seconds. By the time he reached center stage, the venue was a cacophony of thunderous applause and whistling followed almost immediately by a wave of laughter that was repeated again and again for the next hour and fifteen minutes.

As soon as his last encore was over, Robin would walk off the stage, grab a towel, have his wireless mic taken off, and slowly head back to his dressing room accompanied by David, who would be congratulating him on what a great show he'd done. But the minute Robin hit the threshold of his changing area, everyone would peel off and give him his privacy. Fortunately for me, he didn't mind when I would follow him past the threshold of his inner sanctum. That's when I saw and was able to photograph the complete exhaustion, both mentally and physically, that his performance had demanded. He'd remove his sweat-soaked shirt, towel off a bit more, then lie back on a sofa or chair staring into the distance, taking an occasional sip of water while he regrouped. After a few minutes, life would intrude again as the room filled with local VIPs and press. No matter how tired he was, he always took the time to say hello, sign autographs, and pose for photos. When the last fan left, he would pick up his bag, and we'd all head out into the night.

got to see firsthand what it took to do what he did so successfully—meticulous preparation, a superb memory, steady nerves, stockpiles of energy, a love of being on stage, and the ability to recharge himself so every night was a new experience. Obviously, the prerequisite to all this was having a keen sense of humor, a sixth sense of what was funny, and the ability to deliver laughs to an audience in an engaging way.

Before leaving for the night's venue, Robin would always meet with David at the hotel to be briefed on local color, i.e., sports teams, politicians, recent scandals or events. As soon as Robin arrived at the performance site, he would head for whatever passed for a backstage "dressing room," saying hello to anyone he met along the way. Next, he would eat something from a catered food spread of varying quality provided by the show's promoter, then head for his changing area to spend time alone going over his material. Right before showtime, he'd change into his performance clothes, and then Marty would come in and mic him up. Last, somebody from the production crew at the venue would come back for Robin and lead him to an offstage area where he would wait to be introduced to a crowd of 800–1,500 people.

During those few moments in the wings, there was a calm and stillness about Robin that defied logic. He stood there motionless,

The culmination for Robin of all the weeks performing on the road was his HBO special *Robin Williams: An Evening at the Met* taped over two nights in August 1986 at the Metropolitan Opera House in New York City. My assignment for *Newsweek* had ended two months earlier with a cover story by David Ansen referring to Robin as a "comic genius." As far as I was concerned, that wasn't hyperbole.

Over the weeks after the cover shoot, I stayed in touch with Robin, David, and Marsha. We'd all hit it off, had a great time, and forged some kind of bond. It was one of the few times in my career when I became friendly with a subject and actually stayed in contact after my work was finished. One day, I got a call from David saying that Robin wanted me to shoot his album cover for the Met show.

Besides his HBO taping, Columbia records was going to do an album. I immediately signed on.

I had never been to the Met before, and when I showed up at rehearsal on the afternoon of Robin's first show, I was dumbstruck at how huge the place was with its four tiers of wraparound balconies reaching up to its vaulted ceiling and the rows and rows of seats at floor level stretching into the distance. For the next two nights all 3,800 seats would be filled with his fans, all of them expecting to laugh throughout his ninety-minute show. I couldn't believe this was the intimidating setting Robin had chosen for his special. (Actually, he didn't. It was his manager David Steinberg's idea.) I really had my concerns about how Robin, the gladiator comedian, was going to prevail in this Roman Circus, all alone on this massive stage with only his talent, some bottled waters, and a few towels to fall back on.

When Robin and I finally walked out to the front edge of the Met's stage to do some improv shots for possible use as an album cover, I had Robin face me with his back to the cavernous opera house. As I looked out and then down at the orchestra pit, I had the same queasy feeling acrophobics must get when standing on the Golden Gate Bridge—extreme discomfort. On the other hand, Robin could have cared less. He was really enjoying the shoot, seemingly oblivious to the gravitas of his surroundings, acting like he was goofing around in his backyard in San Francisco.

Both nights before the show, Robin went through the same routine he'd done in the smaller venues on the road. The only differences were that his dressing room was the real deal (bordering on lavish) and the catering had jumped about a dozen notches in quality. Once again, the amazing part to me was Robin's complete cool as he stood backstage by the curtain each night waiting for his introduction. As usual, he was in a zenlike state, quiet and still, almost as if he'd dozed off. But the instant his name was announced over the crystal clear speaker system, he took off like a rocket, greeted by tumultuous applause followed seconds later by peals of laughter. (Unlike his previous venues, these sounds had a different tonality to them because of the perfect acoustics in the hall—more distinctive and of higher quality). As soon as the laughs started coming, I'd go off and start shooting, dressed all in black, roaming with my

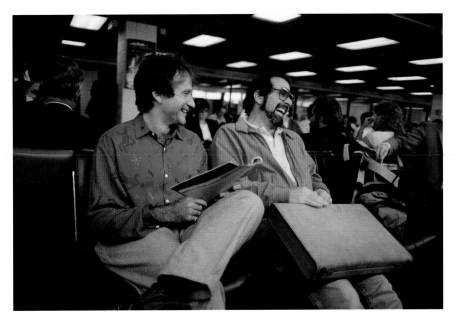

SHARING A LAUGH WITH HIS MANAGER, DAVID STEINBERG, AT THE AIRPORT, PHILADELPHIA, 1986

cameras and my all-access pass, taking my responsibilities seriously as the only still photographer allowed to document what became an epic, Grammy-winning performance.

There was one other difference that set the Met shows apart from the road. Each night after his show there was a long line of top-tier celebrities outside Robin's dressing room waiting to be ushered in to say hello and offer congratulations. On the last night after everyone had left, Robin and I were walking behind the stage from his dressing room to his waiting car when someone called out his name and two people came walking quickly toward him while apologizing for being late. Robin was taken by surprise, then a look of recognition came over his face. He turned to me and did a quick riff in a high voice pretending to be Madonna. A few seconds later the real Madonna and Sean Penn were standing in front of him showering Robin with praise for his great performance. After all he'd been through that night and how bone-tired he must have been, he still had Madonna and Sean laughing as we all headed out. What was on display at that moment was Robin's uncanny and singular ability to make anyone laugh, any time he wanted, no matter what the circumstances.

STANDING ALONE OUTDOORS AT THE BACK OF THE
UNIVERSAL AMPHITHEATER RIGHT BEFORE GOING
ONSTAGE, LOS ANGELES, 1986

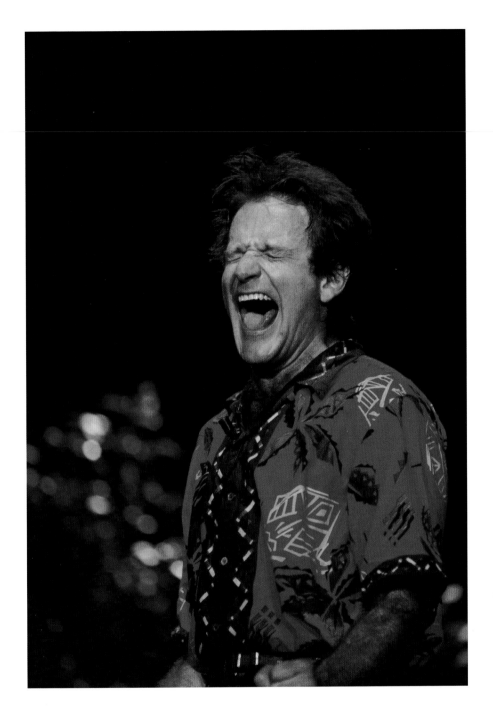 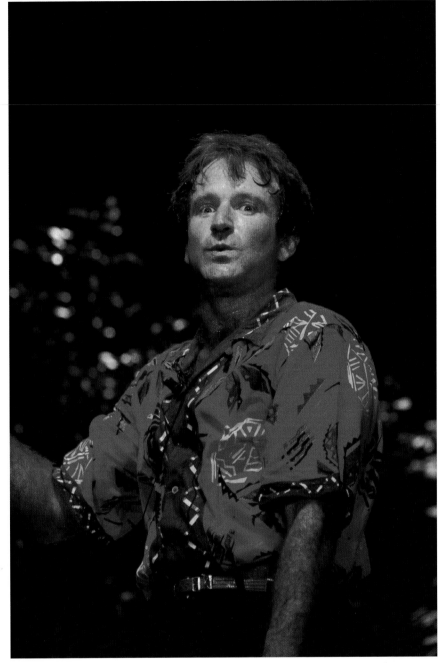

PERFORMING AT A SOLD-OUT SHOW AT THE
UNIVERSAL AMPHITHEATER, LOS ANGELES, 1986

DECOMPRESSING AFTER
UNIVERSAL AMPHITHEATER
PERFORMANCE, LOS ANGELES,
1986

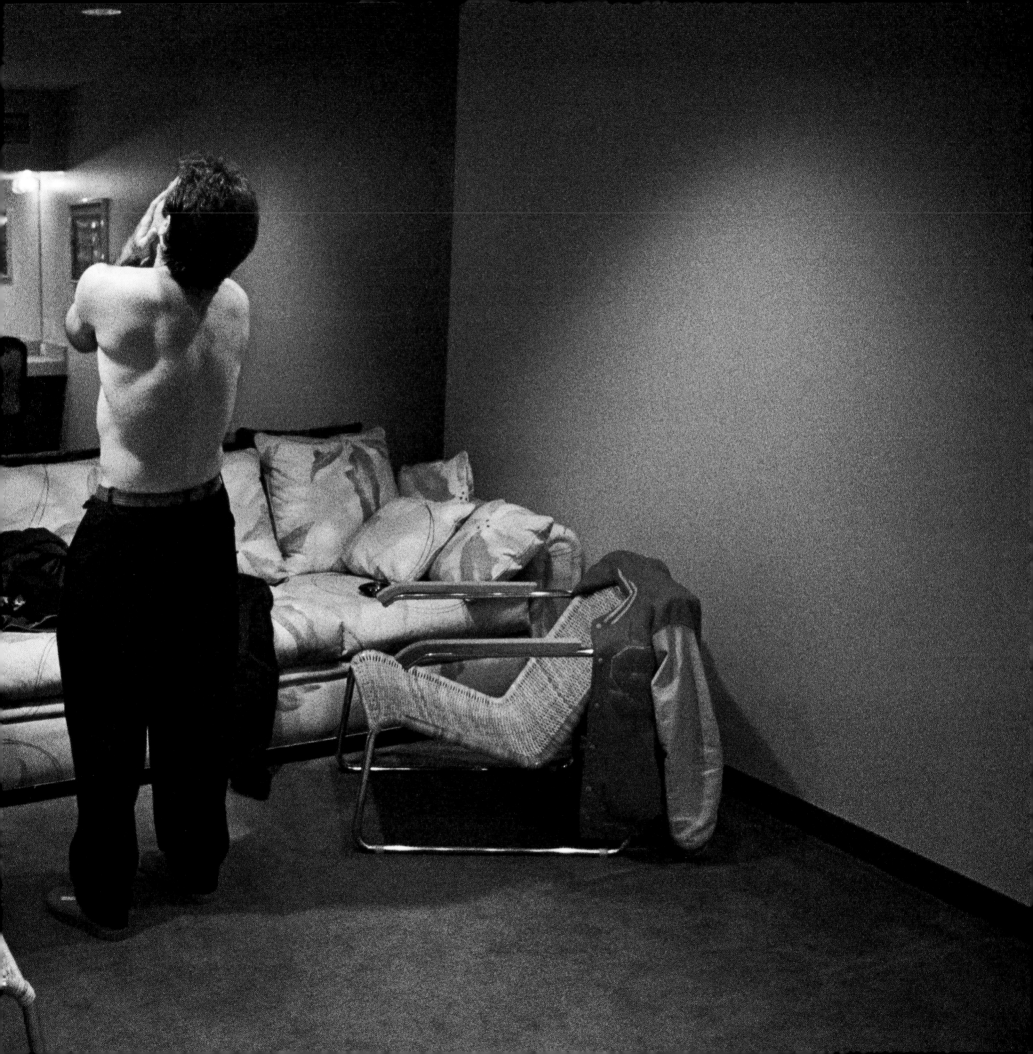

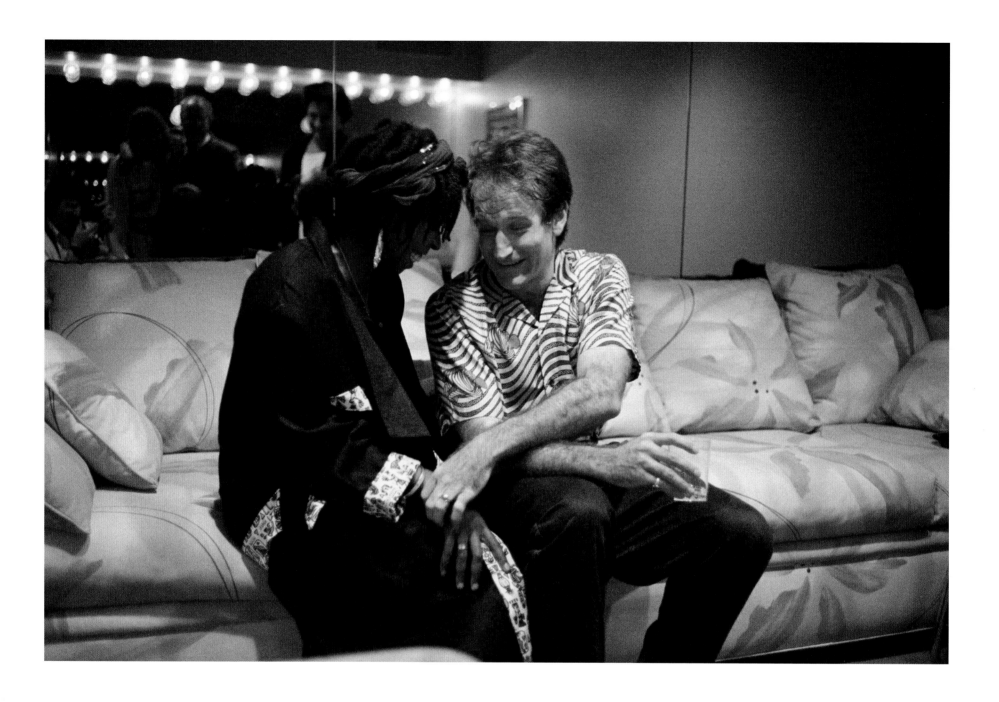

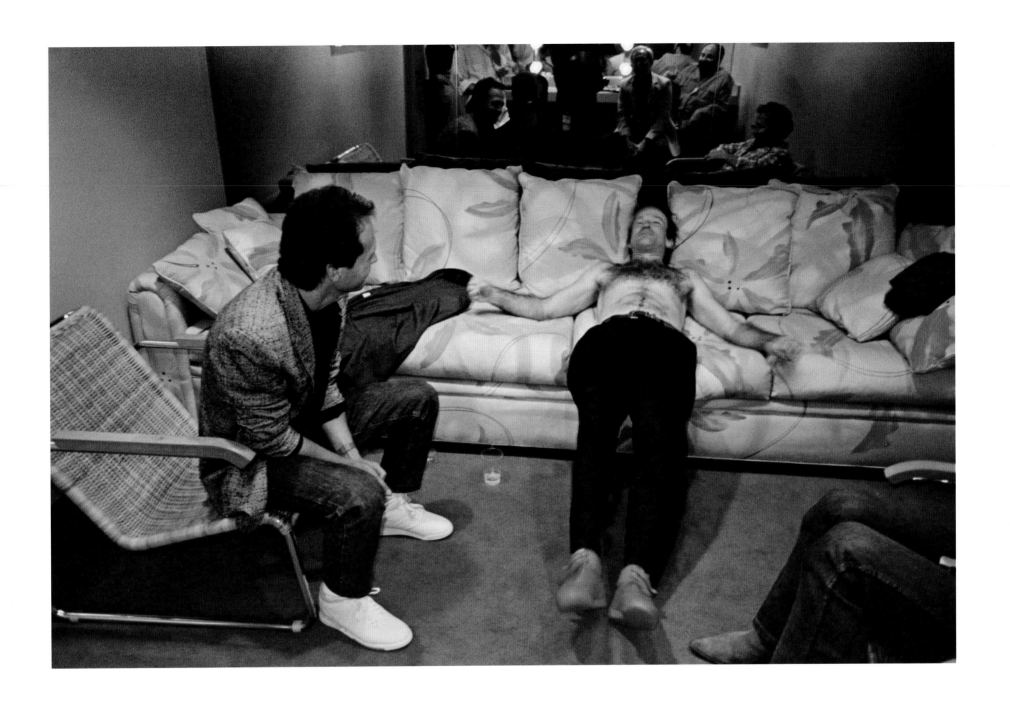

WHOOPI GOLDBERG *(left)* AND BILLY CRYSTAL *(above)*
VISIT ROBIN IN HIS DRESSING ROOM AFTER HIS
STAND-UP SHOW, UNIVERSAL AMPHITHEATER, 1986

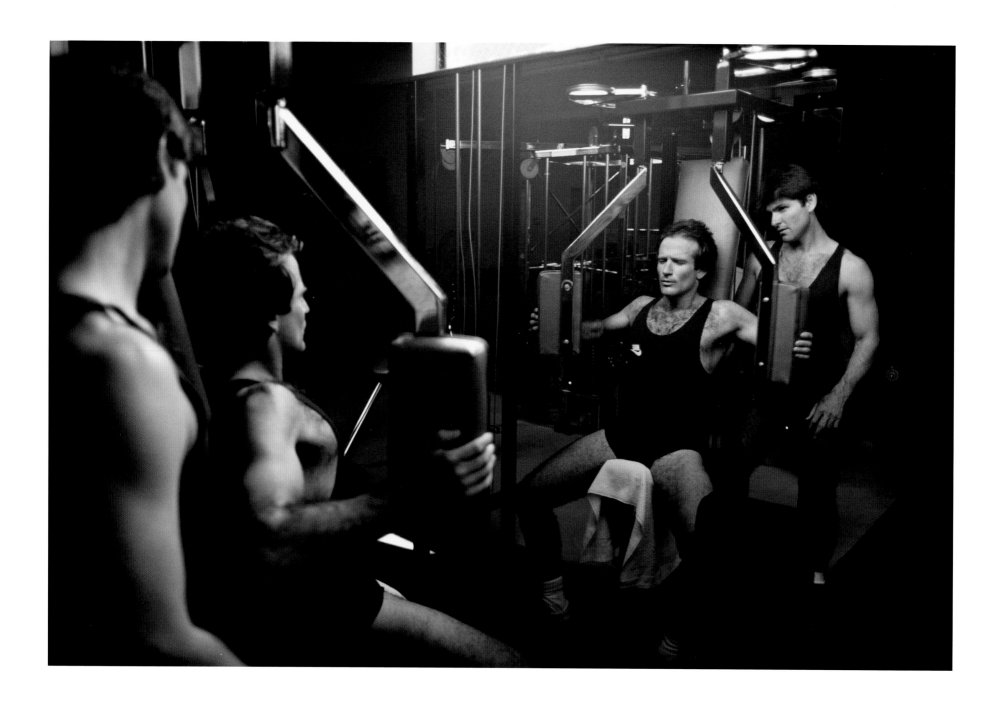

WORKING OUT WITH PERSONAL TRAINER,
DAN ISAACSON, LOS ANGELES, 1986

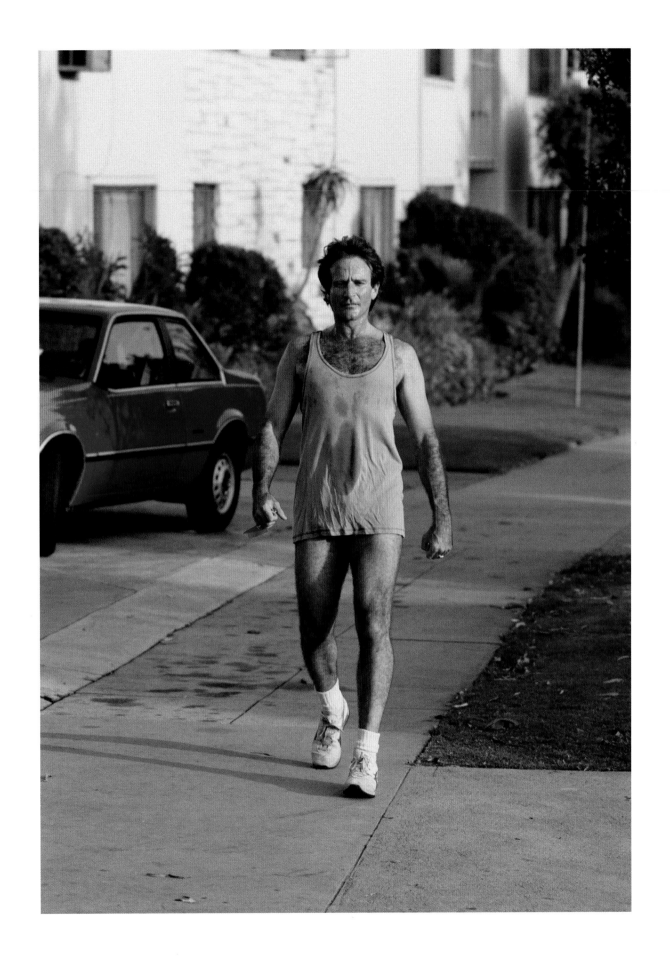

SUCKING IN HIS STOMACH
AND PUFFING OUT HIS
CHEST FOR THE CAMERA
AS HE RETURNS FROM A
RUN, LOS ANGELES, 1986

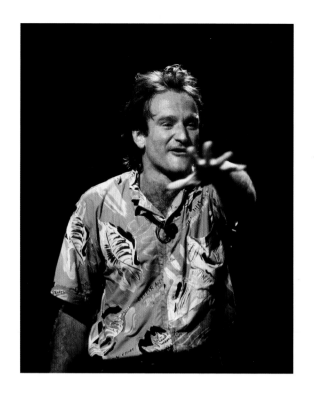
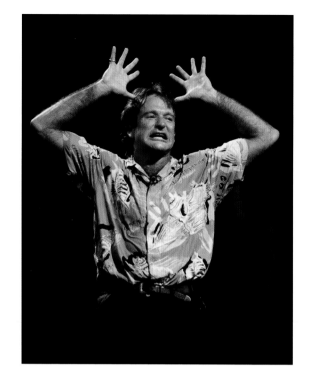
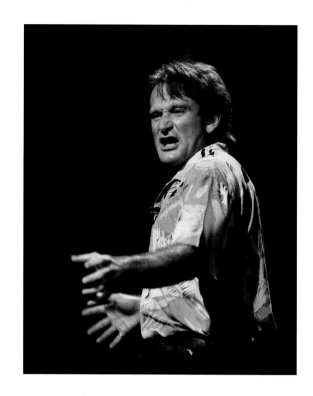
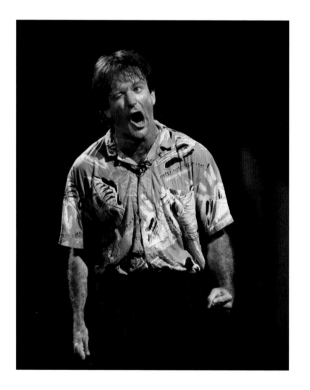
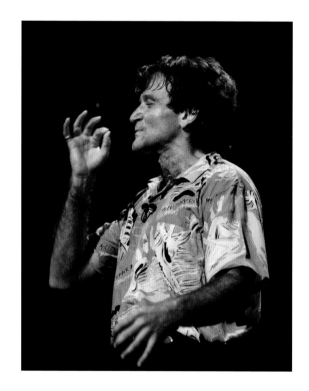

PERFORMING AT THE METROPOLITAN
OPERA HOUSE, NEW YORK, 1986

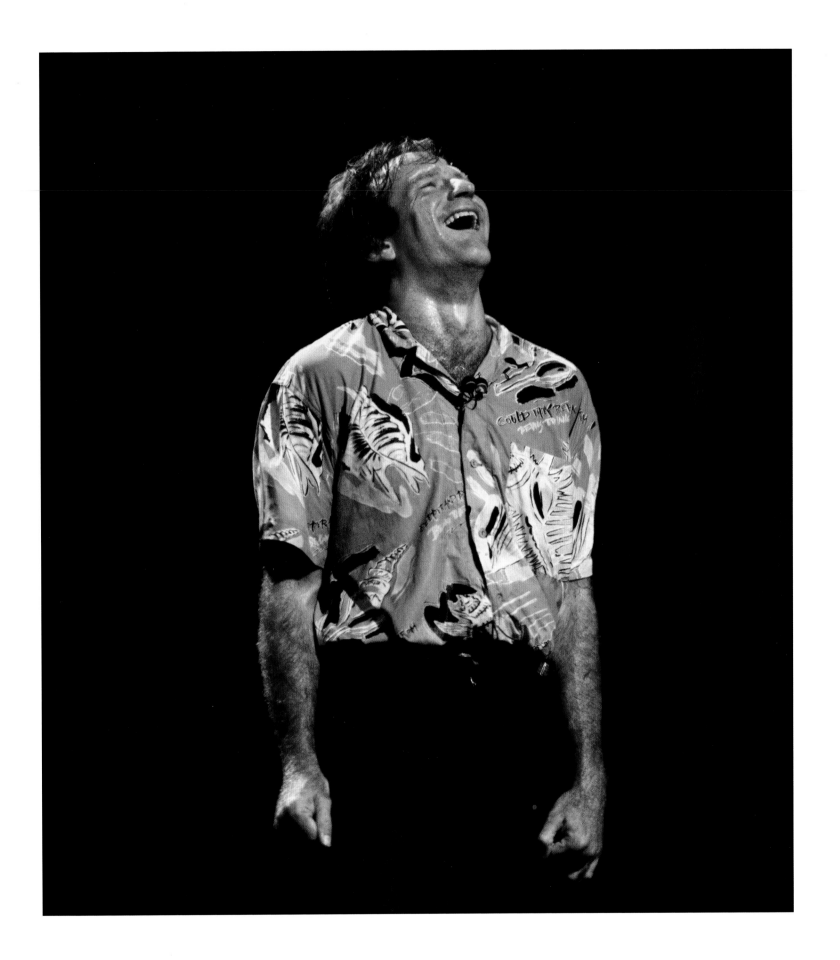

RECEIVING A STANDING OVATION
FROM THE SOLD-OUT CROWD AS
HE LEAVES THE STAGE AT THE
METROPOLITAN OPERA HOUSE,
NEW YORK, 1986

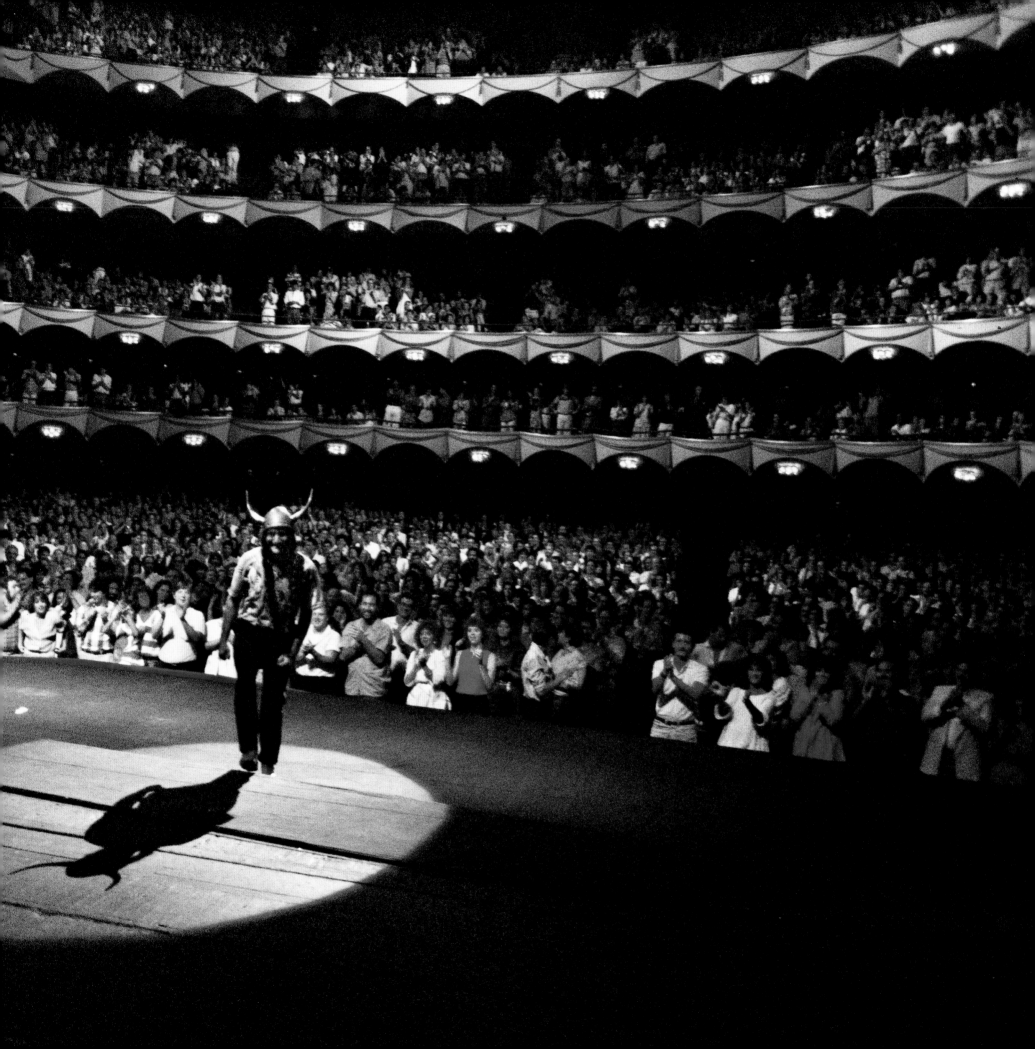

NEWSWEEK COVER SHOOT,
LOS ANGELES, 1986

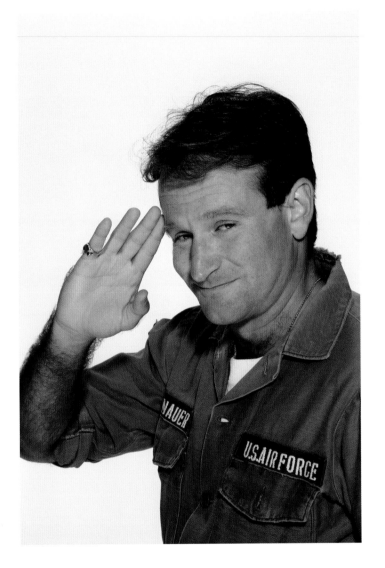

PREMIERE COVER SHOOT FOR
GOOD MORNING VIETNAM,
NEW YORK, 1987

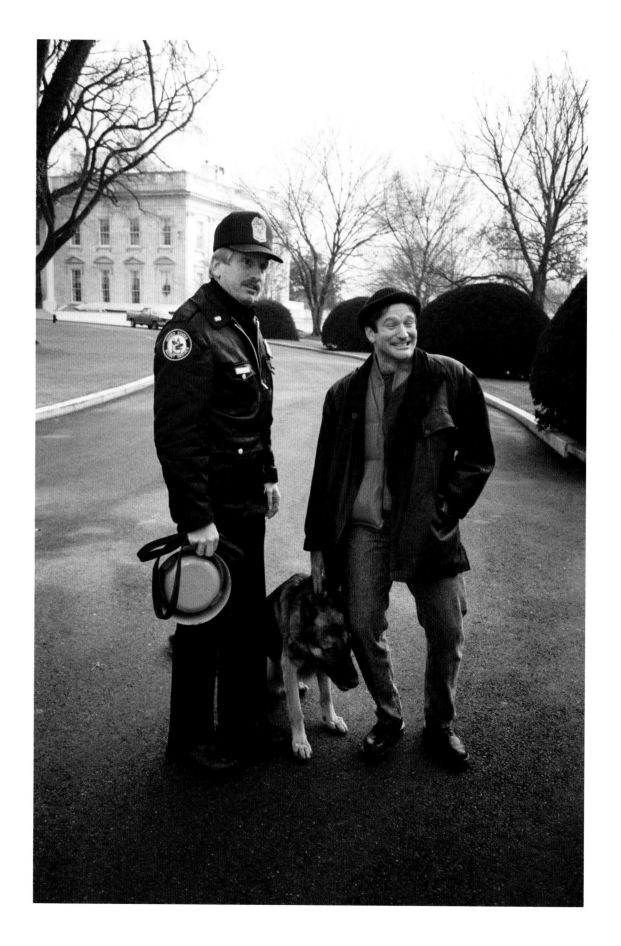

POSING WITH A WHITE HOUSE POLICE
OFFICER AND GUARD DOG IN FRONT
OF THE WHITE HOUSE DURING PRIVATE
VISIT, WASHINGTON, DC, 1989

DC VISIT 1989

In December 1988 Robin was working on *Dead Poet's Society* in Delaware. We talked before Christmas, and the subject of New Year's came up. I asked him if he had any plans, and he said that he'd be stuck on the set working until New Year's Eve. I suggested that since he was so close by, maybe he and Marsha would like to come down to DC and spend the holiday with my wife and me. Due to the uncertainty of his shooting schedule, we decided to wait until New Year's Eve day to talk again. Hopefully, he'd get off early enough to catch a train to Washington.

About mid-afternoon on the thirty-first, Marsha called me from the set to tell me they were going to make it for dinner that night and that she would call me as they were getting on the train. I told her there was a five-star French restaurant that had been written up recently as the finest dining experience in town, but I was sure we couldn't get a table since they'd probably been booked for months. Both she and Robin loved fine cuisine, so it wasn't surprising that she said, "just use Robin's name." At that point in his career, Robin's star power was on the rise thanks to the blockbuster success of *Good Morning, Vietnam*. I told her I'd try to make it happen, but I'd think of some backup options anyway.

When I called the restaurant around 4:30, I immediately asked for the manager. When he got on the phone, I politely asked if there were any openings for that night. All I heard was a gasp of shock on the other end of the phone, and then an indignant voice with a heavy French accent hissed, "That would be impossible!" and hung up. I called right back and asked for the manager again but this time asked the person who answered the phone for the manager's name and to please put me through. When Jean-Paul answered, I used his name right away before he recognized my voice. That got his attention, and I quickly explained that I lived in town and had a special guest I wanted to bring to his restaurant that night, Robin Williams. The phone went silent for about five seconds before a new version of Jean-Paul, polite and gracious, said "I do have something at 9:30. How many will be in your party?"

I called Marsha back and told her that I ended up having to drop Robin's name, and that's what got us the table. She said not to bother picking them up at the train station because of uncertain train times and that they'd take a cab to the house. Around 7:30 my home phone rang, and it was Marsha. Robin had wrapped for the day later than expected, so there was no way they would make a 9:30 reservation. Could I please bump it back to 10:30? I immediately called Jean-Paul and told him what had happened, and after leaving me on hold for a while, he came back on the line and said yes, he could accommodate us. This pattern repeated itself when Marsha called at 9:00 saying they were still running late, and once again Jean-Paul changed the reservation time. An hour later Marsha called from the train and said all of us probably wouldn't get to the restaurant until 11:30. I quickly dialed up Jean-Paul for the third time and explained the problem. Clearly worried at this point that his famous guest might not be coming, he dropped all pretense of pomp and exclusivity and capitulated: "Please do not worry. Whenever you get here, your table will be waiting." The part he left out was, "Please show up! This is a big deal to us."

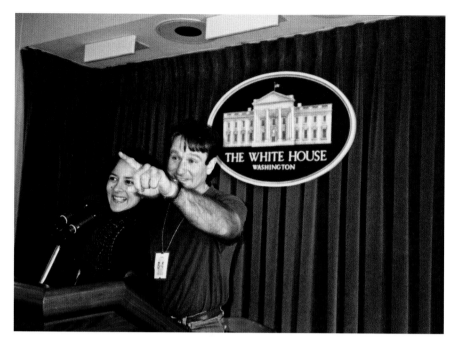

ROBIN (WITH MARSHA) PRETENDING TO BE LARRY SPEAKES CALLING ON REPORTERS IN THE WHITE HOUSE BRIEFING ROOM, WASHINGTON, DC, 1989

By the time we arrived at the restaurant, it was almost midnight and just as Jean-Paul had promised, Mr. Williams's table was ready, directly in the center of the room where everyone could see his entrance and watch him celebrate the New Year. Robin didn't disappoint. Even as tired as he was, he got his second wind and joked with the waiters and Jean-Paul as well as assorted patrons who either came over or called out to him. It was a New Year's Eve with some amazing laughs for anyone who was there. And the food was spectacular, as advertised.

The next morning, New Years Day, I was up by 10:00. Robin and Marsha were downstairs sleeping in the guest room in our newly remodeled lower level (commonly referred to as a basement). By the time my wife came into the kitchen for coffee it was noontime. We both looked at each other and wondered how late our guests were going to sleep. By 2:30 p.m., I was getting a little concerned about why we hadn't heard a sound from downstairs. All sorts of weird thoughts were going through my head: Maybe there was a carbon monoxide leak or maybe our basement had a radon gas problem. By 3:30 my anxiety got the best of me, and I headed downstairs filled with dread. I put my ear up to their bedroom door—dead silence. Just then my English bulldog, Busterella, came barreling down the stairs barking the whole way. As soon as

she reached Robin's door she threw herself against it a few times before I could grab her collar and drag her back upstairs. By the time I came back down again, the bedroom door was open and Robin was shuffling to the bathroom. I said a casual hello, and he answered, "Great bed."

The next day we took Robin and Marsha over to the White House for a tour. My wife was working there in the press office, and she had arranged for a last-minute visit. We basically had the place to ourselves due to the holidays. The only people around were White House police with their guard dogs and a skeleton staff inside. The guards at the gate asked Robin if he'd pose for pictures with them which Robin was happy to do, especially since he was then able to get close to their dogs and Robin loved dogs. The highlight of the tour was Robin in the press room giving his impression of Larry Speakes at the podium answering questions.

After the visit we drove around the White House perimeter in my gray Chevy Cavalier station wagon. As we stopped at a red light by the Treasury Department, a car filled with teenagers pulled up next to us. Robin, in a wool cap, was in the backseat right behind me, closest to their car. Our windows were open due to the unseasonably warm weather, so everyone in the other car got a good look at him. Suddenly, two girls in the car who had rolled down their windows started screaming and pointing, "That's Robin Williams! Look, it's Robin Williams!" Robin was noncommittal, but waved back and smiled. As the light changed, the guy behind the wheel in the other car started yelling at the girls, "Will you two shut up! That can't be him! He's in a Chevy Cavalier, for Christ's sake!" We all cracked up at that because Robin had been teasing me all day about my "cool" car—did somebody give it to me, was business really that bad, were you stoned when you bought it?

That set the tone for the rest of the day. There were lots of laughs at my expense, although I did get in a few shots. That night we had a seafood feast back at the house with some very large Maine lobsters as the main attraction. They were a perfect prop for Robin to do voices and improv as he cracked, crushed, and pulled the lobster apart. It was another meal with Robin where I was laughing so hard and so often that I never finished my food. This was a pattern that would be repeated many times in the years ahead.

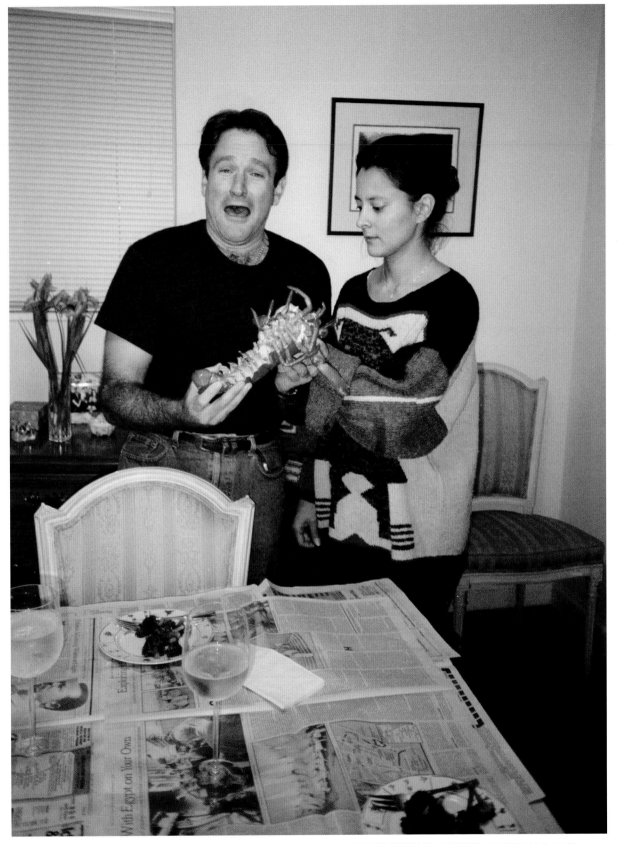

ROBIN (WITH MARSHA) TRYING TO CONTROL HIS EXCITEMENT AFTER MEETING HIS
DINNER LOBSTER, ARLINGTON, VA, 1989

ROBIN BACKSTAGE AT *COMIC RELIEF* WITH
HIS MANAGER, DAVID STEINBERG (center), AND
DANCERS FROM THE SHOW, LOS ANGELES, 1989

ROBIN AND MARSHA, NEW YORK, 1989

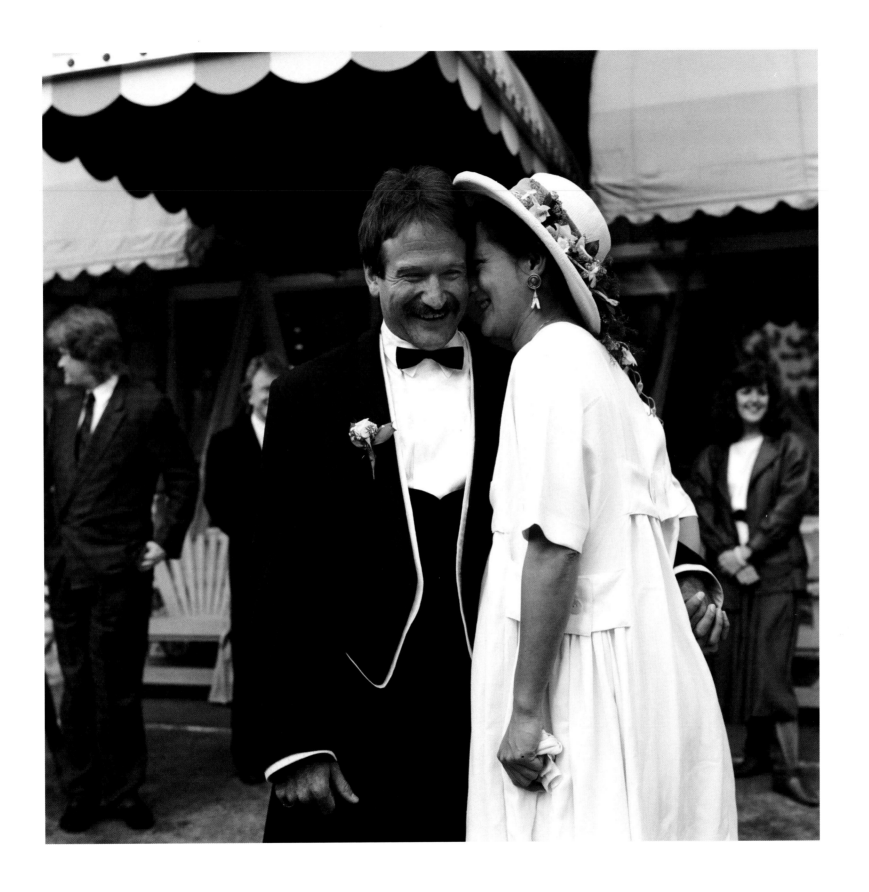

WEDDING DAY, APRIL 30, 1989, LAKE TAHOE

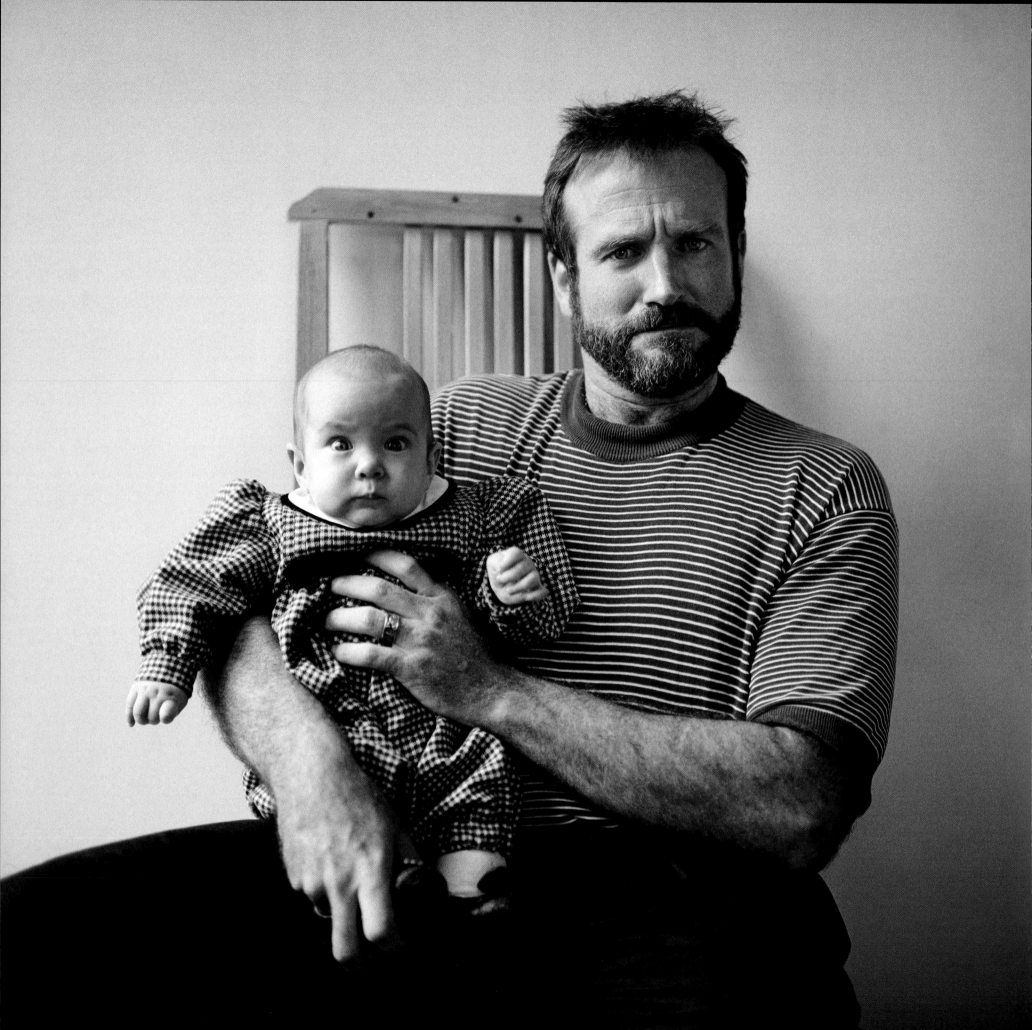

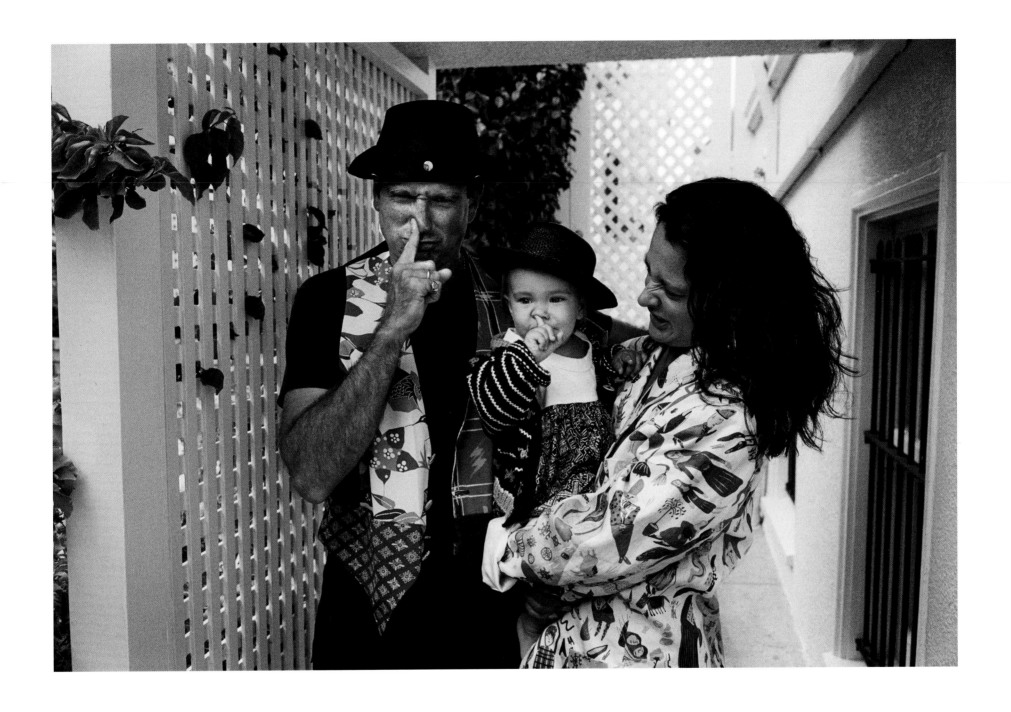

ROBIN WITH DAUGHTER ZELDA, NEW YORK, 1989 *(left)*
AND AT HOME IN SAN FRANCISCO, 1990 *(above)*

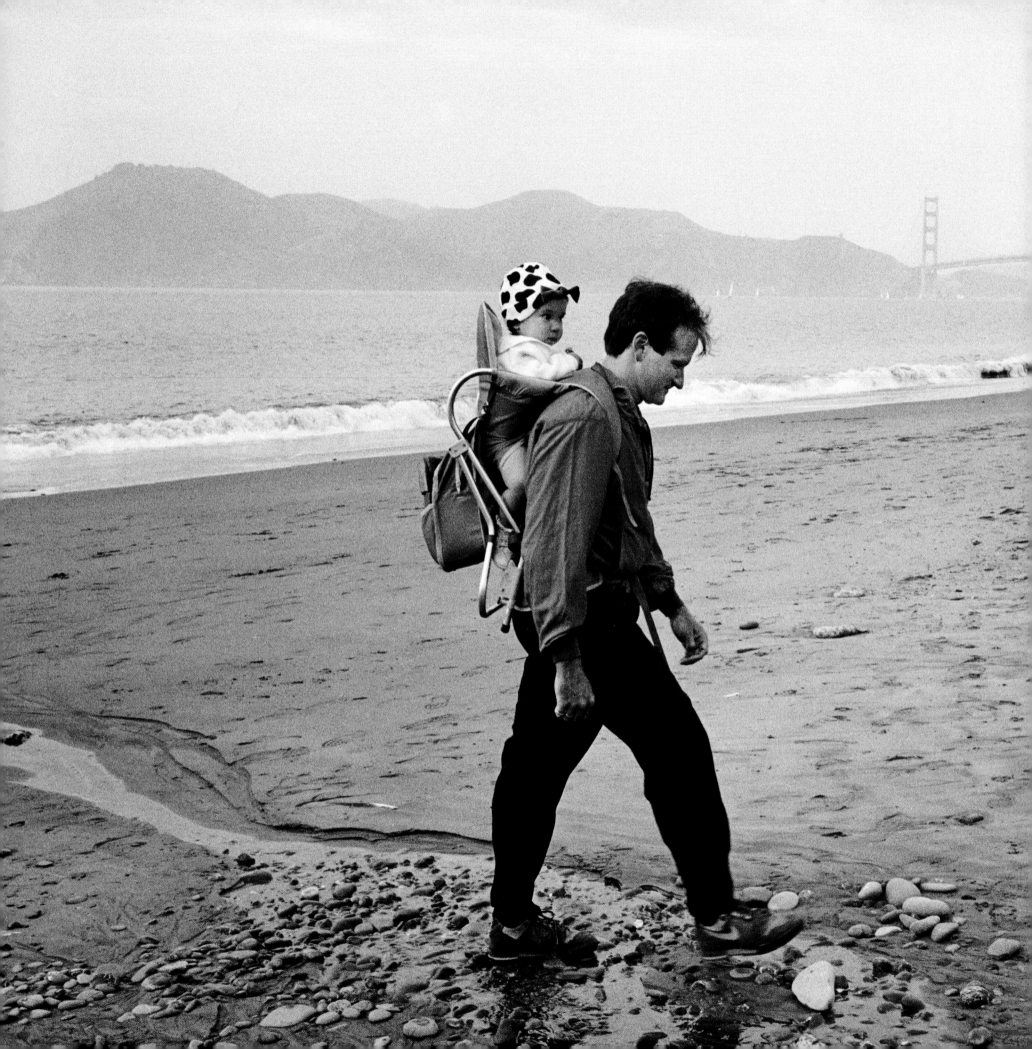

ROBIN WITH ZELDA,
SAN FRANCISCO, 1990

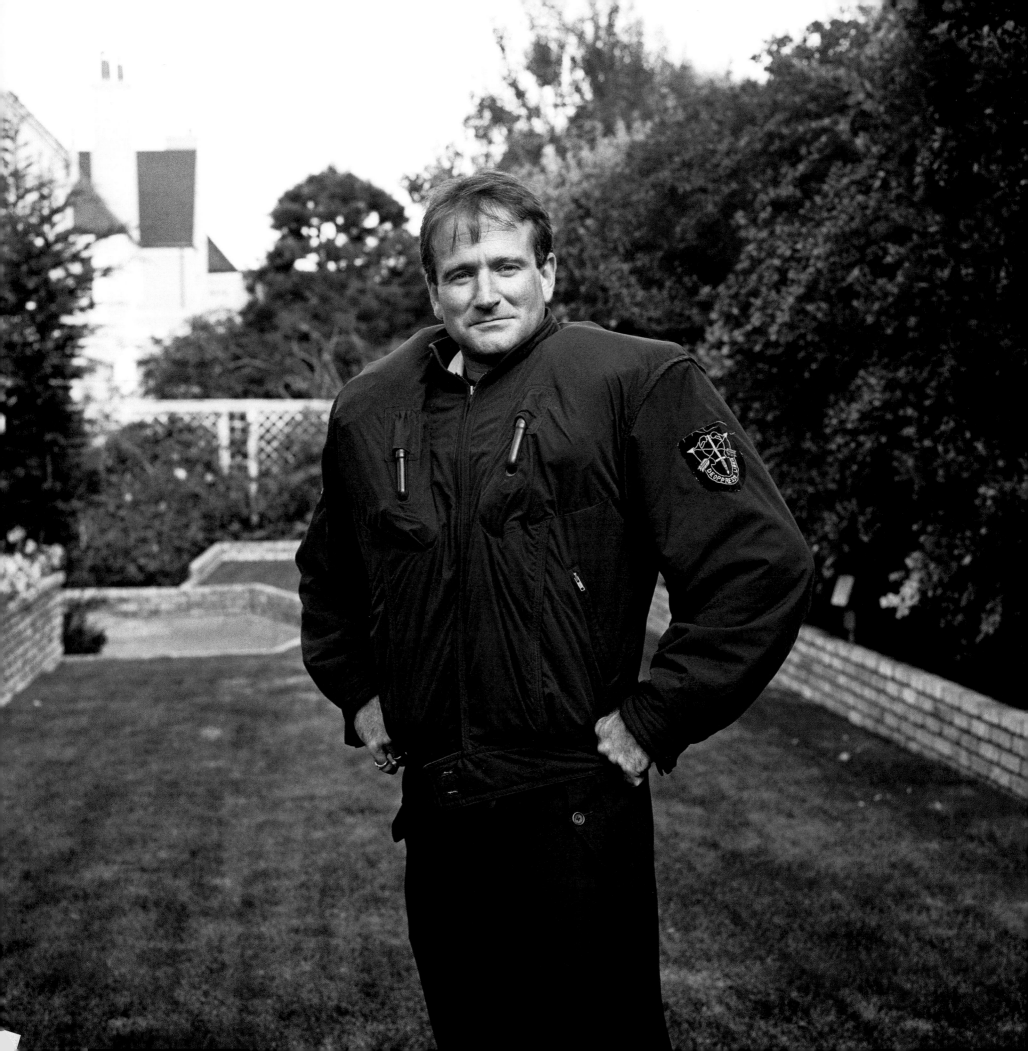

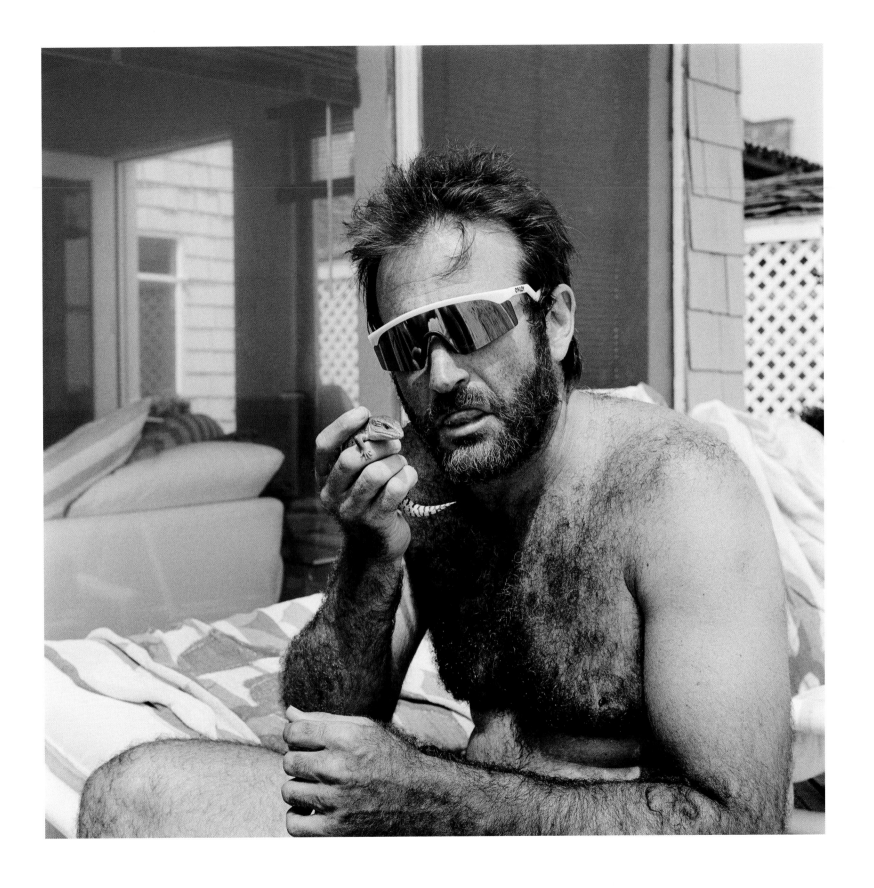

POSING IN INFLATABLE JACKET DURING *VOGUE* MAGAZINE
SHOOT, SAN FRANCISCO, 1990 *(left)* AND WITH PET LIZARD
AT HIS RENTAL HOUSE IN MALIBU, 1989 *(above)*

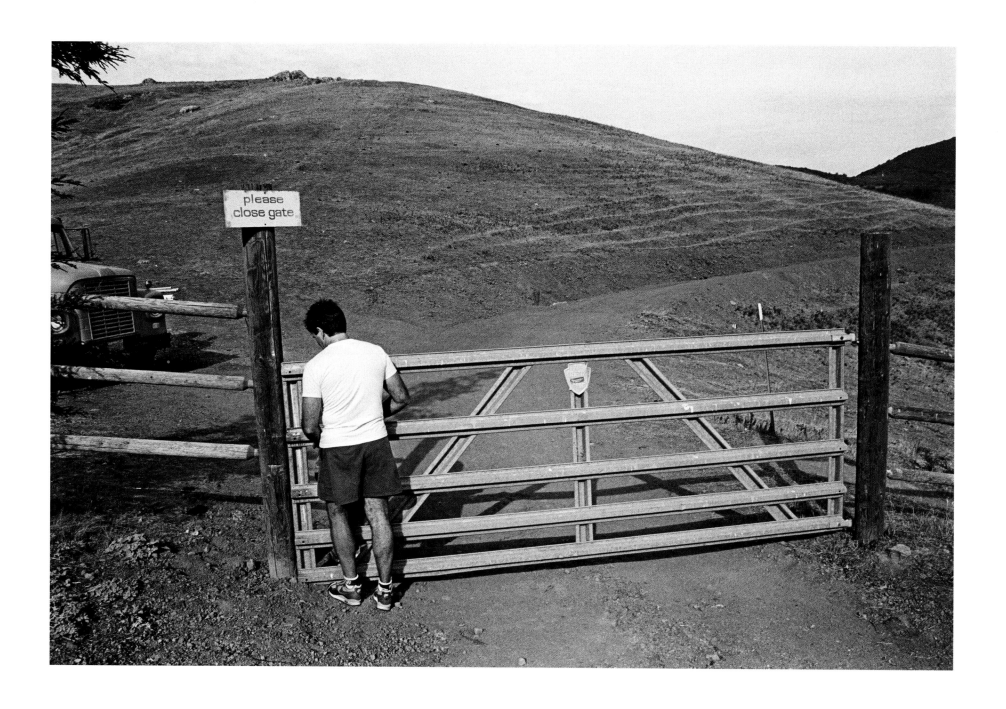

CLOSING ONE OF THE GATES
TO HIS RANCH, NAPA, 1990

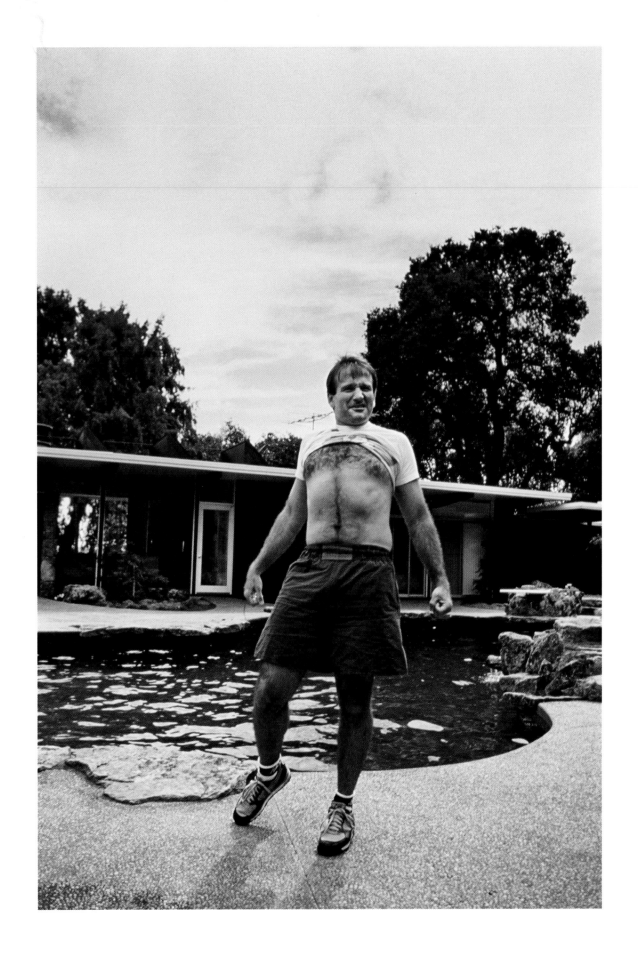

REVEALING HIS
PHYSIQUE BY HIS POOL,
NAPA RANCH, 1990

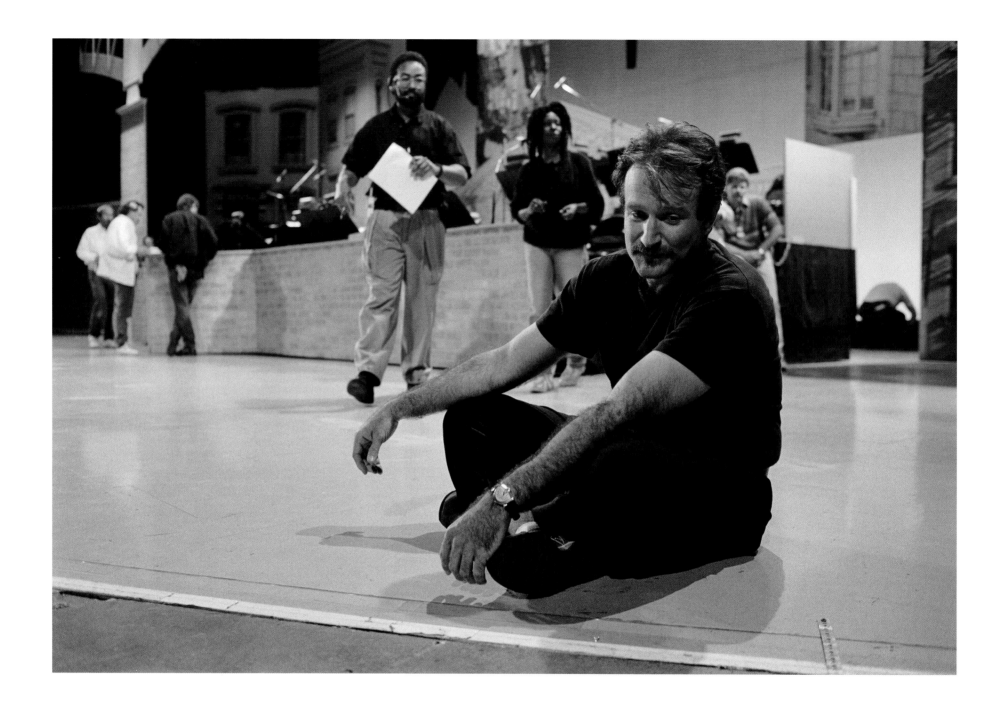

TAKING A BREAK ON STAGE DURING *COMIC RELIEF*
REHEARSALS, NEW YORK, 1990

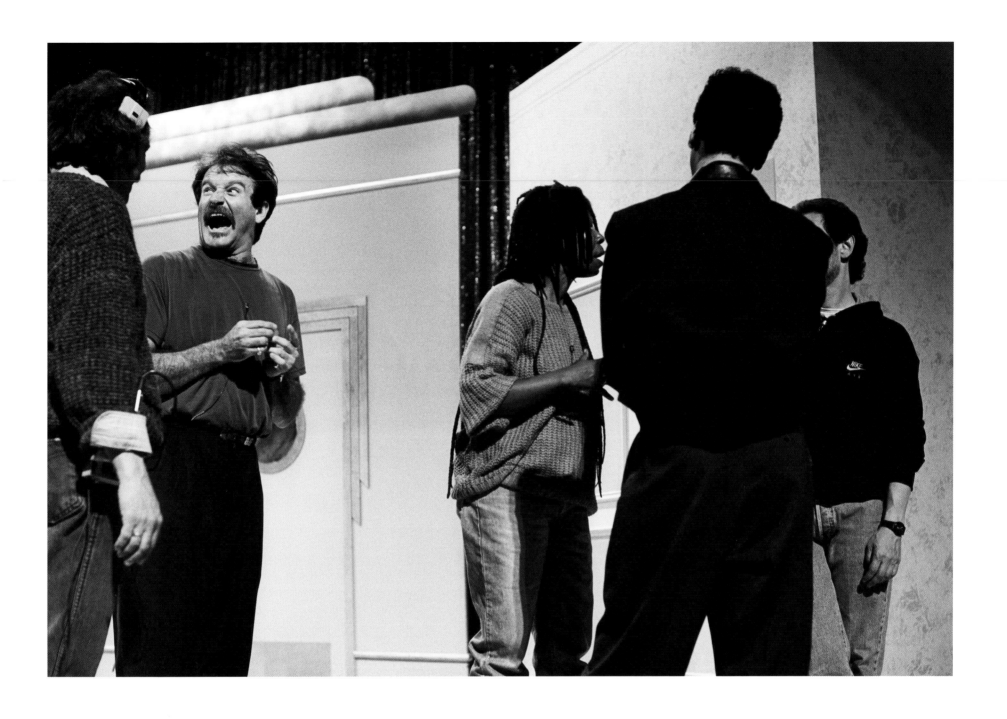

ENTERTAINING A PRODUCTION ASSISTANT DURING
COMIC RELIEF REHEARSALS, NEW YORK, 1990

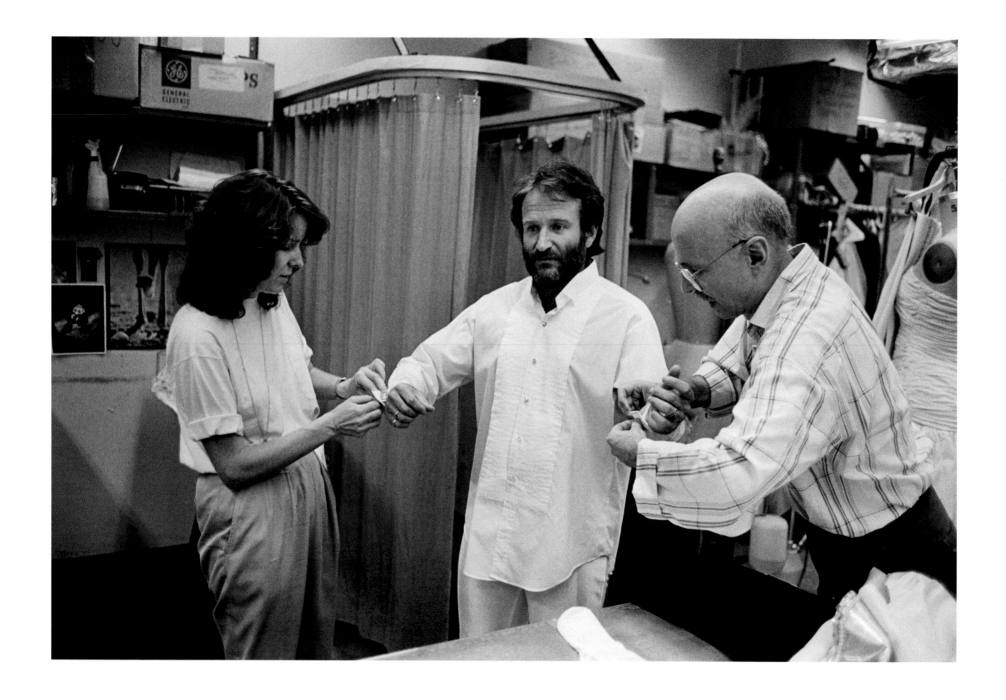

COSTUME FITTING BY WARDROBE STAFF DURING BREAK
IN *COMIC RELIEF* REHEARSALS, NEW YORK, 1990 *(above)*
AND (L TO R) BILLY CRYSTAL, WHOOPI GOLDBERG, AND
ROBIN REHEARSING DANCE NUMBER FOR *COMIC RELIEF*,
NEW YORK, 1990 *(right)*

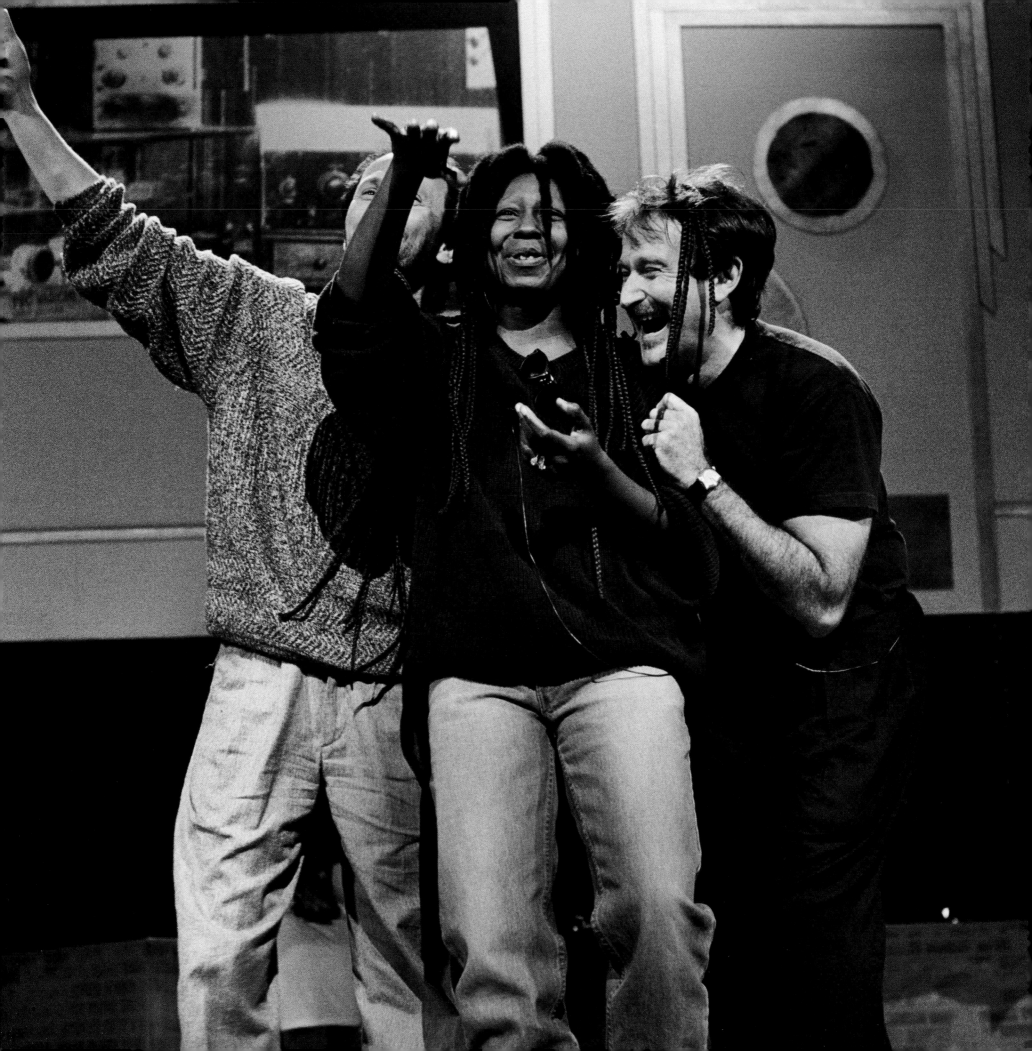

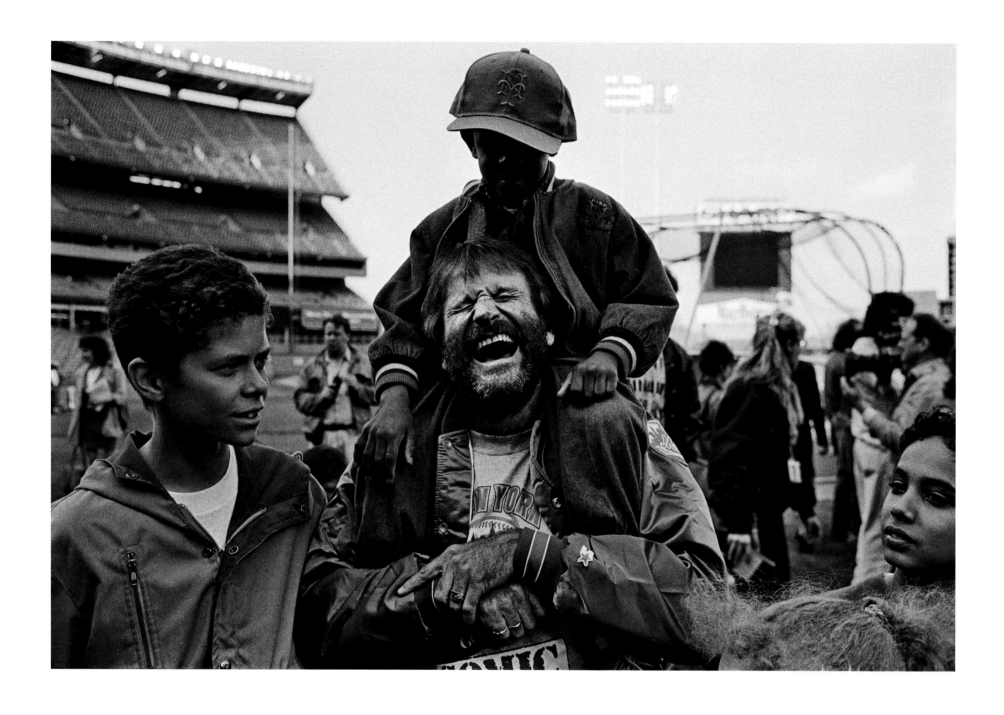

ROBIN WITH LOCAL BOY ON HIS SHOULDERS DURING
A PROMOTIONAL EVENT FOR *COMIC RELIEF* AT METS
GAME *(left)* AND (L TO R) BILLY CRYSTAL, WHOOPI
GOLDBERG, ROBIN, AND BOB ZMUDA CHEERING
DURING METS GAME, NEW YORK, 1990 *(right)*

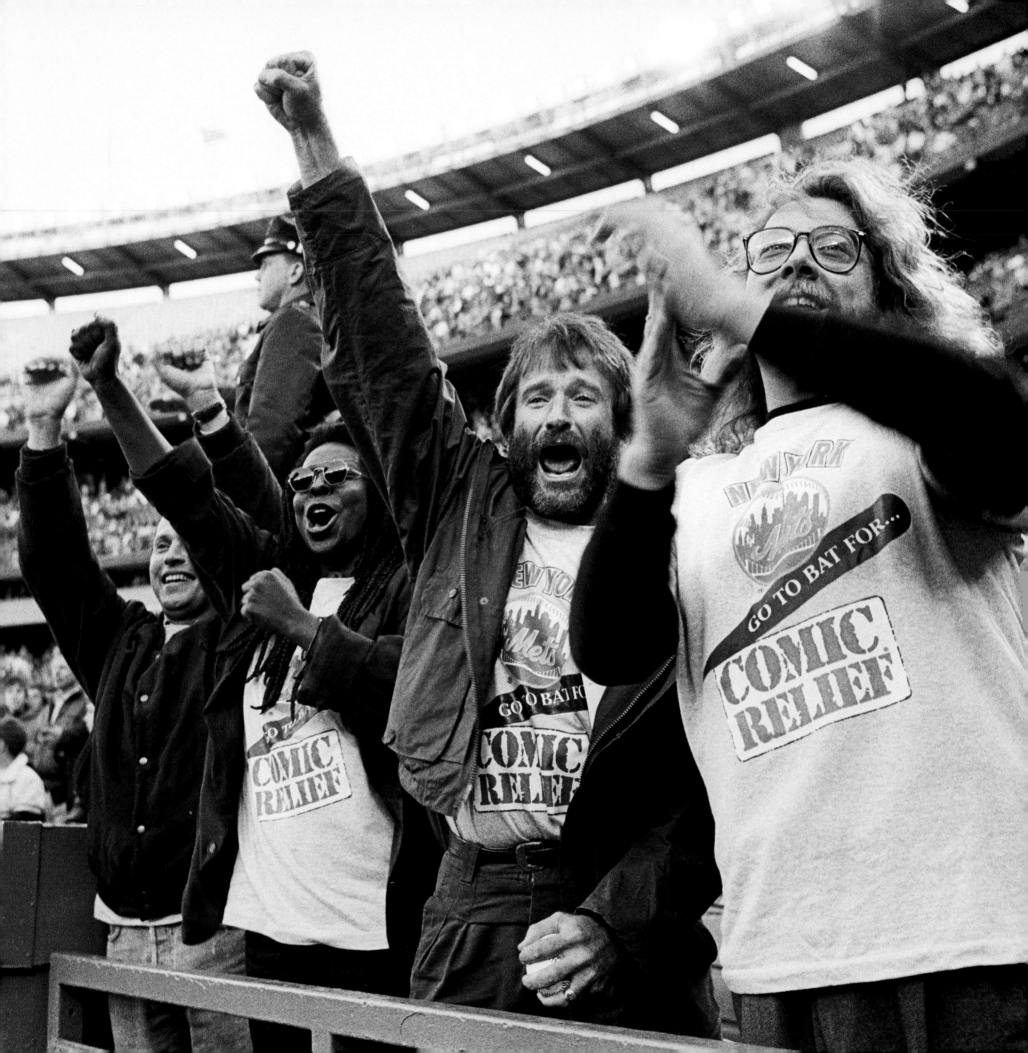

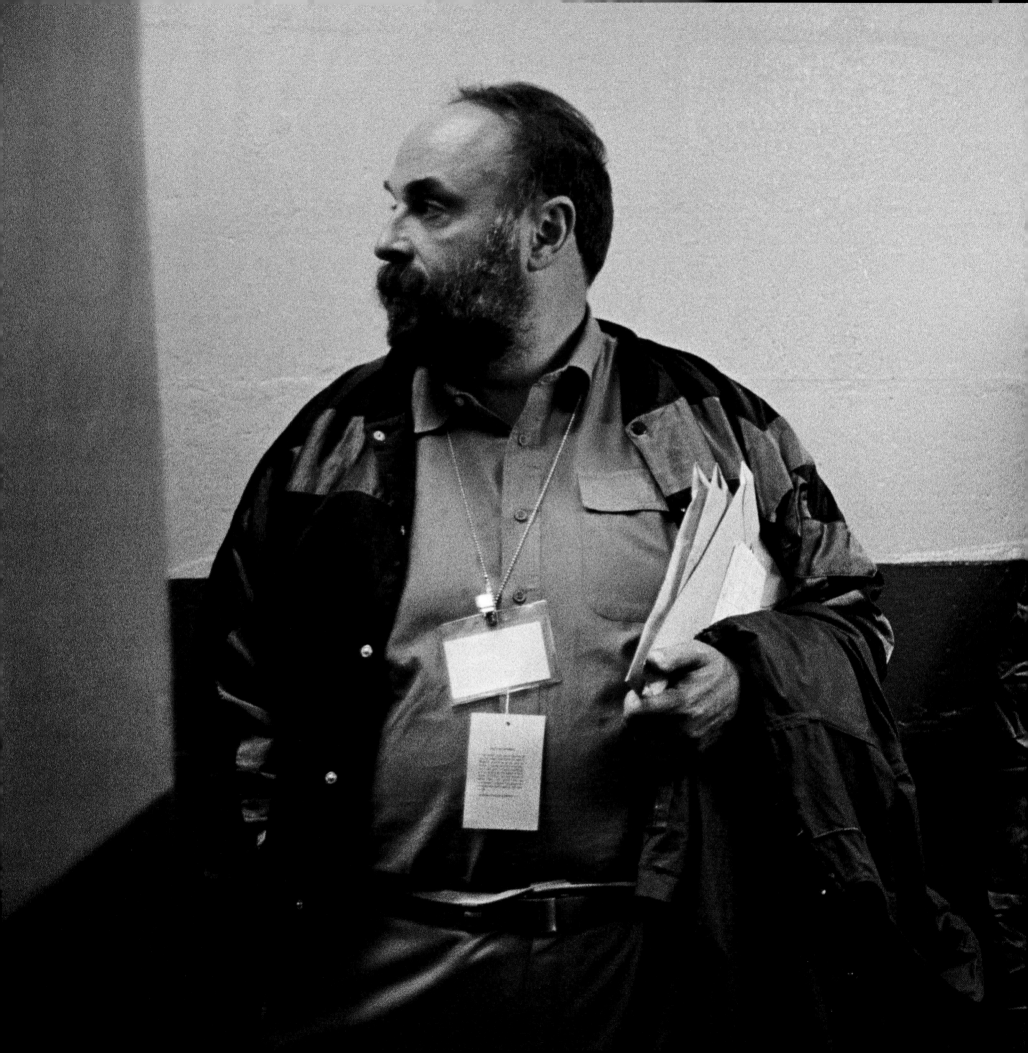

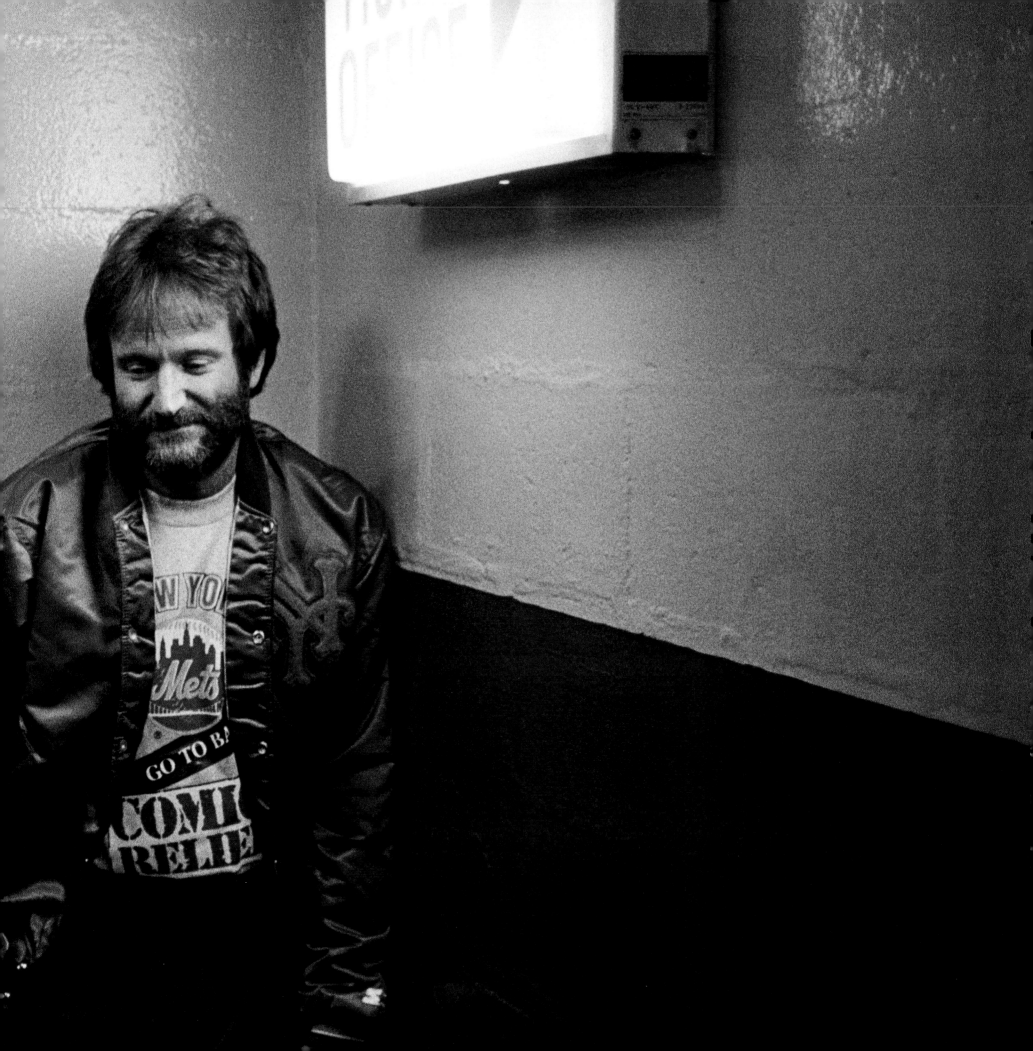

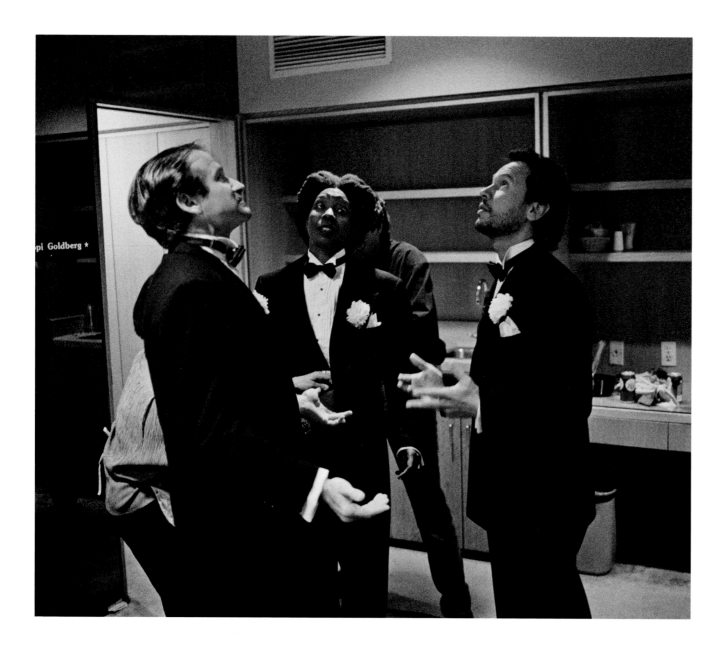

preceding page
ROBIN WITH HIS PUBLICIST, MARK RUTENBERG,
NEW YORK, 1990

this page and right
LAST MINUTE REHEARSAL BEFORE TAKING
STAGE FOR LIVE *COMIC RELIEF* SHOW,
NEW YORK, 1990

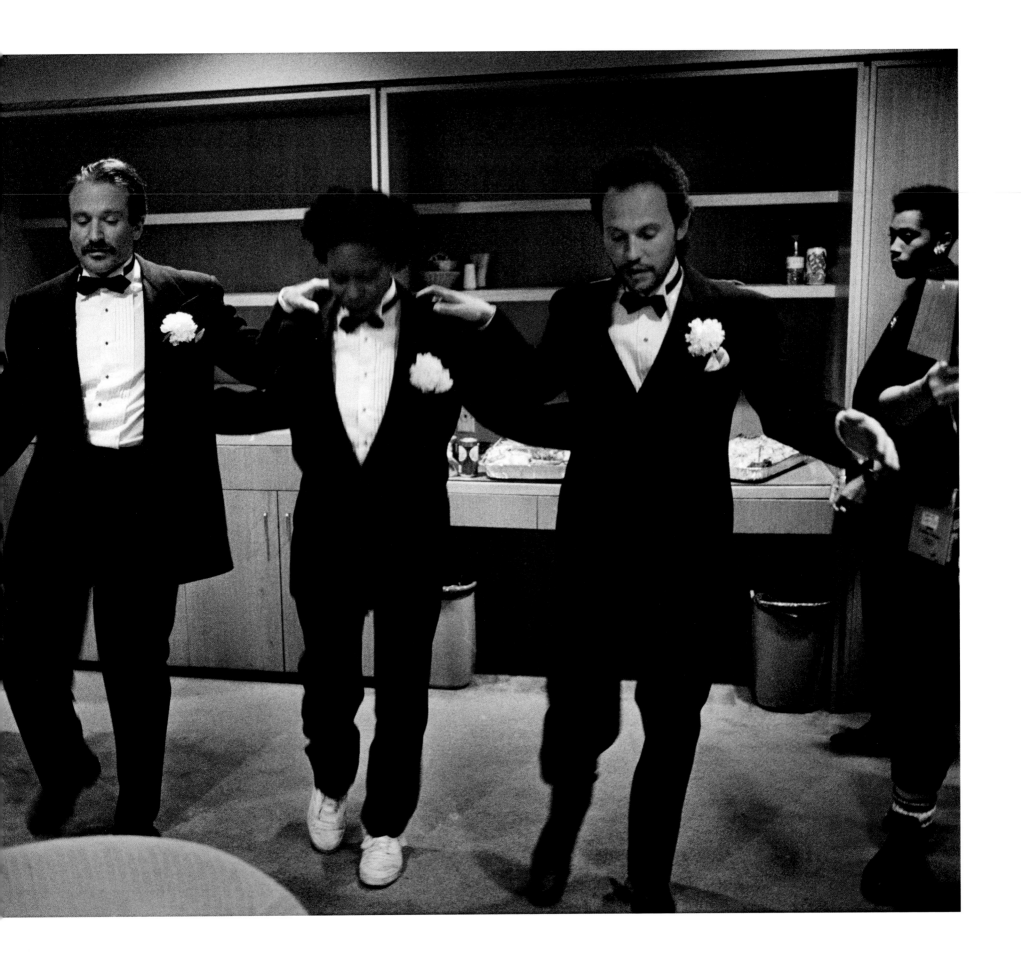

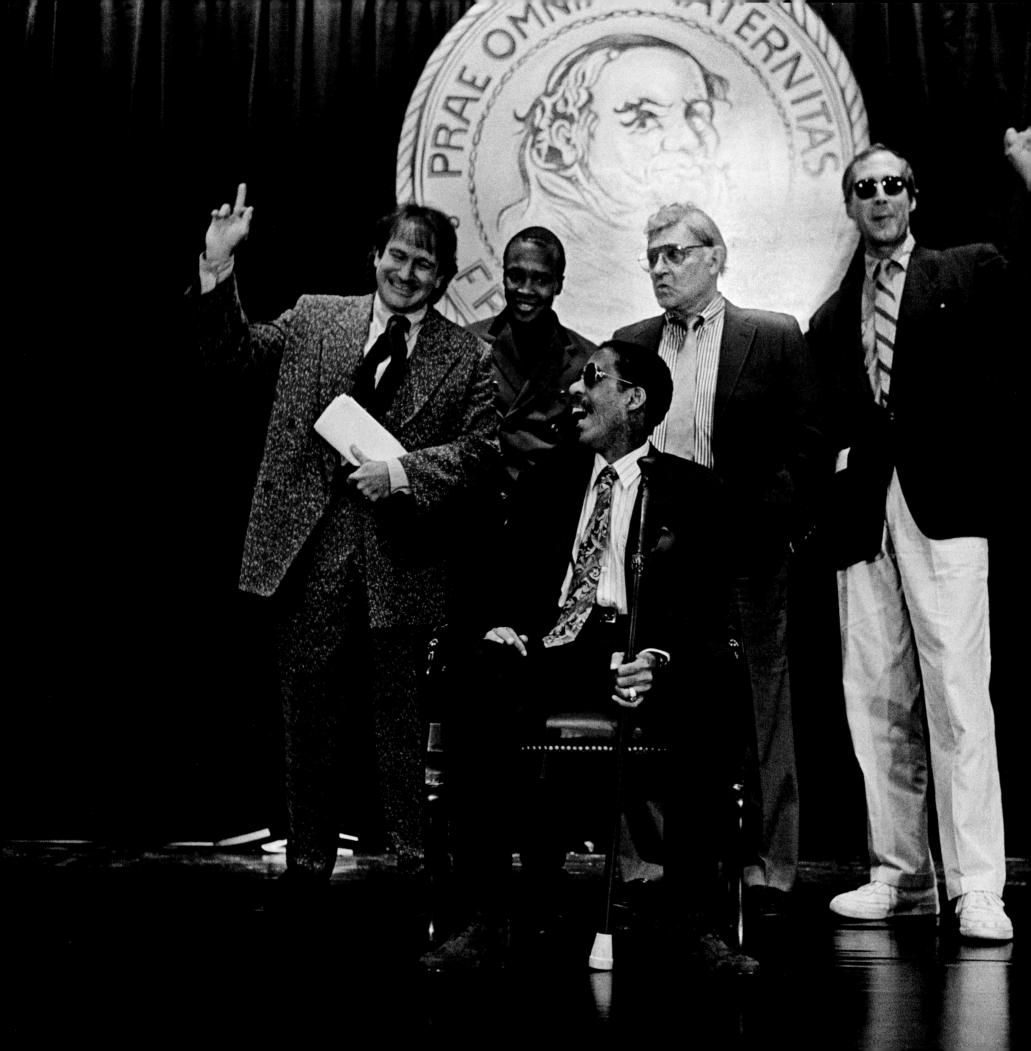

RICHARD PRYOR FRIARS CLUB ROAST, (L TO R)
ROBIN, SUGAR RAY LEONARD, RICHARD PRYOR,
ROD STEIGER, CHEVY CHASE, AND QUINCY
JONES, NEW YORK, 1991

THE WEDDING 1991

In early October 1991 I traveled to East Hampton, Long Island to shoot my second (and last) wedding thanks to Robin's glowing recommendation. He and Marsha had been out to dinner the previous month with Steven Spielberg and Kate Capshaw, who happened to mention they were having trouble finding a wedding photographer. Steven didn't want the usual posed color photos, but instead preferred to have their nuptials weekend shot exclusively in black-and-white and in a photojournalistic style. That's when the Williamses brought up my name and recommended that they use me, directing them to my book *Comedians*, which had just been published and was shot in the style they were looking for. About a week later Kate gave me a call, and after telling me that Robin and Marsha would be guests and most importantly, that I wouldn't be obligated to shoot the standard wedding shots, I felt a lot more comfortable and said yes.

On Friday night of the wedding weekend, there was a dinner party for out-of-town guests. Although I was busy taking pictures, I also had time to watch Robin as he interacted with the A-listers from the entertainment business who filled the room. He was pretty subdued, for him—almost shy actually. I don't think he was particularly comfortable in that setting, surrounded by studio heads, super-agents, and top-tier producers and directors who could directly affect his career. He definitely was keeping the lid on his more gregarious self, just blending in and making conversation. The same thing happened the next day during a pre-wedding luncheon. He was unobtrusive and polite, engaging in small talk with some of the other actors who were

there. It was like he was on his best behavior because adults were in the room. I was surprised by all this because I'd never seen Robin so subdued for such a prolonged period of time.

Finally, later that afternoon, the relaxed and entertaining Robin was back. He was playing touch football with a pickup team of fellow guests who were actually serious about winning. Unfortunately for his teammates, football wasn't Robin's thing. I'm not sure he even understood the game, let alone the rules. After a few dropped passes and missed tags, he decided to do some very funny "play-by-play" running dialogue which released the competitive tension and basically broke up the game. During the team photos, he was still going strong, doing an improv bit of his wife Marsha, who was very pregnant at the time, giving birth to a football.

The night of the wedding ceremony, the huge tent behind the Spielbergs' summer house was filled to capacity with the biggest stars (Barbra Streisand, Harrison Ford, Tom Hanks, Dustin Hoffman, Robin, etc.) and most powerful off-camera players in the entertainment industry (George Lucas, Jeffrey Katzenberg, Steve Ross, Sidney Sheinberg, Mike Ovitz, etc.). In a surprising gesture of hospitality, Kate told me she wanted me to enjoy her wedding and invited me to sit at Robin's table for the evening when I wasn't busy photographing the festivities.

During dessert, Steven picked up a microphone and after thanking everybody for coming, jokingly said something like, "OK, with all this talent in the room, who'd like to entertain us while we're

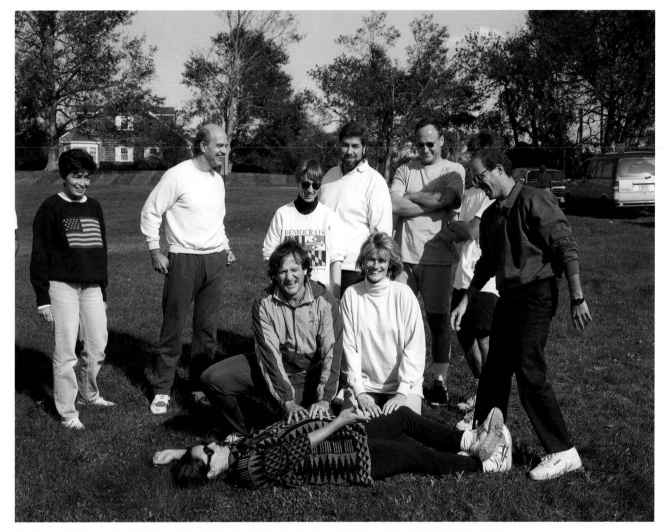

ROBIN FEELING MARSHA'S PREGNANT BELLY BEFORE TEAM PHOTO WITH
SPIELBERG WEDDING GUESTS AT TOUCH FOOTBALL GAME, EAST HAMPTON, 1991

finishing dessert?" When no one immediately volunteered, he called out a major celebrity's name who was seated nearby and tried to pass him the mic. Unfortunately, his famous guest was having none of it, acting as though Steven was trying to hand him a live grenade. With a look of terror on his face, he kept shaking his head no to Steven and stayed planted in his seat.

The next few stars Steven approached again acted like the microphone was radioactive. As some hoots and hollers filled the tent egging on certain people to take the mic, it became painfully obvious that there was no way some of the biggest entertainers in the world were going to risk "bombing" in front of such an elite audience. Suddenly, the most intrepid entertainer in the tent and the funniest improv comedian on the planet, Robin Williams, popped up from his chair, grabbed the mic from Steven, and had the crowd in the palm of his hand and laughing for the next five minutes.

On display was one of Robin's greatest attributes—his fearlessness. When others of equal or greater stature hesitated for any number of legitimate reasons, Robin alone stepped on to the high wire without a net and made it look easy getting to the other side. Although it was brief, it was the one performance of Robin's I'll never forget.

ROBIN CRACKS UP DUSTIN HOFFMAN DURING
STEVEN SPIELBERG AND KATE CAPSHAW'S
WEDDING RECEPTION, EAST HAMPTON, NY, 1991

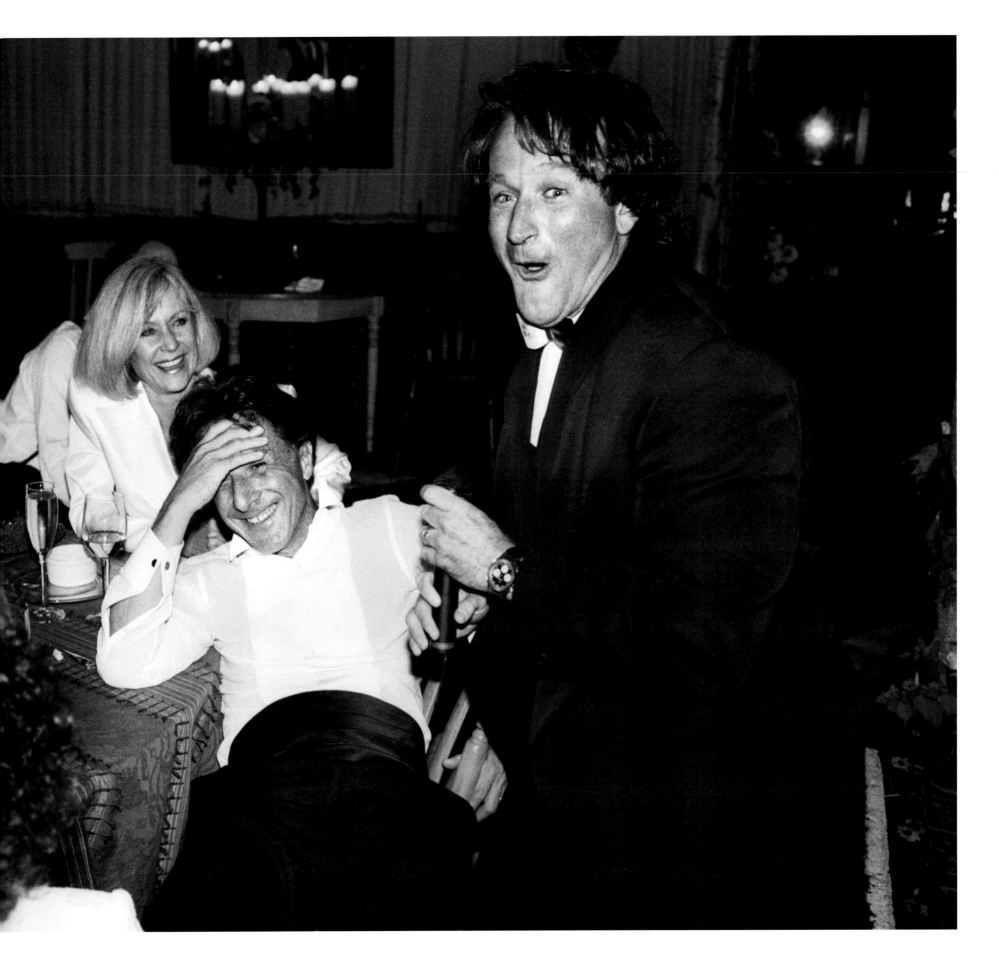

LOOSENING UP BEFORE PRESS JUNKET
INTERVIEW FOR *HOOK*, 1991

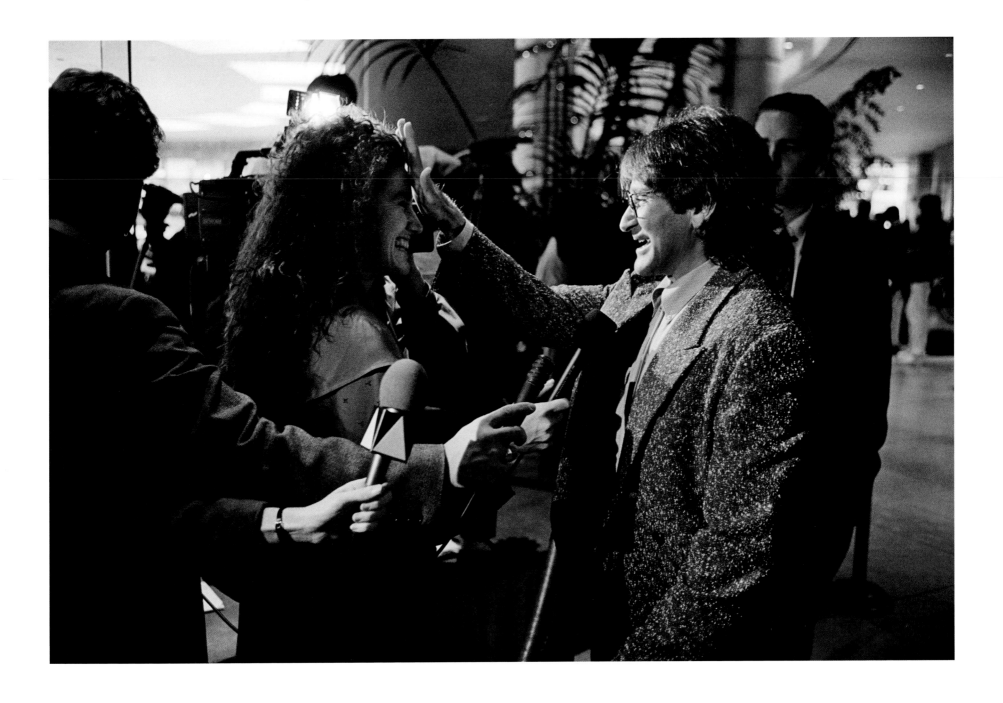

JOKING WITH PRESS AT *HOOK*
PREMIERE, LOS ANGELES, 1991

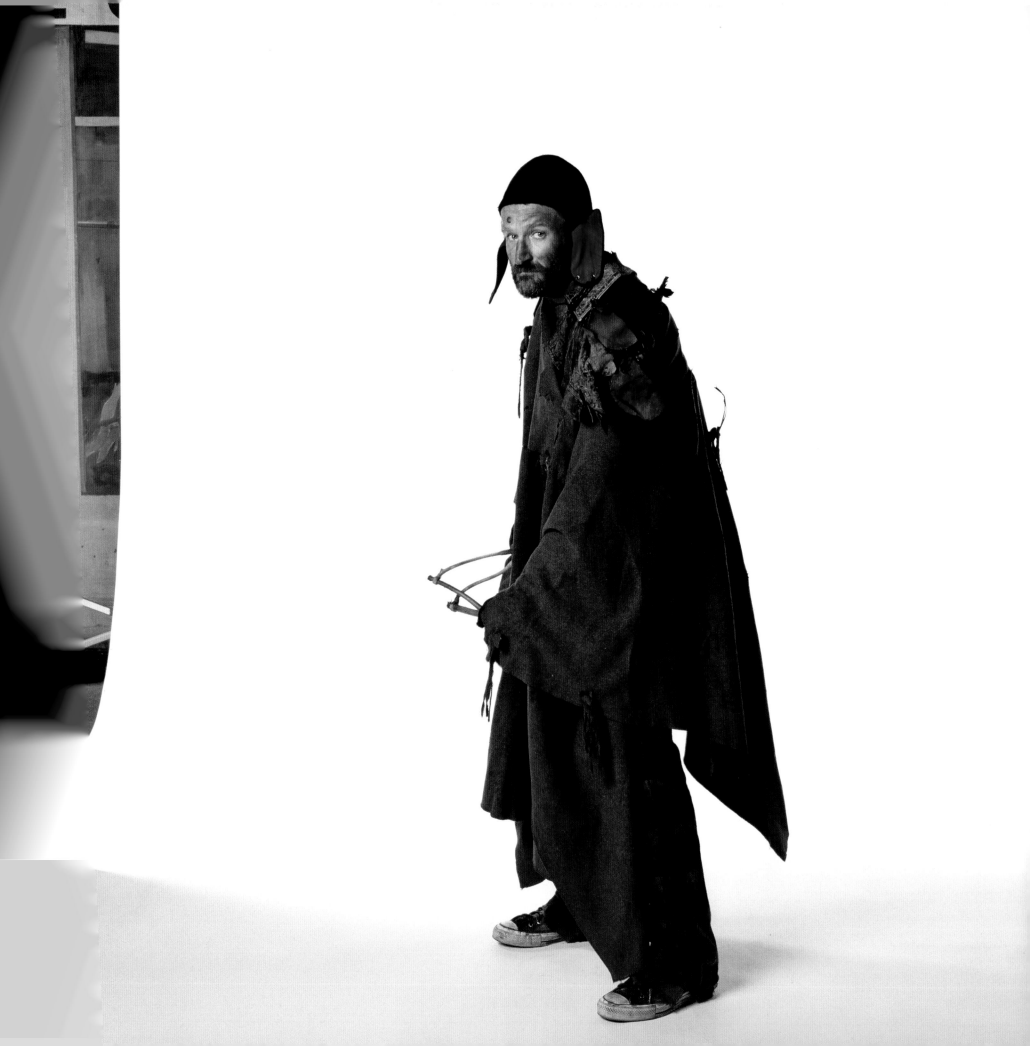

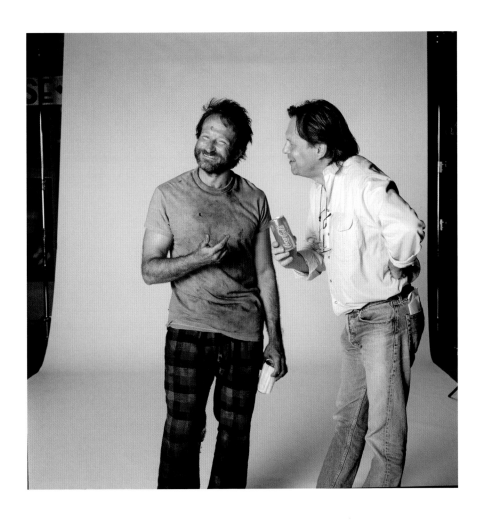

ON THE SET OF *THE FISHER KING*, ROBIN IN COSTUME *(left)*
AND JOKING WITH DIRECTOR TERRY GILLIAM *(above left)* AND
ACTRESS MERCEDES RUEHL *(above right)*, LOS ANGELES, 1991

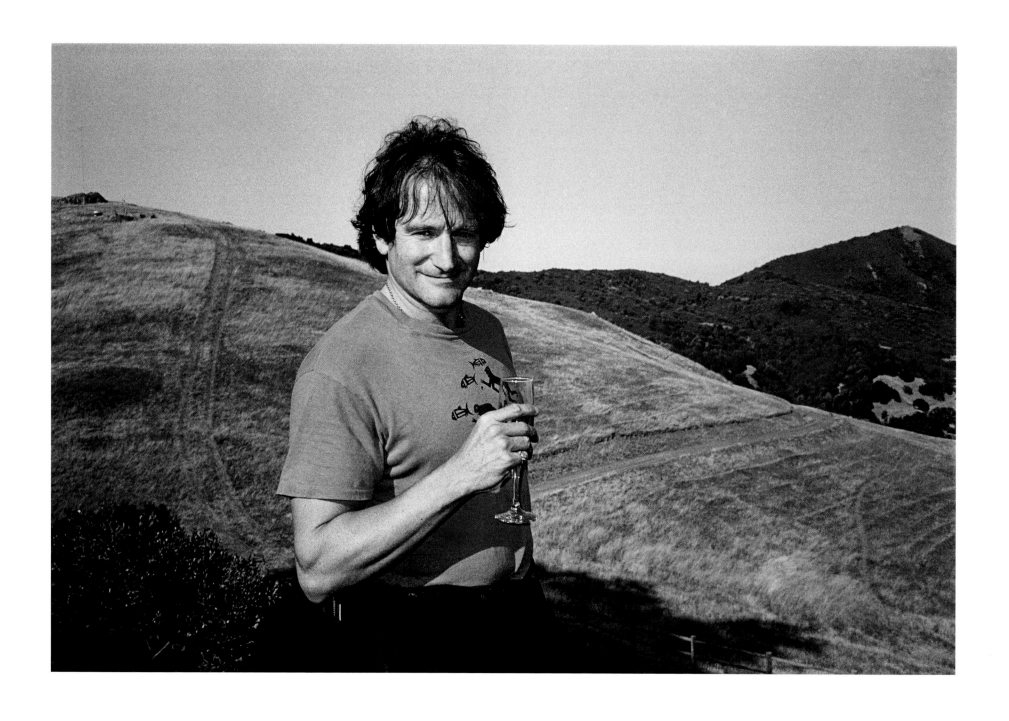

right and above
ROBIN'S FORTIETH BIRTHDAY PARTY,
NAPA RANCH, 1991

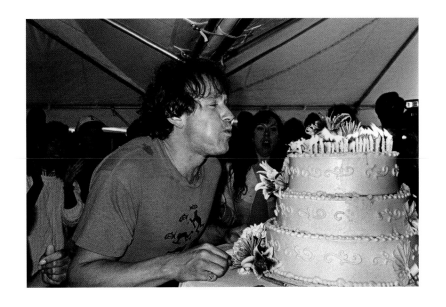

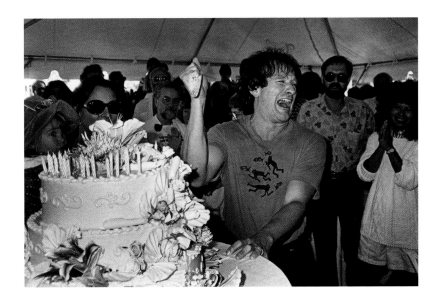

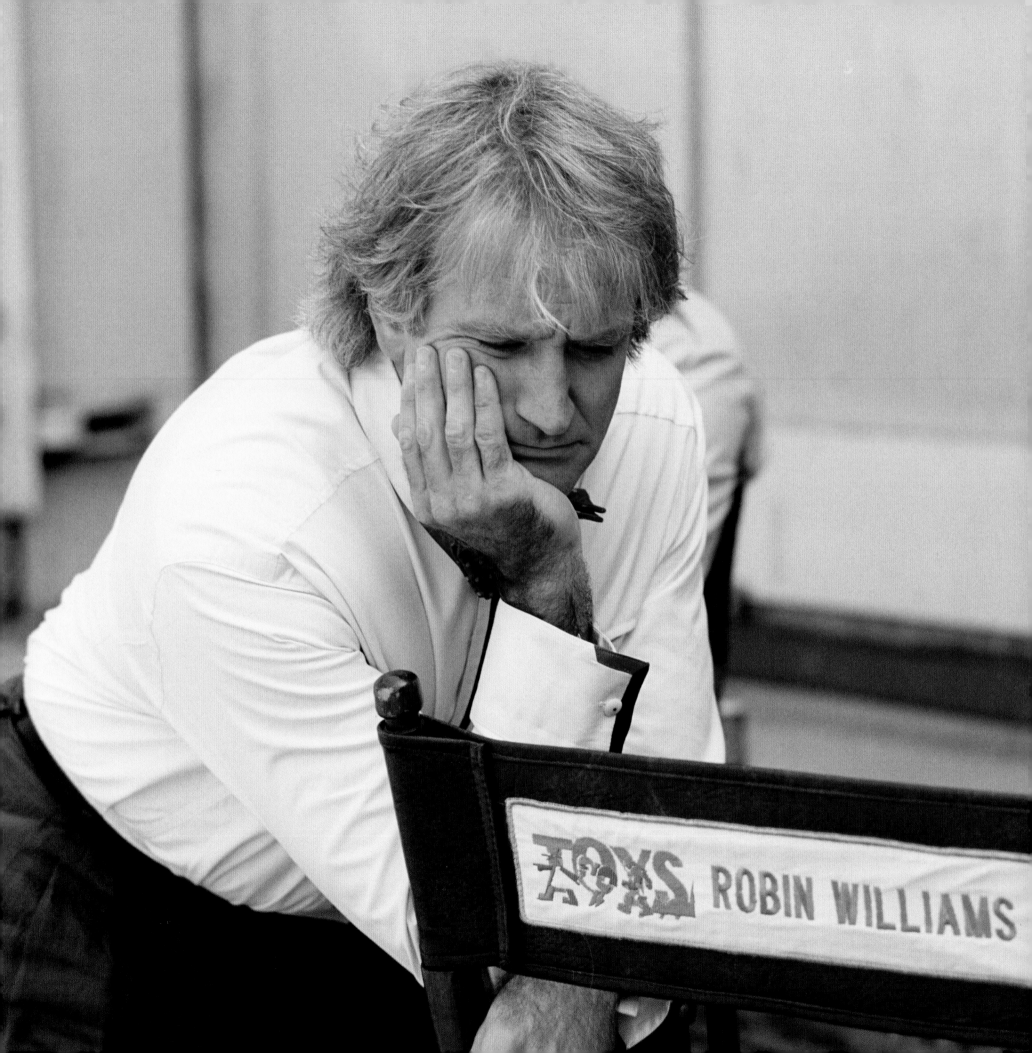

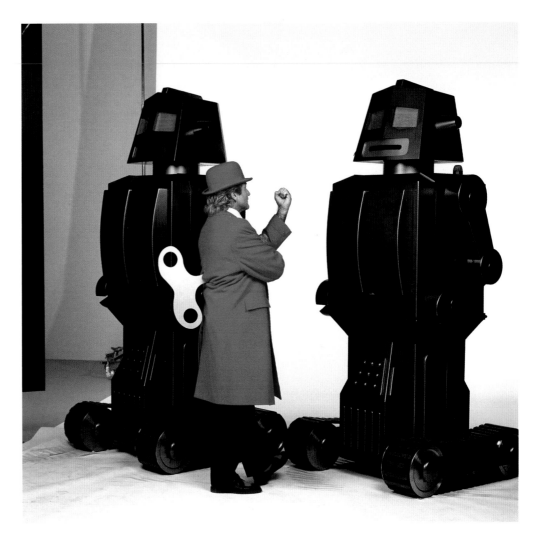

ON THE SET OF *TOYS*,
LOS ANGELES, 1992

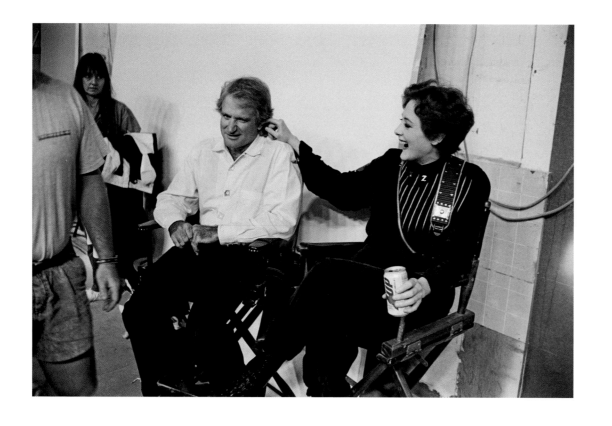

ROBIN AND JOAN CUSACK *(above)* AND
WITH ROBIN WRIGHT AND JOAN CUSACK *(right)*
ON THE SET OF *TOYS*, LOS ANGELES, 1992

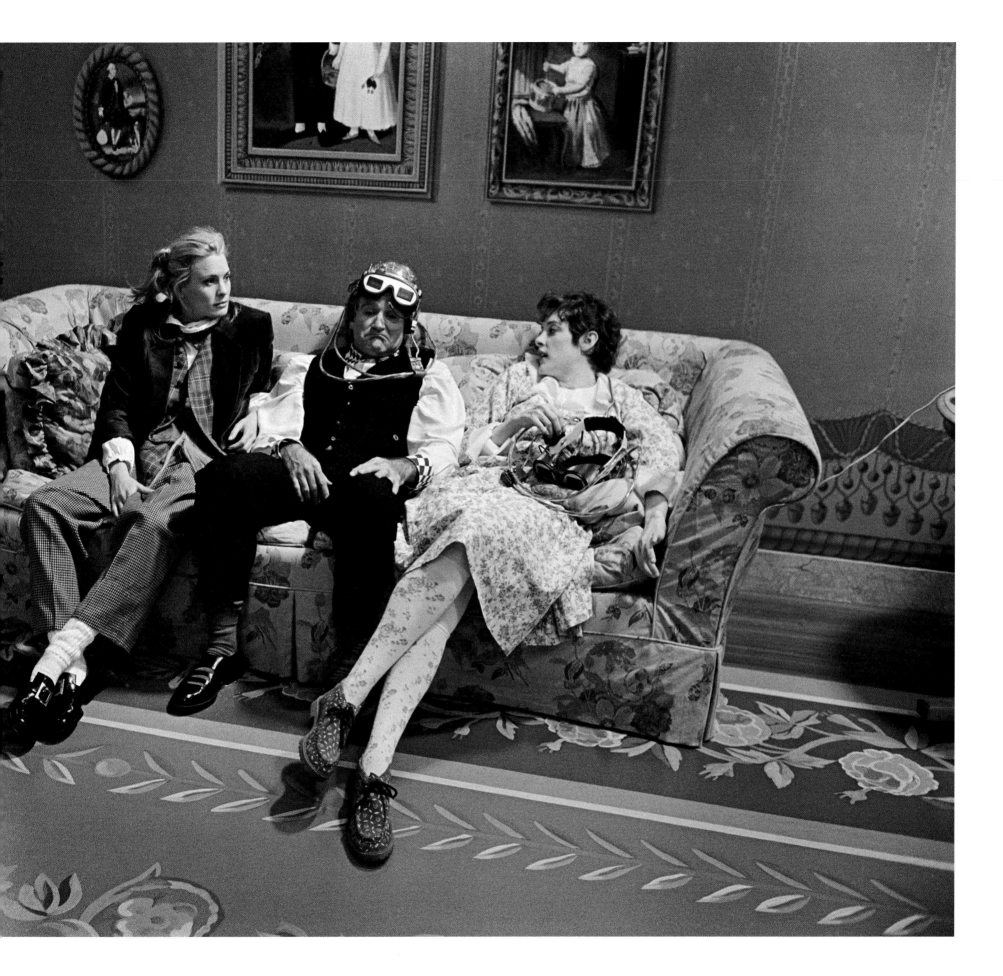

ROBIN WITH DIRECTOR BARRY LEVINSON
ON THE SET OF *TOYS*, LOS ANGELES, 1992

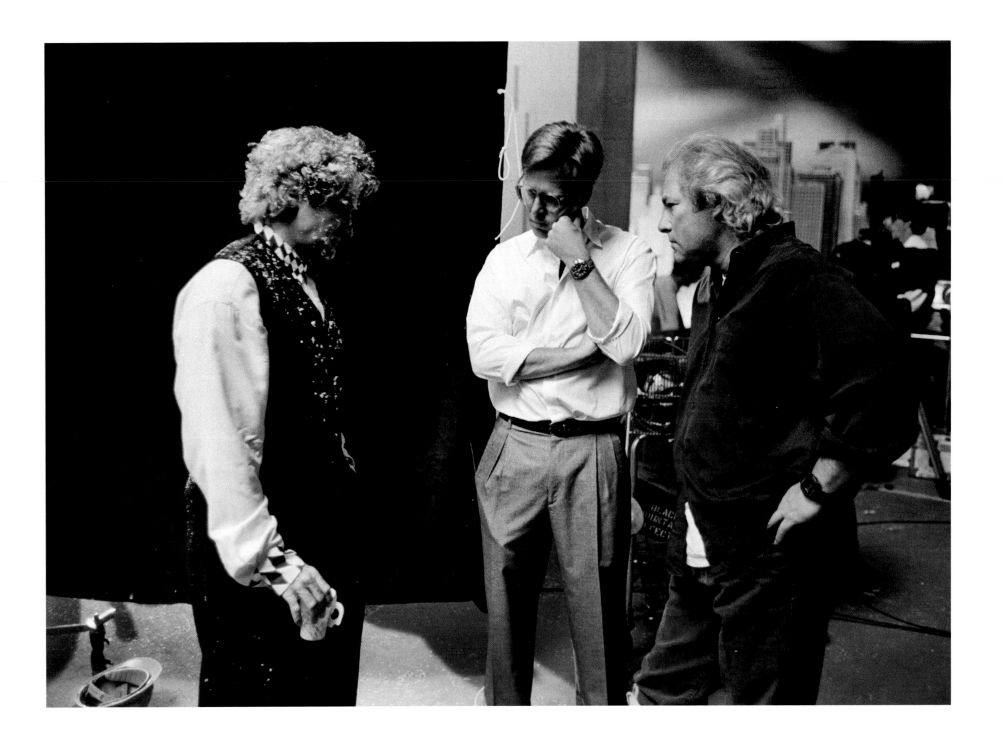

ROBIN WITH PRODUCER MARK JOHNSON
AND DIRECTOR BARRY LEVINSON ON THE
SET OF *TOYS*, LOS ANGELES, 1992

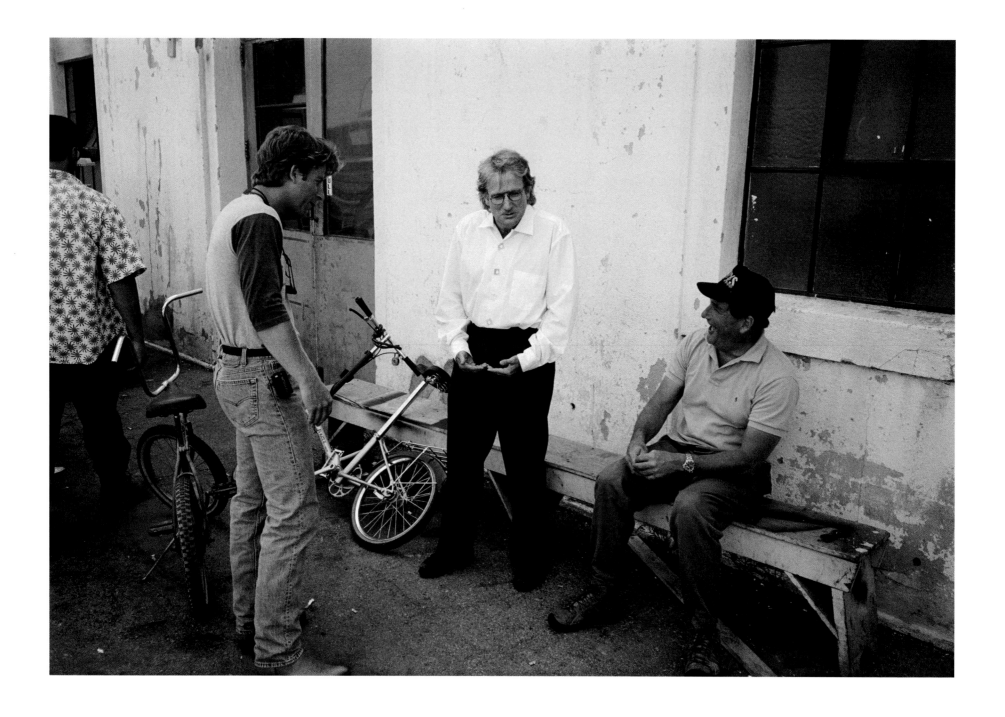

ROBIN WITH CREW OUTSIDE THE *TOYS* SET,
LOS ANGELES, 1992

This photo is only one example of the many times on shoots when Robin would give me the middle finger salute. There was never any malice intended, and he was always smiling when he did it. What it meant was: I know you're here doing your job, screw this crap going on around us, I'm glad you're here. (The woman off to the left is Robin's makeup artist, Cheri Minns, who witnessed many such salutes during her years with Robin.)

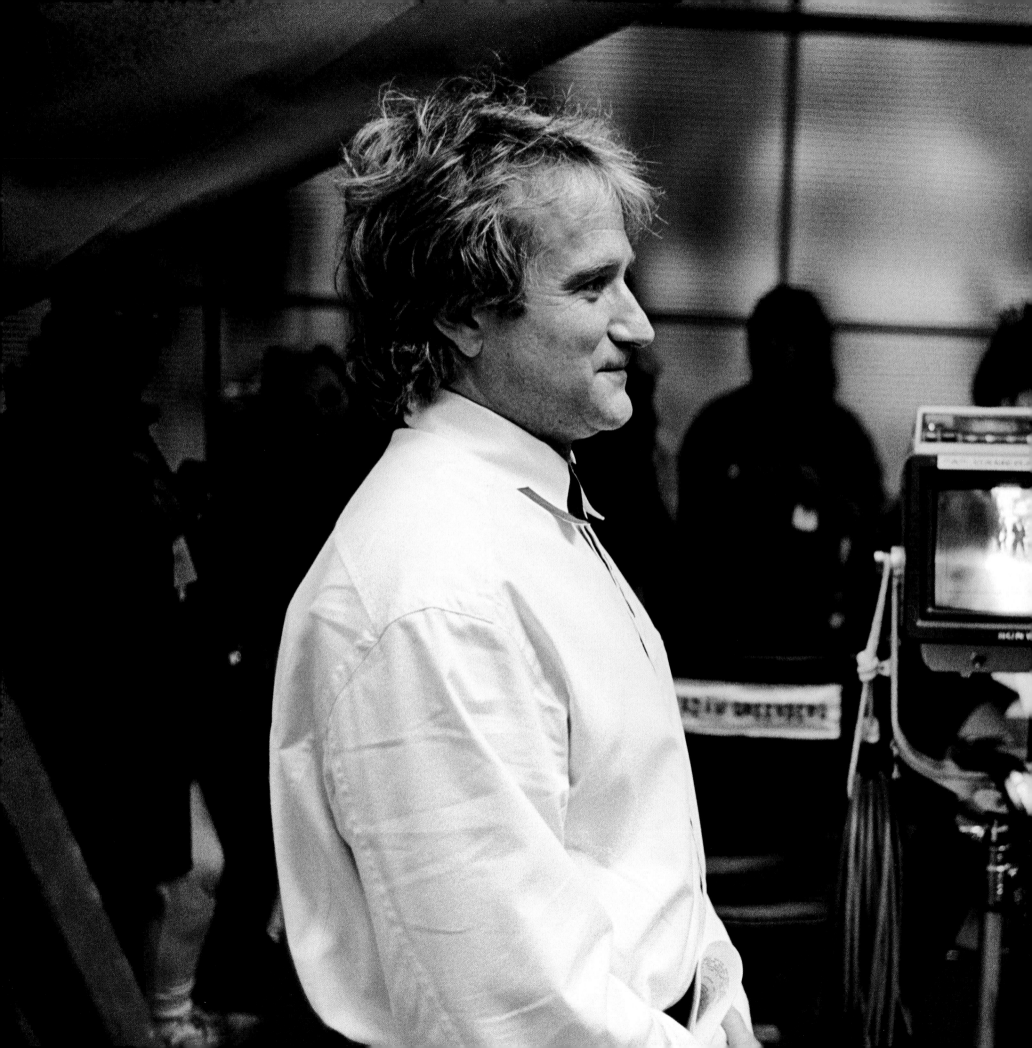

ON THE SET OF *TOYS*, LOS ANGELES, 1992

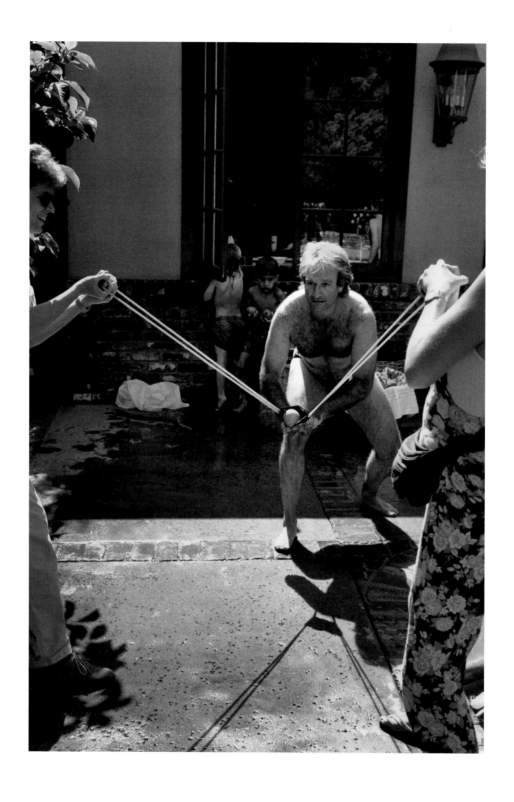

ROBIN LAUNCHING WATER BALLOONS INTO A
NEIGHBOR'S YARD WITH HIS KIDS AND THEIR FRIENDS
(above) AND RELAXING IN THE SWIMMING POOL OF
HIS RENTAL HOUSE AFTER RUNNING OUT OF WATER
BALLOONS *(right)*, LOS ANGELES, 1992

CAP FERRAT 1992

In July 1992 my wife and I found ourselves in a private car with a driver leaving the airport in Nice, France on our way to meet Robin and his family at the quay in Cap D'Antibes. I had mentioned to Robin a few months earlier that we were planning a trip to Paris that summer, and he suggested that we meet up for a few days while he, Marsha, and the kids (plus nannies) were staying at the Grand-Hotel Du Cap on the French Riviera. It turned out that getting flights for the right dates was no problem, but staying at the Grand-Hotel Du Cap was a nonstarter with the rooms starting at $800 a night. After beating a hasty retreat, we finally found a small hotel nearby that looked clean and cost 75 percent less. Robin said there wouldn't be any problem because we could spend as much time as we wanted at his hotel as his guests.

When we arrived at the quay we found Robin on deck regaling the crew of the mega-yacht he and his family had been cruising on as guests. They'd just arrived from Capri that morning after a smooth overnight trip. After greetings all around, everyone gathered on the aft deck for some food and drink. Robin was in a great mood, relaxed, and obviously in vacation mode. As we enjoyed the magnificent repast, Robin mentioned to me how much he was enjoying shipboard life—the privacy, the instant service, the spectacular food, and the onboard gym where he could work out. The only downside was that at sea the boat was in constant motion, which was fine if things were calm, but if the weather got ugly, it was "mal de mer" time.

Later in the afternoon, the stewards started offloading the Willams entourage's luggage (which was formidable) while Robin went around saying his good-byes to the other guests and thanking the captain and crew, who were busily taking photos with him (and of him). With everything packed up, our small caravan headed out to the next stop, the magnificent Grand-Hotel Du Cap in nearby Cap Ferrat. When we arrived, I spent some time looking over the lush grounds and walking around the lobby where Robin and his party were checking in. It was readily apparent why this elegant hotel commanded major dollars for a room. Completely jet-lagged at this point, my wife and I called it a day and took a local taxi to our hotel.

The next morning we joined Robin, Marsha, and the kids sitting around the hotel's stunning infinity pool. Robin was wearing his mirrored, wraparound shades and a Speedo swimsuit, lying back on a pool lounger and soaking up the sun. Not one to sit still too long when outdoors, he was soon headed to the rocky area nearby where the Mediterranean Sea met the hotel. Donning his flippers and face mask, he looked like an excited kid ready to experience something new and adventurous, smiling the whole time, but not quite ready to jump into the cold water some distance below. While Robin was still pondering his next move, somebody dove in ahead of him (that would be me) and proceeded to splash him with seawater. Like anybody would do in similar circumstances, Robin got pissed off at the obnoxious jerk taunting him and unloaded some some choice expletives at him before giving up and leaping into the water.

DEMONSTRATING HIS INFLATABLE JACKET TO MEGA YACHT CREW, CAP D'ANTIBES, FRANCE, 1992

When he finally had enough of bobbing around in the Med, Robin negotiated the metal ladder anchored into the rocks and was immediately greeted by some hotel guests who asked if he would pose for a picture with them—which just goes to show, even at a super-expensive, exclusive five star hotel, you can never leave your celebrity at the door. It wasn't like Robin was the only celebrity guest. As the day progressed, he had conversations by the pool with Ralph Lauren and Elton John to name a few. I have no idea what they were talking about because I wasn't about to stroll over and have Robin introduce me. But I did notice that there was an easy repartee Robin had going on with them, and of course, it helped that he could always put people at ease by finding something funny to say. Interestingly, during the entire time I knew Robin, I never saw him really in awe of anyone. Instead, he would be polite, respectful, and occasionally deferential (if the person's ego required it).

That night we all headed to Nice for a group dinner at a well-known seafood place by the water. Robin's good friend Eric Idle and his wife Tania were there along with some others from the comedy world I'd never met before. It was a laid-back evening as Robin and his friends outdid each other telling crazy, funny stories and joking about anything and everything. There were only brief periods where people stopped laughing to eat their food. What I found most interesting was that no single person at the table, including Robin, dominated the dinner "stage" that night. It was obvious that they all had mutual respect for one another and that Robin genuinely enjoyed laughing at and laughing with his real comedic friends.

Another night, after dinner, there was a spontaneous vote to head to Monte Carlo and hit the casinos. As usual, thanks to Robin, we were welcomed at the most exclusive one in town and were led in behind the velvet ropes by management. About an hour later after Robin and Marsha had tried their luck at the craps tables, we were escorted to our waiting car by casino security. As we approached the front exit, we heard loud shouting coming from outside in the street. When the door opened, we immediately saw what all the commotion was about. Dozens of people were crowded behind velvet ropes shouting out Robin's name, waving magazine covers with

Robin's photo, and holding up VHS boxes from his movies hoping to have them signed. And all this was happening at one in the morning. I had no idea where all these people had come from or where they managed to find all things Robin to have autographed. From the look on Robin's face, I think even he was taken aback at this unexpected outpouring from his fans. He shouted greetings to everyone in French and then took a few minutes to pose for pictures and sign his autograph on whatever people put in front of him. That was the moment I first realized Robin had really crossed over and become an international star with a worldwide fan base.

The next few days the routine was time by the pool, into the Med, and back into the pool or sitting around it. Robin was always approachable and mingled easily with the guests regardless of age. He had a blast having water gun fights with his kids and others' kids who didn't seem to know or care who the hairy guy was who was really into the game. At lunchtime we made a few excursions to local restaurants where Robin talked to the chefs (in French of course) and posed for photos giving a thumbs up on their cuisine. He was always cheerful and didn't appear to be bothered by all the attention he generated.

There were a few times, though, late in the day, when I would catch Robin with a pensive, almost painful, look on his face. Obviously, there were things on his mind that had nothing to do with his vacation. This wasn't the first time, or would it be the last, when I'd see Robin go "distant" and withdraw from his surroundings, alone with his thoughts.

The last night of our visit, my wife and I took Robin and Marsha out to dinner at the hotel restaurant to thank them for their generosity and for having us along. Robin never looked better—tanned, rested and blond (for his movie *Toys*). Besides the idyllic setting, there were two other things I clearly remember from that night. First, the selection of wine on the hotel's list was spectacularly expensive. If Marsha (Robin didn't drink) selected the wrong wine, we would be cutting our vacation a little short. Fortunately for us, she politely ordered a bottle of red in the low three-figure range. Second, was Marsha proudly telling us about Robin's new movie that he'd completed just before they'd left on vacation and how amazing Robin

was in it. She said it was going to break new ground and showcase his talents like never before. Robin chimed in about how much fun he had shooting it and was looking forward to seeing it on screen. In fact, he'd wanted to do the movie so much, he told us, that he'd waived his usual price (around $8 million at the time) and done it for scale. This was all news to me. I had no idea he had gone off and quietly shot another film, and for scale no less. "What's the movie called?" I asked. He slowly smiled and said, "*Aladdin*".

The animated feature film *Aladdin* went on to make $504 million worldwide and became a huge cash cow for Disney. It also made Robin a bigger star than ever and as Marsha had predicted, his tour de force improv performance had truly amazed people. Disney had actually done reanimation on the movie to match Robin's riffs. I happened to see Robin a few months after the movie came out. After I congratulated him on all his success, he mentioned that there was a little problem going on with Disney, specifically how they were using his character's voice to sell merchandise. It was also apparent to anyone who paid attention at the time that Robin was grossly underpaid for his contribution to the film, so I'd guess that didn't settle well with him either. To make peace and bury the hatchet, the folks at Disney gave Robin a Picasso painting estimated to be worth $1 million. According to Robin and Marsha, who were avid art collectors, it wasn't a very good one. (Here's Robin goofing on it at his home in San Francisco.)

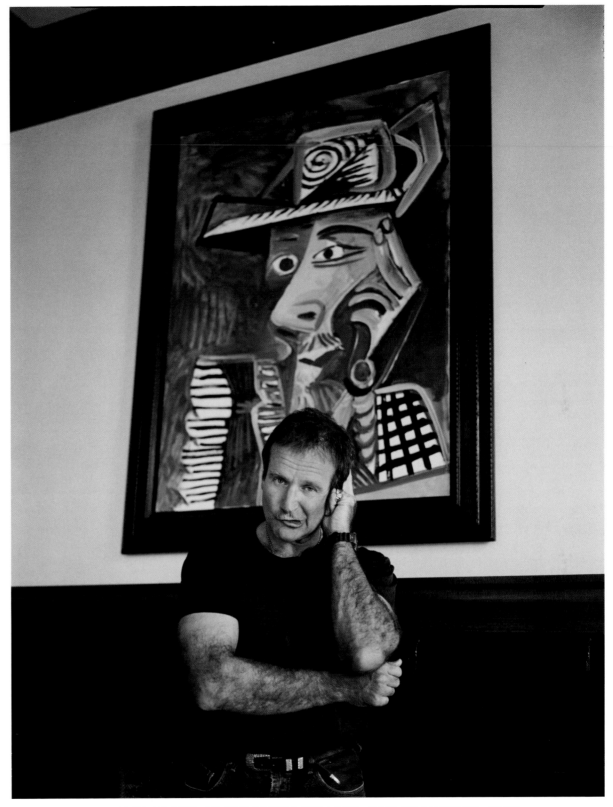

POSING AT HOME IN FRONT OF HIS "GIFT" PICASSO, SAN FRANCISCO, 1993

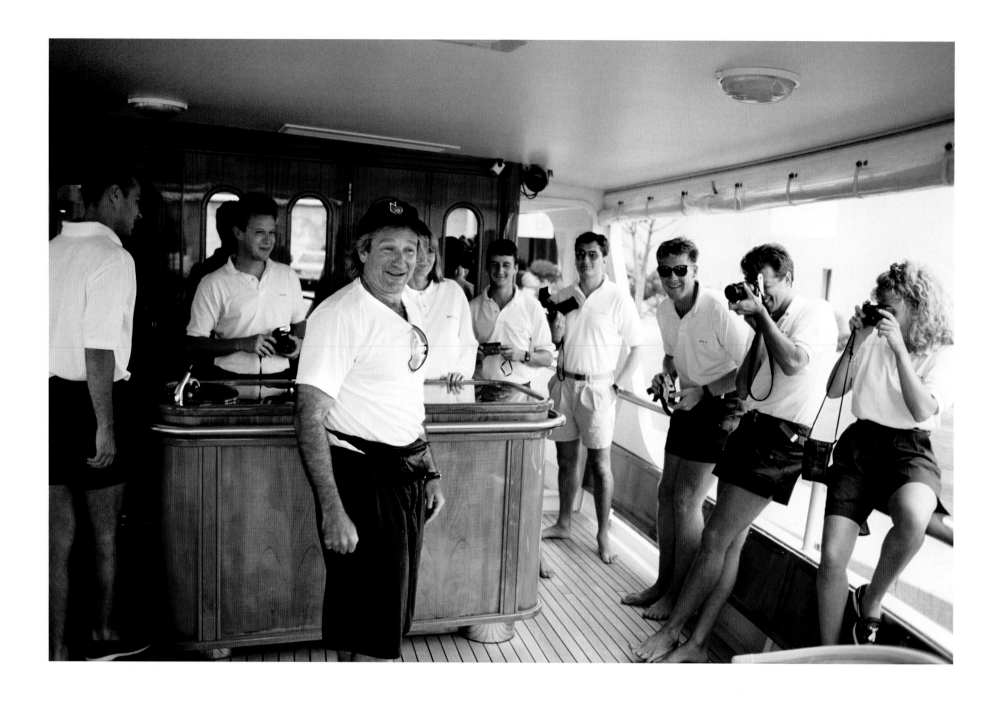

ENTERTAINING CREW MEMBERS ABOARD
MEGA-YACHT, CAP D'ANTIBES, FRANCE,
1992

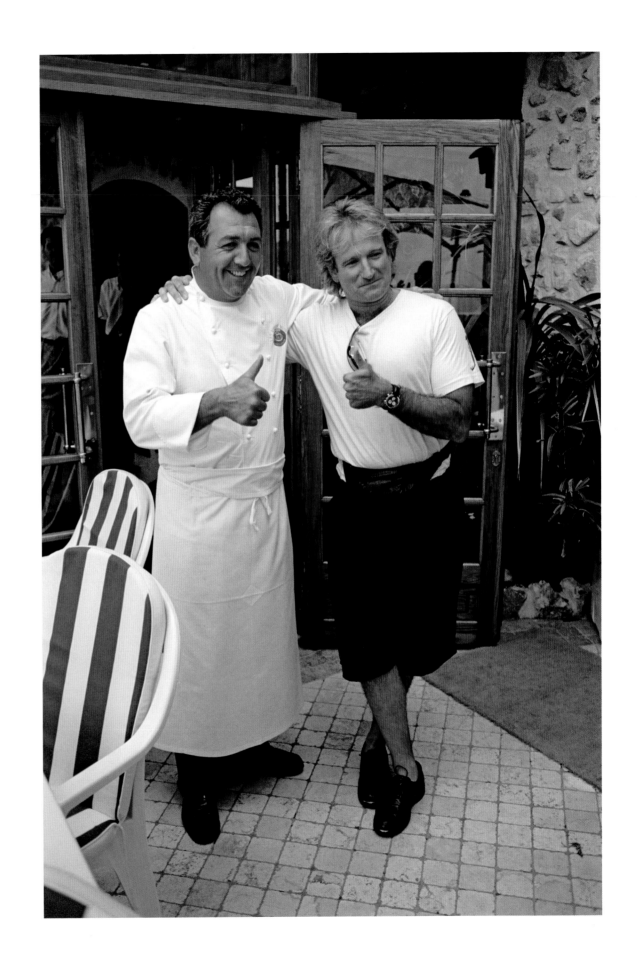

POSING WITH CHEF AFTER
"TRES BON" LUNCH,
CAP FERRAT, FRANCE, 1992

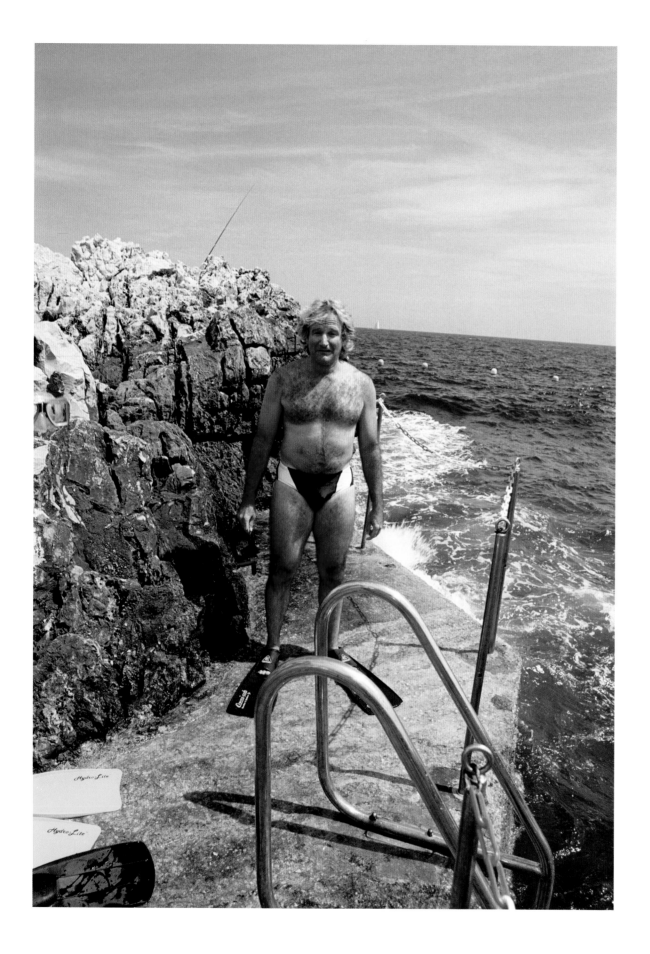

PREPARING TO TEST THE
WATERS OF THE MED WITH
FLIPPERS, SNORKEL, AND MASK,
CAP FERRAT, FRANCE, 1992

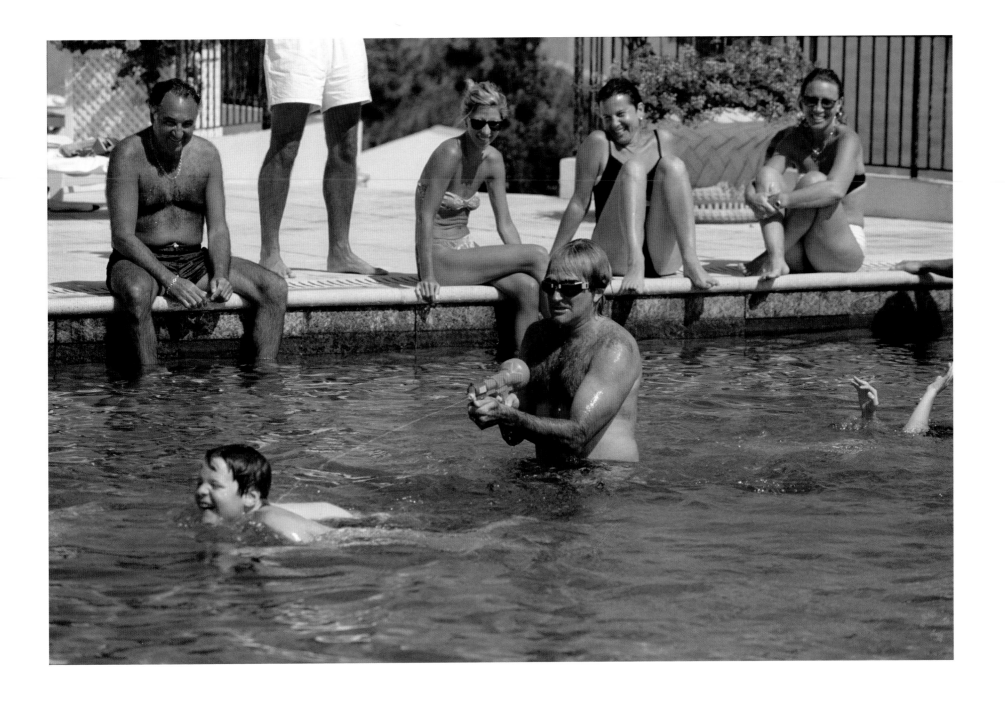

IN THE MIDST OF A WATER GUN
FIGHT WITH KIDS IN THE POOL
OF THE GRAND-HOTEL DU CAP,
CAP FERRAT, FRANCE, 1992

A QUIET MOMENT,
CAP FERRAT, FRANCE, 1992

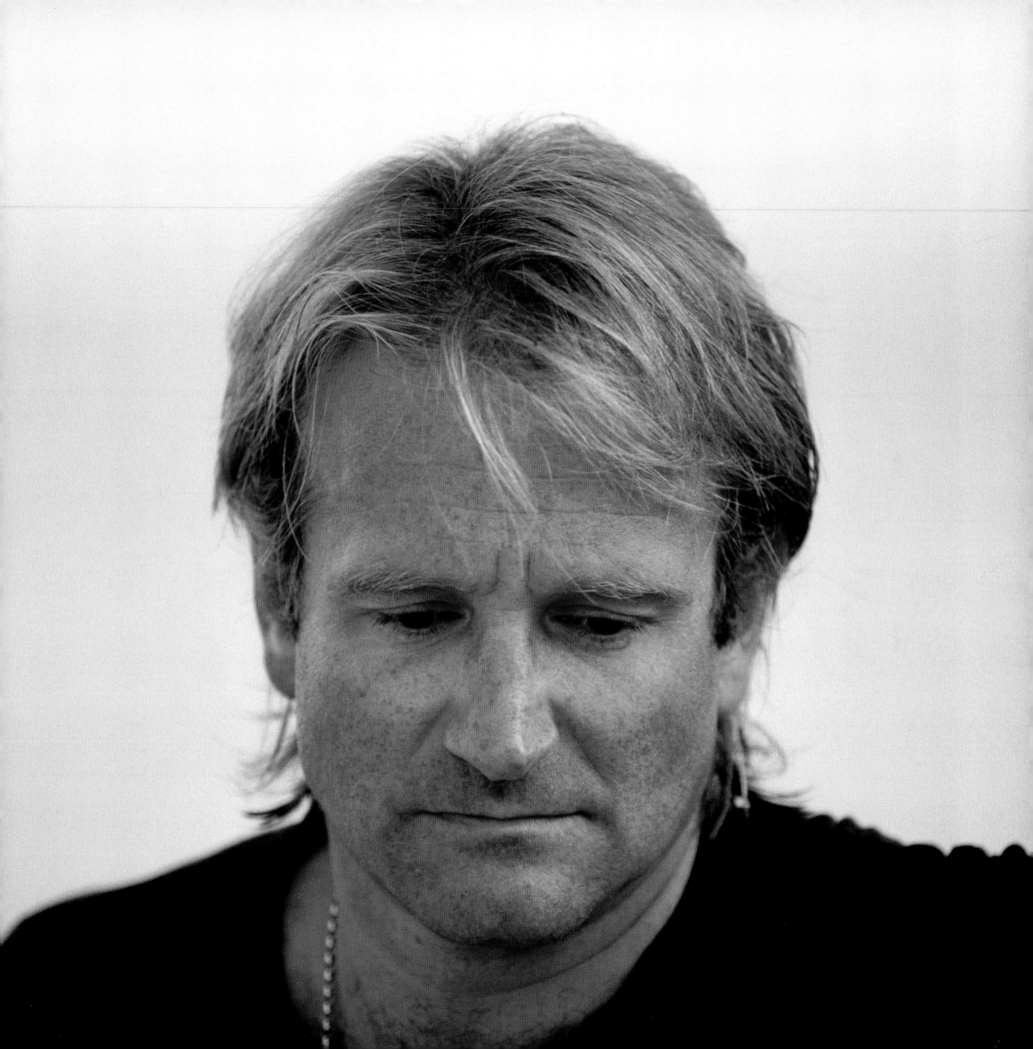

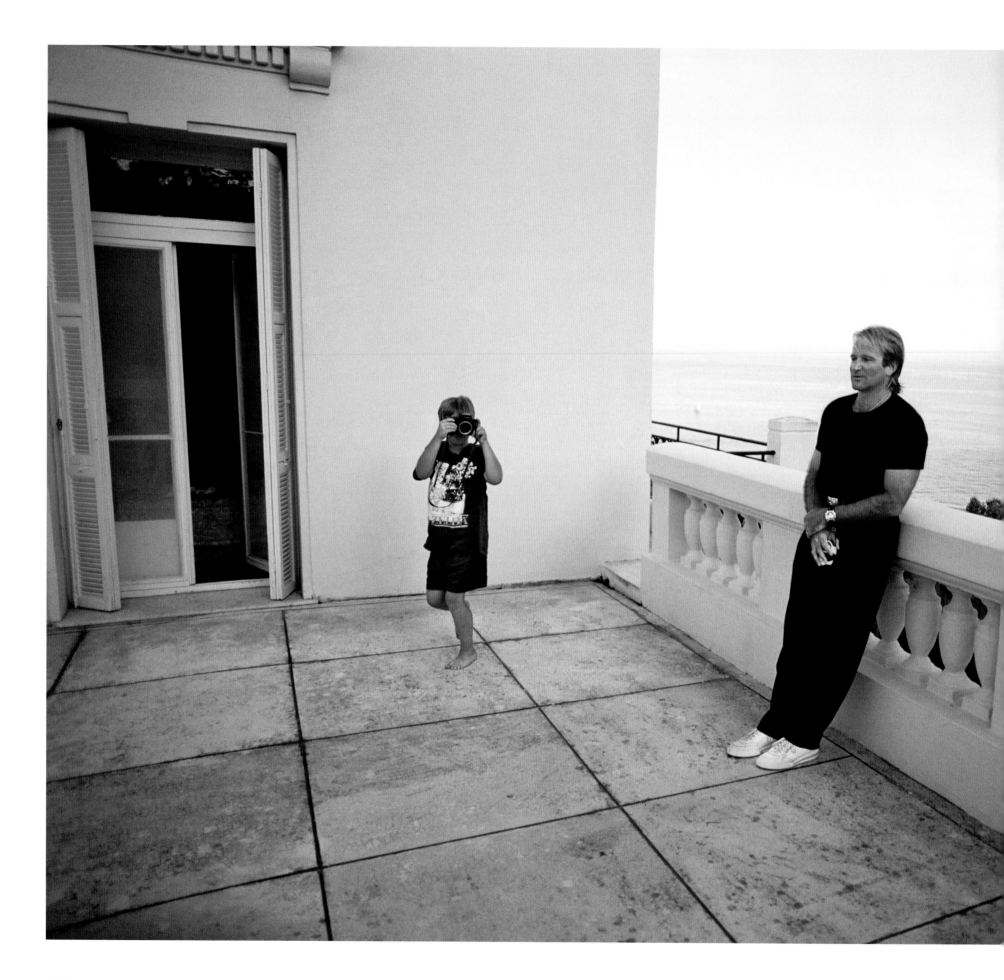

ROBIN'S SON, ZAK, GRABS A PHOTO OF HIS
FATHER ON THE BALCONY OF THE GRAND-HOTEL
DU CAP AT THE END OF THE DAY, CAP FERRAT,
FRANCE, 1992

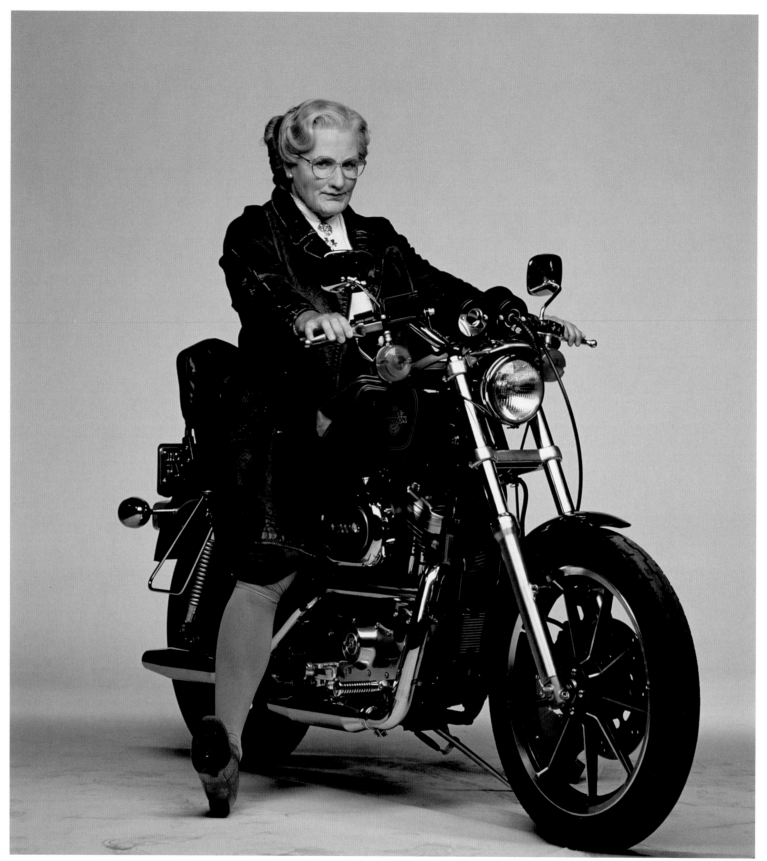

ROBIN ON HARLEY DURING A PUBLICITY SHOOT FOR *MRS. DOUBTFIRE*, RICHMOND, CA, 1993

MRS. DOUBTFIRE 1993

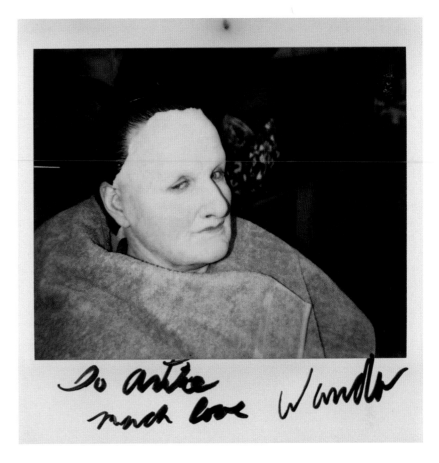

I heard about the *Mrs. Doubtfire* project early on in casual conversation with Robin, no doubt because he and Marsha were producers on the movie and were involved from the beginning. My involvement soon followed when I got a call from the studio that they wanted me to fly up to San Francisco to photograph Robin's makeup and wardrobe test for the film.

The day of the shoot was overcast and rainy, but inside the location building, everyone's spirits were upbeat and excited. Robin was already sitting in the chair having his facial mask and makeup applied and trying on different wigs. Chris Columbus, the energetic young director who already had a few megahits on his resume, was talking to the various specialists, making suggestions and giving approvals as Robin continued his transformation, which by then was pretty spectacular.

After about an hour, Mrs. Doubtfire's hair and makeup look for the first set of photos was locked in. "She" headed over to the wardrobe area to get fitted with the appropriate body padding and to try on various ensemble possibilities. When the final decisions were made and all was in place, Mrs. Doubtfire stepped into the middle of the room and introduced herself for the first time. As she walked around trying out her new persona using various women's voices and accents, one thing was for sure. Robin Williams had left the building.

Chris decided that it was time for the freshly minted Mrs. Doubtfire to meet the real world, so he handed her an umbrella to keep her dry from the ongoing drizzle and out she went on to the city street with me close behind starting to take pictures. Chris just wanted Robin to walk slowly down the street and then back up the street to see how Mrs. Doubtfire came across in her movements and appearance as a middle-aged nanny going about her business on a rainy afternoon. I kept shooting away as Robin tried out his new alter ego, really enjoying the challenge and smoothly transitioning into the part. When he finally came back inside, there was applause, excitement, and smiles all around from the talented people who had created her. No need for more testing. They'd found their Mrs. Doubtfire.

Unfortunately, that glorious day was probably the easiest and most enjoyable one Robin ever had transforming into Mrs. Doubtfire. By the time I showed up at the studio location in Richmond,

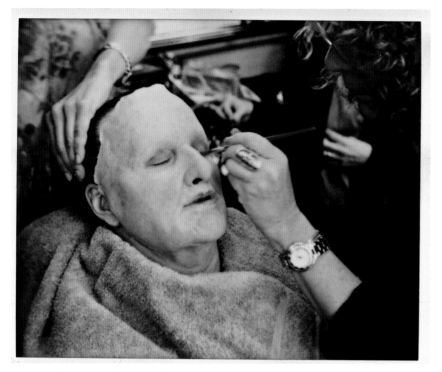

ROBIN DURING MAKE-UP TEST FOR *MRS. DOUBTFIRE*, SAN FRANCISCO, 1993

California to spend ten days photographing the poster ad and some behind-the-scenes material, the film had been shooting for weeks. Word was already out around the set about what Robin had to go through on the days he had his scenes as Mrs. Doubtfire. Apparently, he was picked up from his house in San Francisco around four in the morning, driven an hour to the set, where he then sat in the makeup chair for another three hours. How could anybody be a happy camper after an ordeal like that and then have to shoot for the rest of the day in a hot building wearing all that suffocating garb?

However, even under duress, you could still find the real Robin under all the hair and makeup and padding. It's just that when you talked to him, it was like having an out-of-body experience, at least for one of us. His normal voice seemed to be coming from a far away place and you'd find yourself talking to someone who

physically wasn't there. He'd still joke and be pleasant, but it's fair to say on some days he was a bit cranky. I quickly got the drift of the situation and learned that on the days Robin was in drag, it was best to be extra sensitive and solicitous and definitely not tease him.

Another strange thing happened on the days Robin was a woman. He became annoyed (i.e., jealous) if any man, especially a good-looking one, seemed to be overly friendly to his attractive wife Marsha who was on set every day in her capacity as producer. Totally unaware of any of this, I'd brought a second assistant on the shoot who happened to be young, Italian, and very good-looking. He was also my liaison with the production company in terms of scheduling or any special needs we might have, which meant he was always dealing with Marsha. From my perspective, it was nice to see that the two of them were getting along so well. Not so

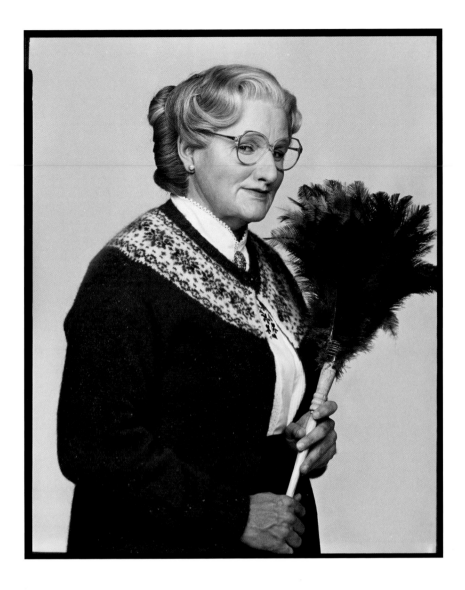

demure mouth of sweet Mrs. Doubtifire. An hour later after quick treatment by some on-scene paramedics, all was smiles and a classic scene was put on film.

Although everybody connected with the film—Robin, Marsha, Chris Columbus, Elizabeth Gabler from Fox—suspected the film would be successful, I don't think anybody anticipated what a worldwide blockbuster and children's film classic it would become. It was also another rung up the ladder in Robin's already ascendant career.

(Just for the record, that little makeup test shoot from that rainy day on the streets of San Francisco wound up producing the best poster for the film (IMHO): an unidentified older heavyset woman in dowdy clothes seen from the back holding an umbrella with the slug line: "Robin Williams *is* Mrs. Doubtfire".)

much for Robin. Mrs. Doubtfire was more than a little peeved by what she perceived was going on, and by the end of the first week, it was strongly suggested by management that assistant #2 remain out of Robin's sight line for the rest of the shoot.

All was calm after that except for the day Mrs. Doubtfire caught her blouse on fire in a carefully choreographed kitchen scene with a body double. When Robin stepped in to do the cooking part, he had to lean over a boiling pot on top of a lit burner. Someone had forgotten to turn off the flame prior to rolling the cameras, and unfortunately, Robin wound up grabbing a scalding hot kettle handle, which instantly went flying in the air amidst some agonizing screams followed by a string of choice expletives pouring out of the

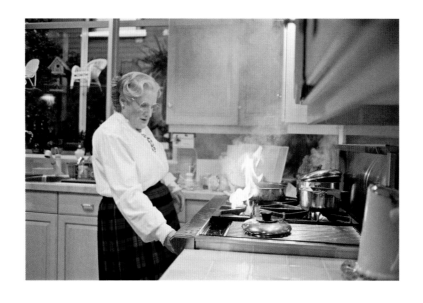

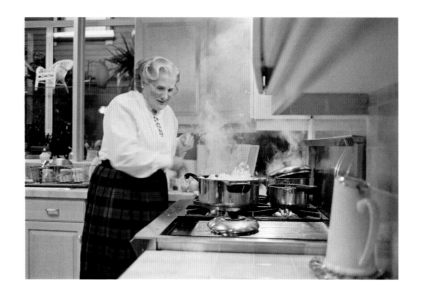

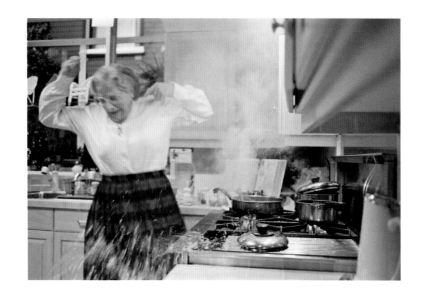

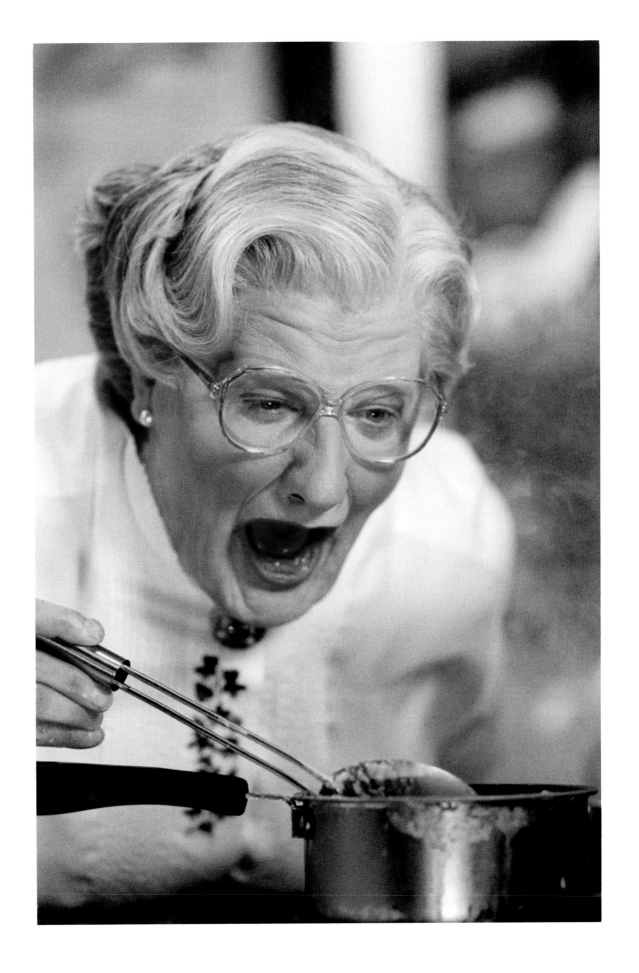

ROBIN DROPS A POT OF BOILING WATER AFTER BURNING HIS HAND *(left)*, AND, A FEW HOURS LATER, LEANS OVER THE STOVE *(right)* DURING THE FILMING OF THE "BURNING BLOUSE" SCENE IN *MRS. DOUBTFIRE* RICHMOND, CA, 1993

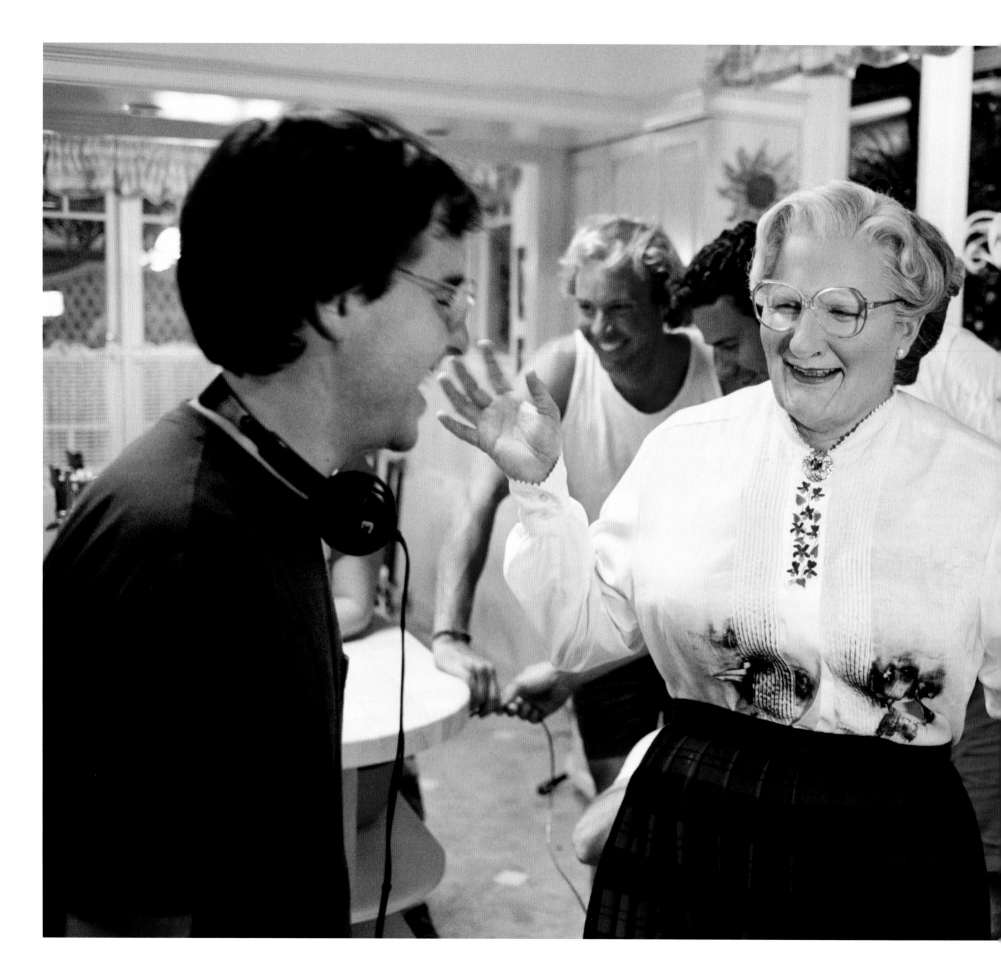

ROBIN LAUGHING WITH DIRECTOR CHRIS COLUMBUS
AFTER SUCCESSFULLY FILMING THE "BURNING
BLOUSE" SCENE ON THE SET OF *MRS. DOUBTFIRE*,
RICHMOND,CA, 1993

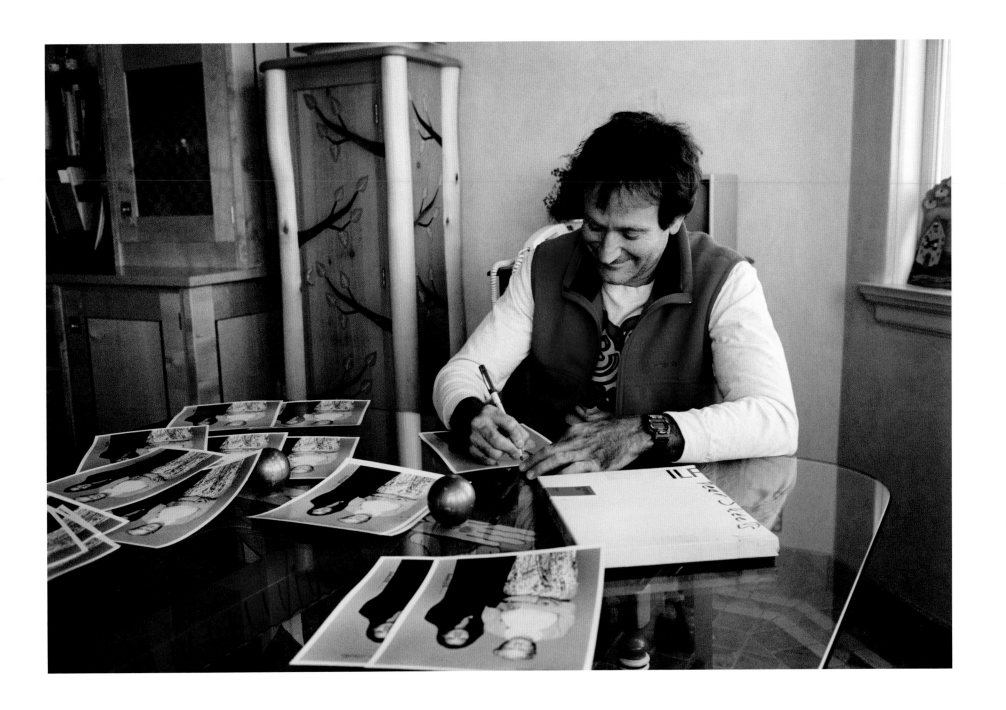

MRS. DOUBTFIRE (ROBIN) AND WIFE MARSHA POSING
DURING A PORTRAIT SHOOT FOR *THE NEW YORKER*,
RICHMOND, CA, 1993 *(left)* AND SITTING AT HIS KITCHEN
TABLE SIGNING SPECIAL *MRS. DOUBTFIRE* PRINTS FOR THE
CAST AND CREW, SAN FRANCISCO, 1993 *(above)*

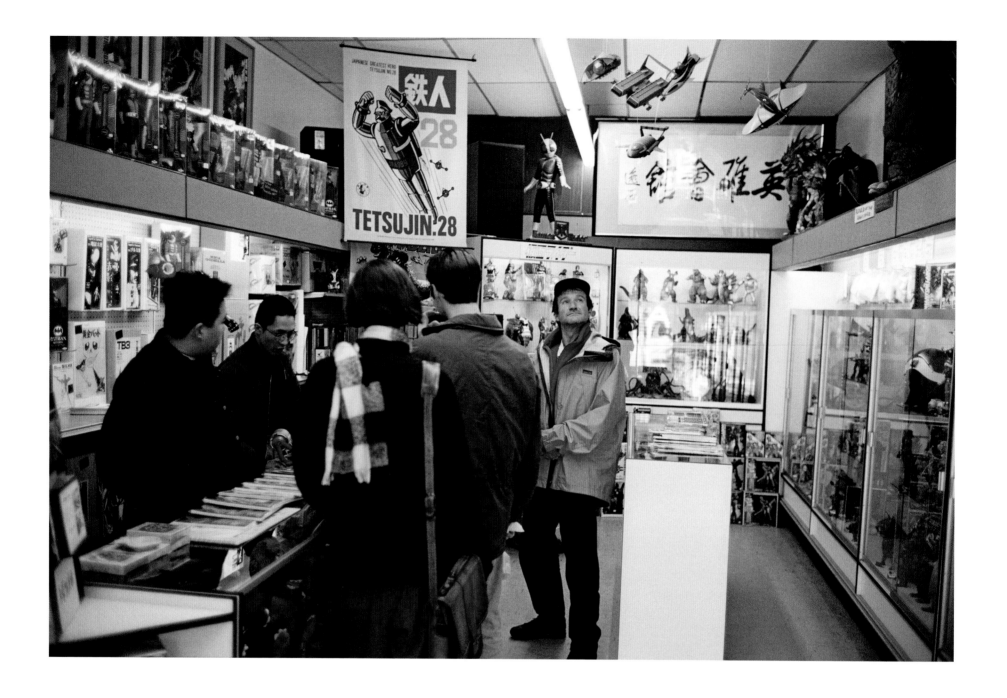

VISITING ONE OF HIS FAVORITE TOY STORES,
HEROES CLUB, SAN FRANCISCO, 1993

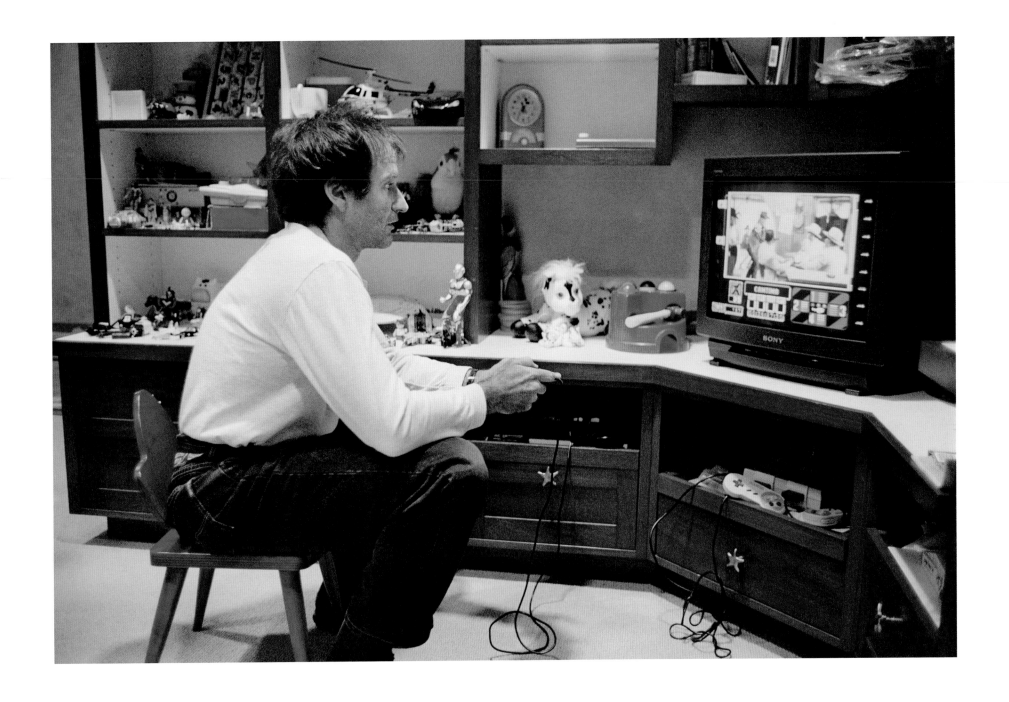

AT HOME PLAYING A VIDEO GAME IN THE KIDS'
PLAYROOM, SAN FRANCISCO, 1993

right and above
PUBLICITY SHOOT, SAN FRANCISCO, 1993

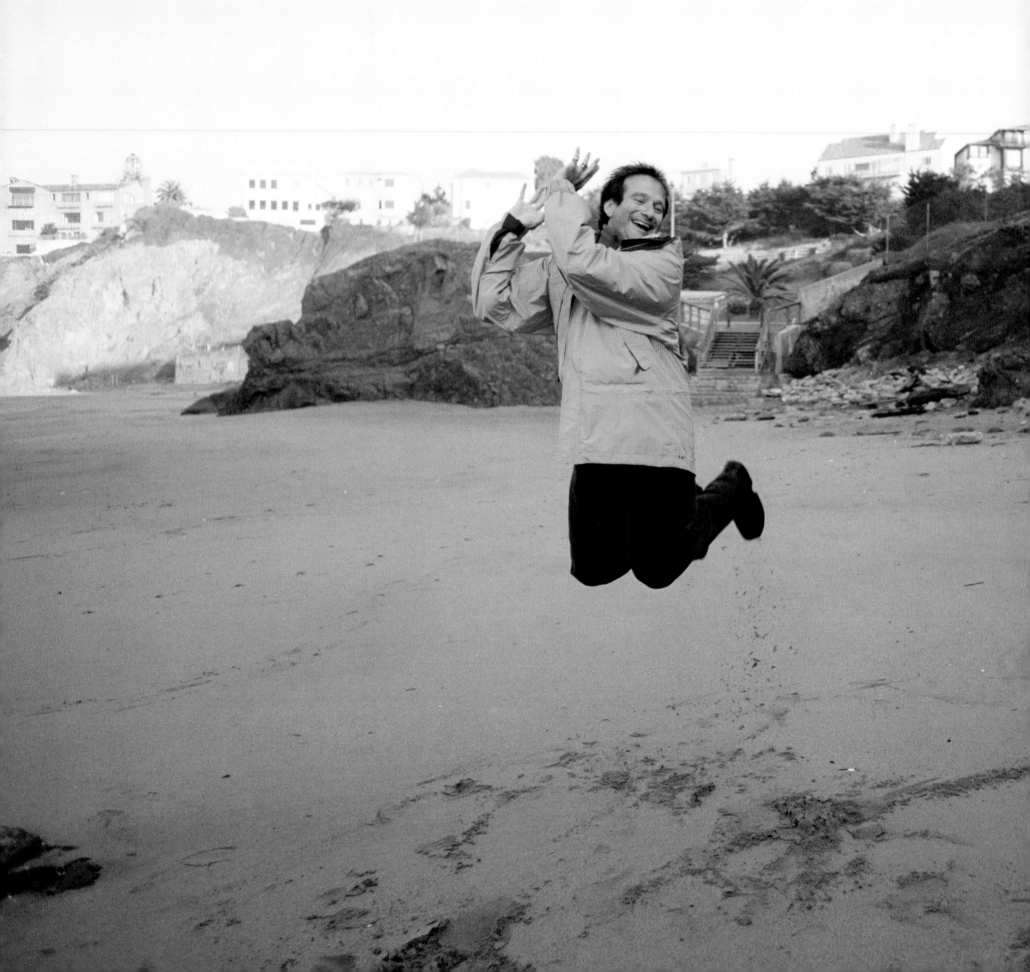

In 1993 Robin was in Baltimore shooting a special guest appearance in an episode of his good friend Barry Levinson's television series Homicide: Life on the Street. *Robin called me and asked if I wanted to drive over to the set from DC and have dinner. I told him I was working on a new photo project with my 8x10 view camera and asked if it would it be OK if I took some portraits of him during breaks in the filming. He said that would be fine, and told me where to meet him the next day. When I saw him walking off the set for the first time, I almost didn't recognize him. He was playing the part of a mild-mannered tourist whose wife is murdered, and he had physically transformed himself for the role, both in his look and in his body language. That night we had a great meal with the producer Mark Johnson, the director, and the thirteen-year-old boy who was playing Robin's son in the episode. Robin had told me earlier what an amazing actor the kid was. His name was Jake Gyllenhaal, and the director was his father, Stephen. The ratings for the show when it aired in January 1994 were huge, and Robin was nominated for an Emmy for Guest Actor in a Drama Series.*

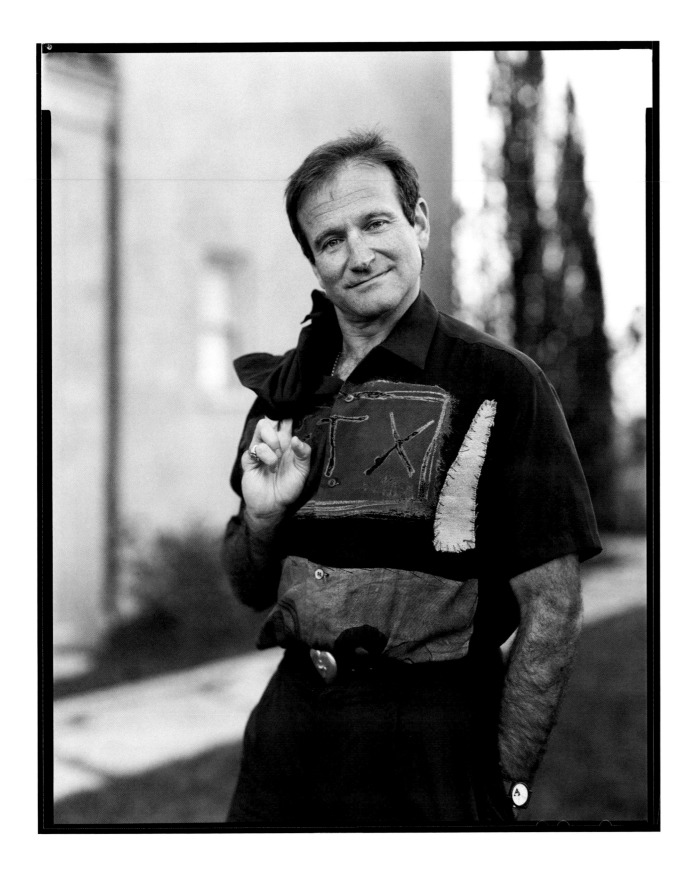

EASTER,
SAN FRANCISCO,
1995

LAKE TAHOE, 1996

SAN FRANCISCO, 1995

131

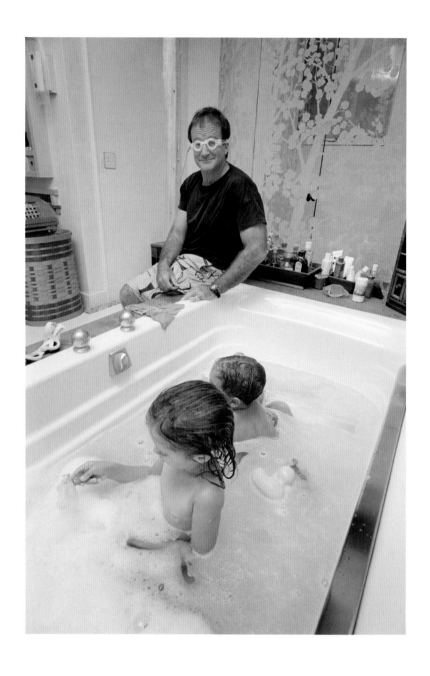

BATH TIME AT HOME WITH ZELDA (front) AND
CODY, SAN FRANCISCO, 1995 *(above)* AND READING
A BEDTIME STORY TO ZELDA, SAN FRANCISCO,
1995 *(right)*

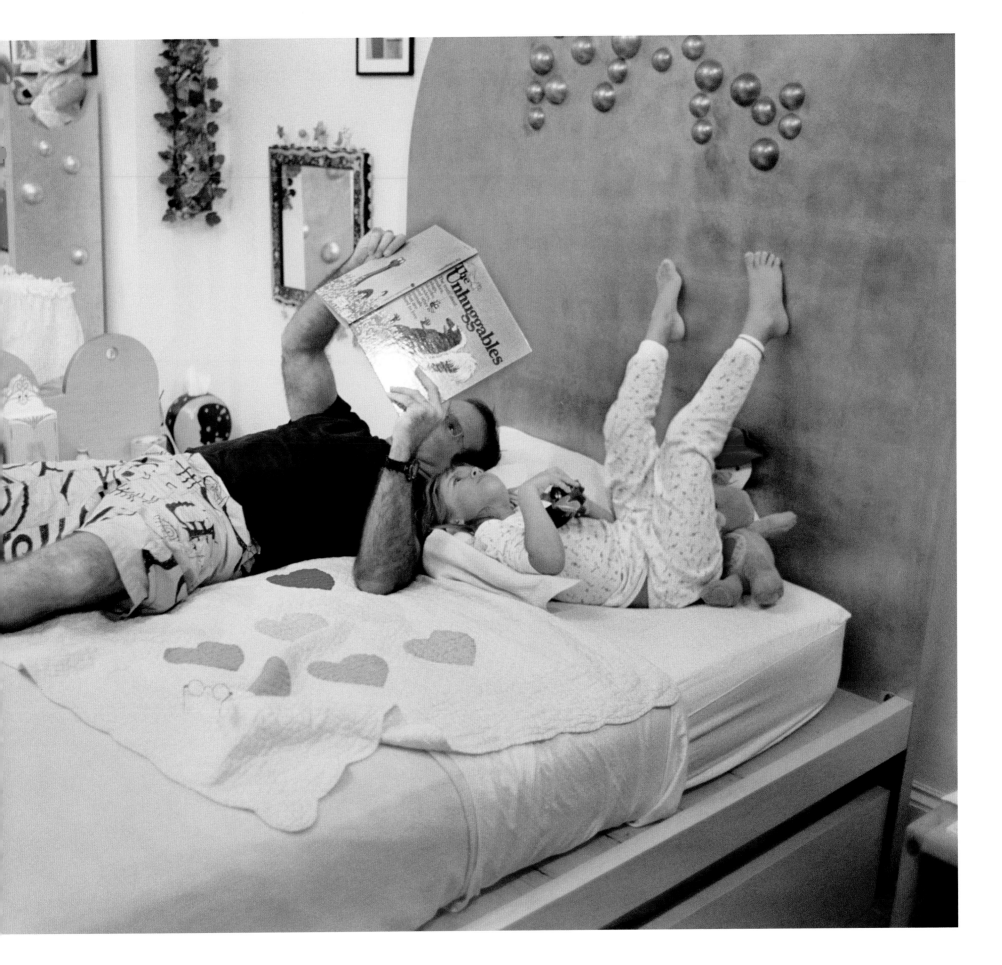

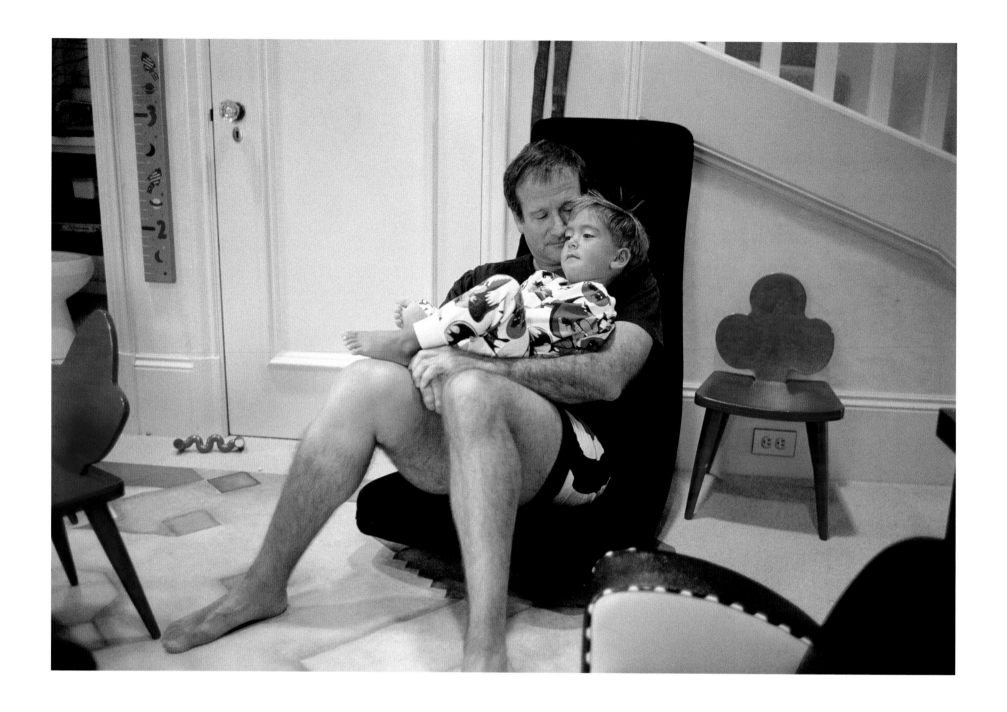

SHARING A QUIET MOMENT WITH HIS
SON CODY IN THE KIDS' PLAYROOM,
SAN FRANCISCO, 1995

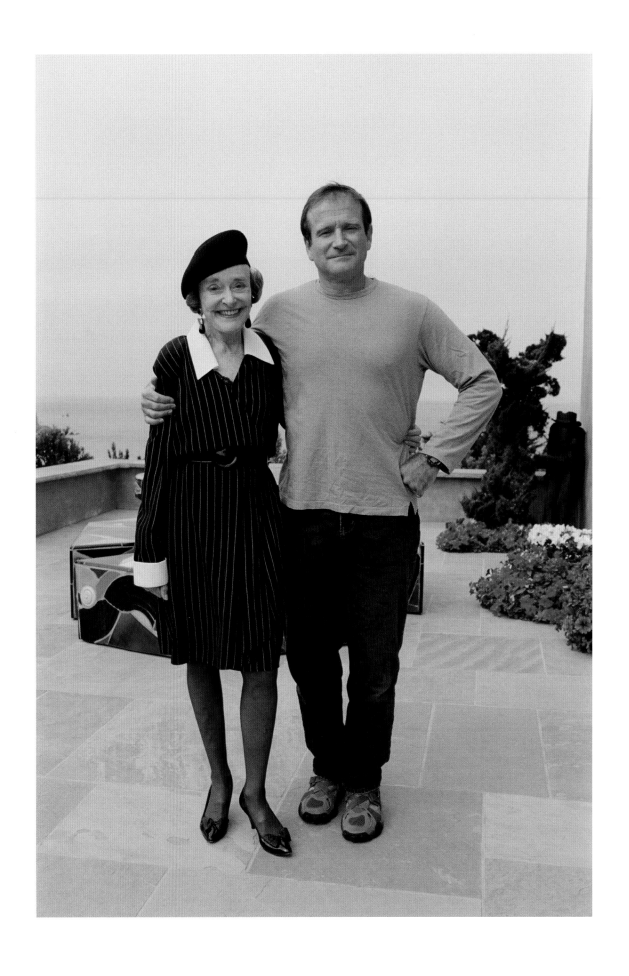

WITH HIS MOTHER, LAURIE
WILLIAMS, SAN FRANCISCO, 1995

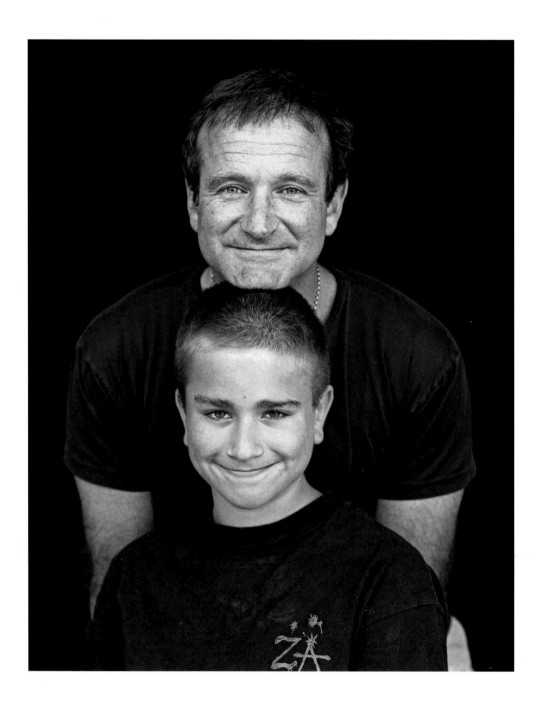

ROBIN AND HIS SON ZAK, SAN FRANCISCO, 1995 *(above)*
AND THE WILLIAMS FAMILY BY THE FRONT DOOR OF THEIR
HOME (L to R: ROBIN, ZAK, ZELDA, MARSHA, AND CODY),
SAN FRANCISCO, 1995 *(right)*

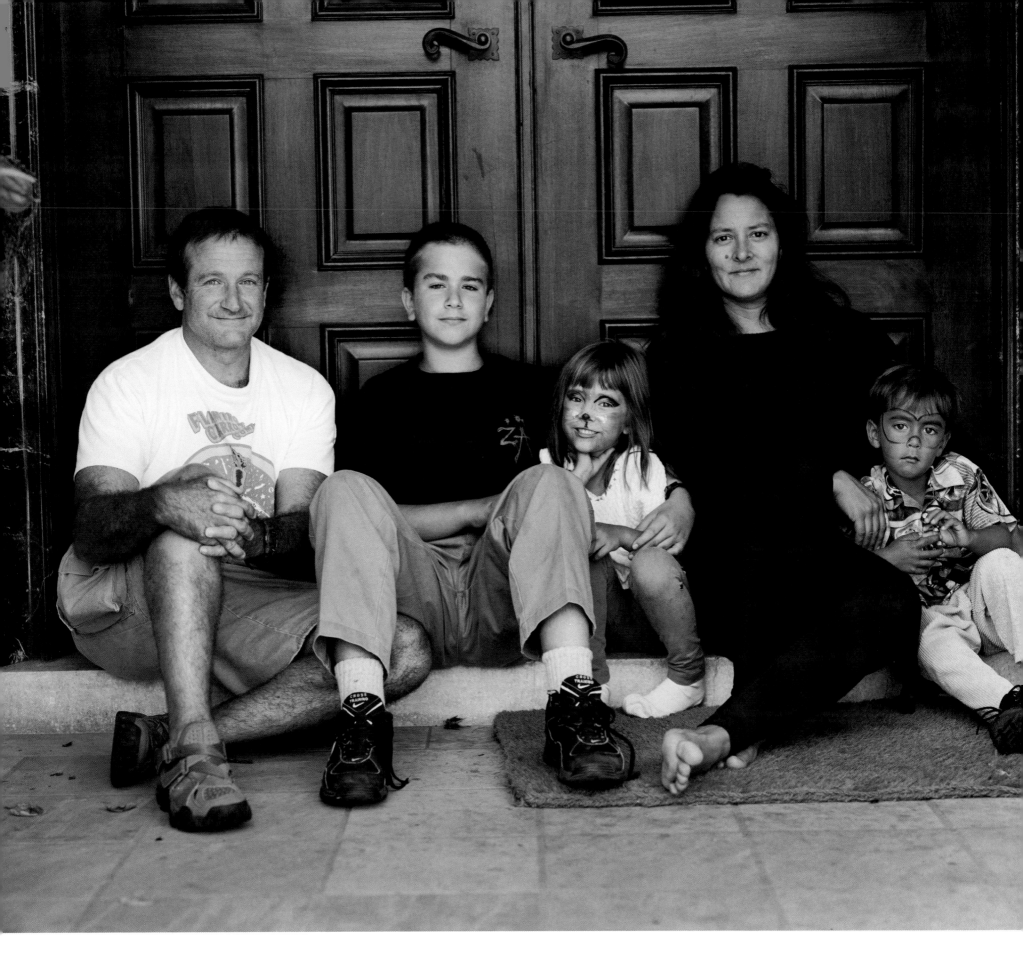

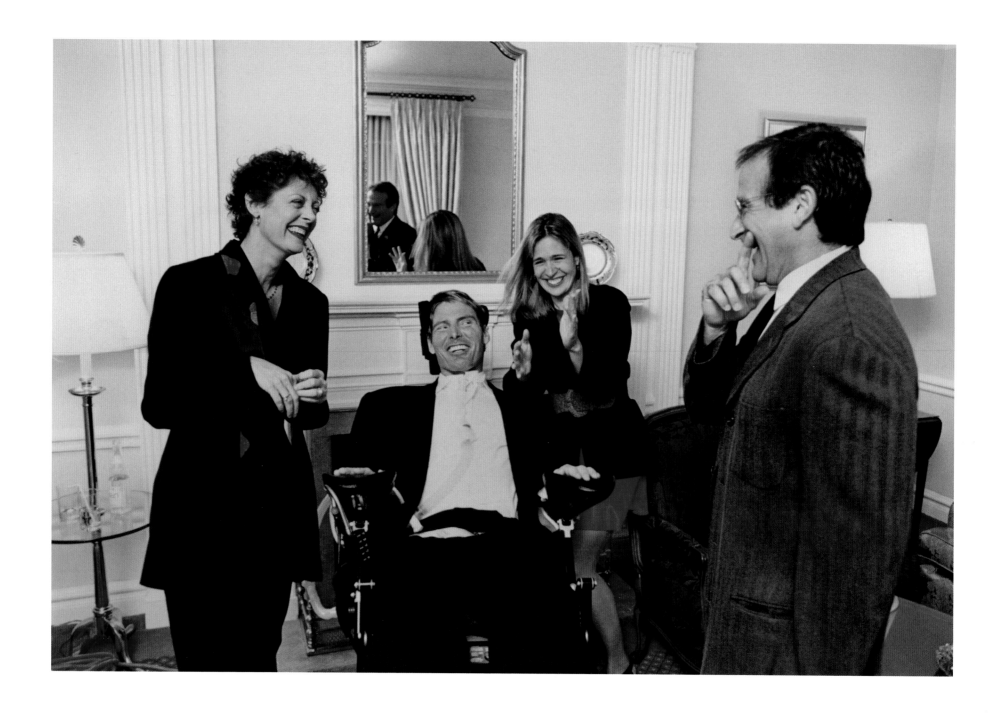

SUSAN SARANDON, CHRISTOPHER REEVE,
DANA REEVE, AND ROBIN SHARE A LAUGH IN
CHRISTOPHER'S SUITE AT THE PIERRE HOTEL PRIOR
TO HIS APPEARANCE AT THE CREATIVE COALITION
SPOTLIGHT AWARDS DINNER, NEW YORK, 1996

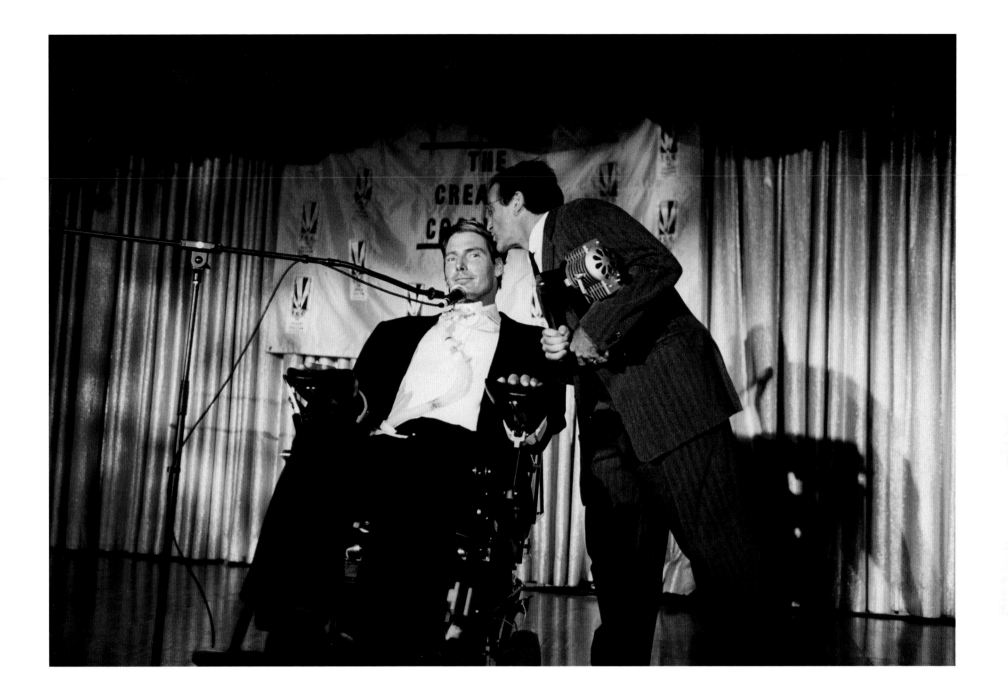

In October 1996 I was in New York shooting the poster for Robin's film The Birdcage. *One afternoon I received a call from Marsha Williams, who was with Dana Reeve, Christopher Reeve's wife. They explained that Chris would be attending the annual Creative Coalition Spotlight Awards dinner at the Pierre Hotel the following night. It would be his first public appearance since his horseback riding accident a few months earlier that had left him paralyzed. Although the event was closed to the press, they still wanted the event covered, but by a single photographer who would then distribute photographs to the media. The following night I was the "official" photographer for Christopher and through my agency Sygma, the photos were on the wire via the Associated Press, going worldwide within an hour. The pictures were free to newspapers, but all proceeds from the sale of the images to magazine and television outlets were donated to the Christopher Reeve Foundation.*

ROBIN AND NATHAN LANE DURING THE POSTER
SHOOT FOR *THE BIRDCAGE*, NEW YORK, 1996

ROBIN AND BILLY CRYSTAL DURING THE POSTER
SHOOT FOR *FATHERS' DAY*, LOS ANGELES, 1997

right and above
ROBIN AND BILLY CRYSTAL ON THE SET
OF *FATHERS' DAY*, RENO, 1997

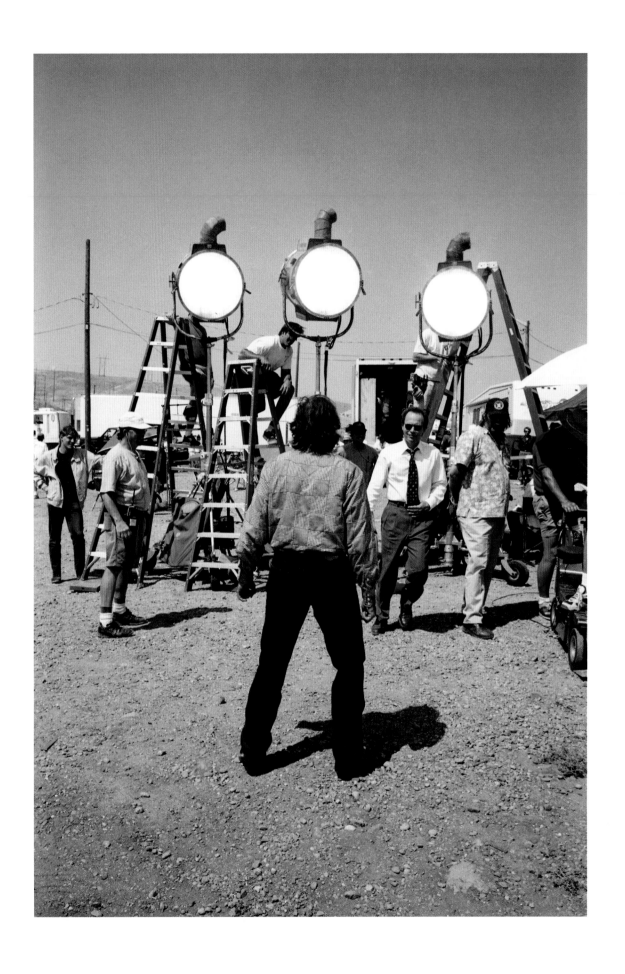

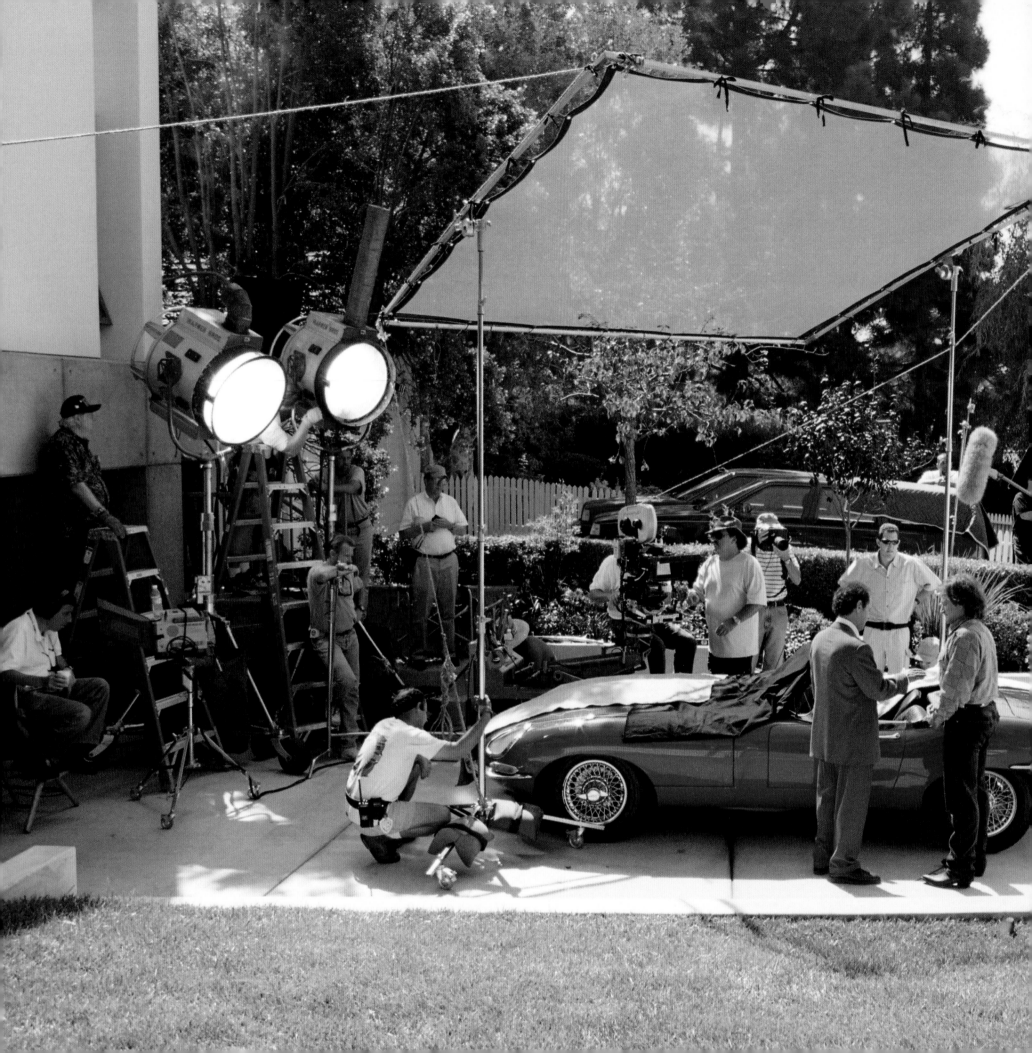

FATHERS' DAY SET, LOS ANGELES, 1997

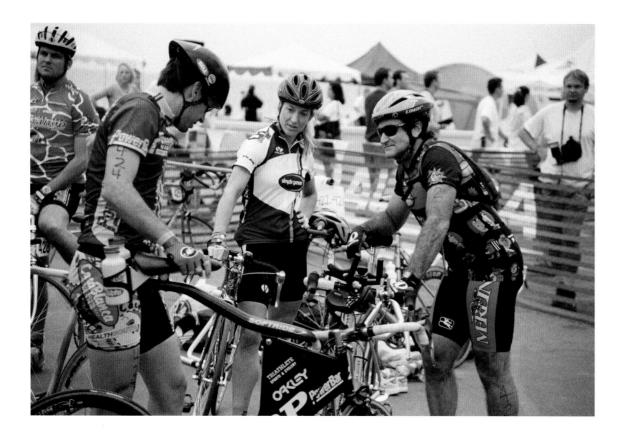

ROBIN WITH OTHER CYCLING COMPETITORS
IN A CHARITY RACE, MALIBU, 1998 *(above)* AND
WITH ONE OF HIS BELOVED LIGHTWEIGHT BIKES
OUTSIDE HIS GARAGE (THERE WERE TWENTY
MORE INSIDE), SAN FRANCISCO, 1995 *(right)*

*One of Robin's passions was cycling. He was a serious
rider and often participated in charity races for causes he
supported. He had dozens of bikes of all weights, sizes, and
specialties, plus all the accoutrements to go with them—from
helmets to shoes to a dizzying array of jerseys. Whenever
possible, he would bring a selection of his prized bicycles
with him on location and try to get a ride in during breaks in
his shooting schedule.*

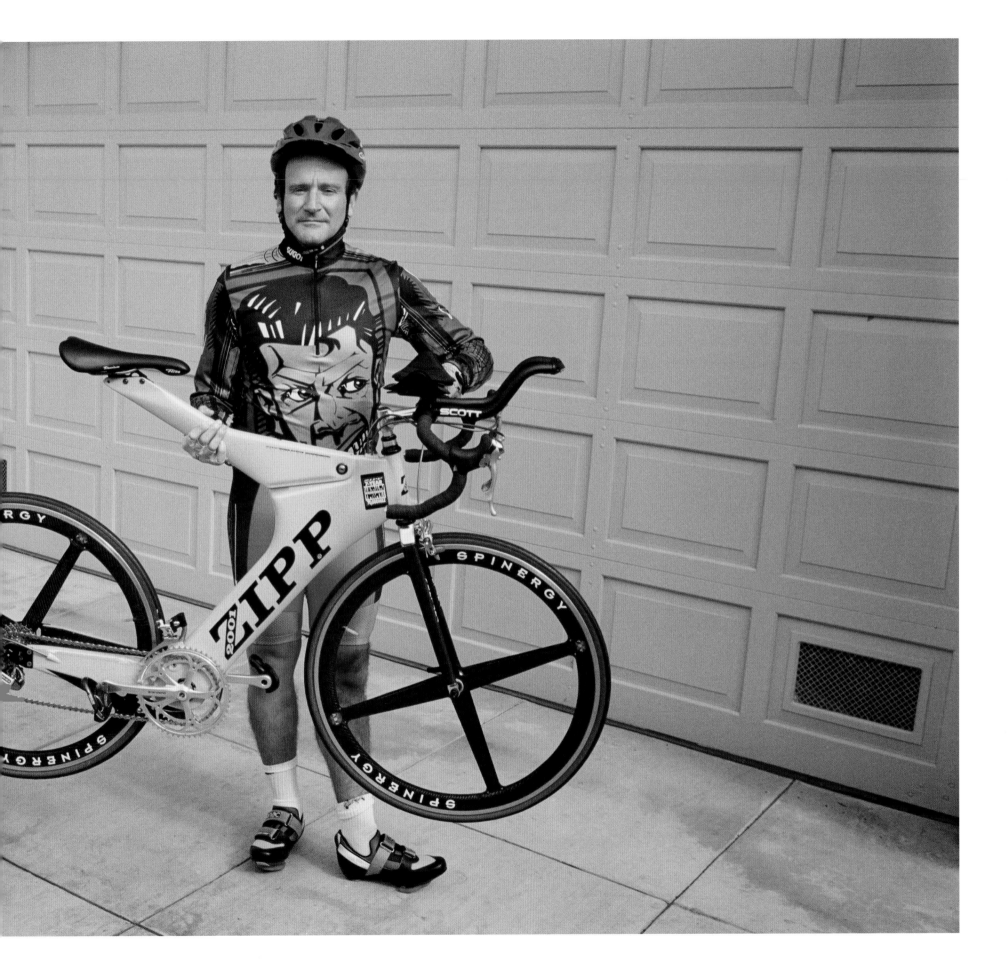

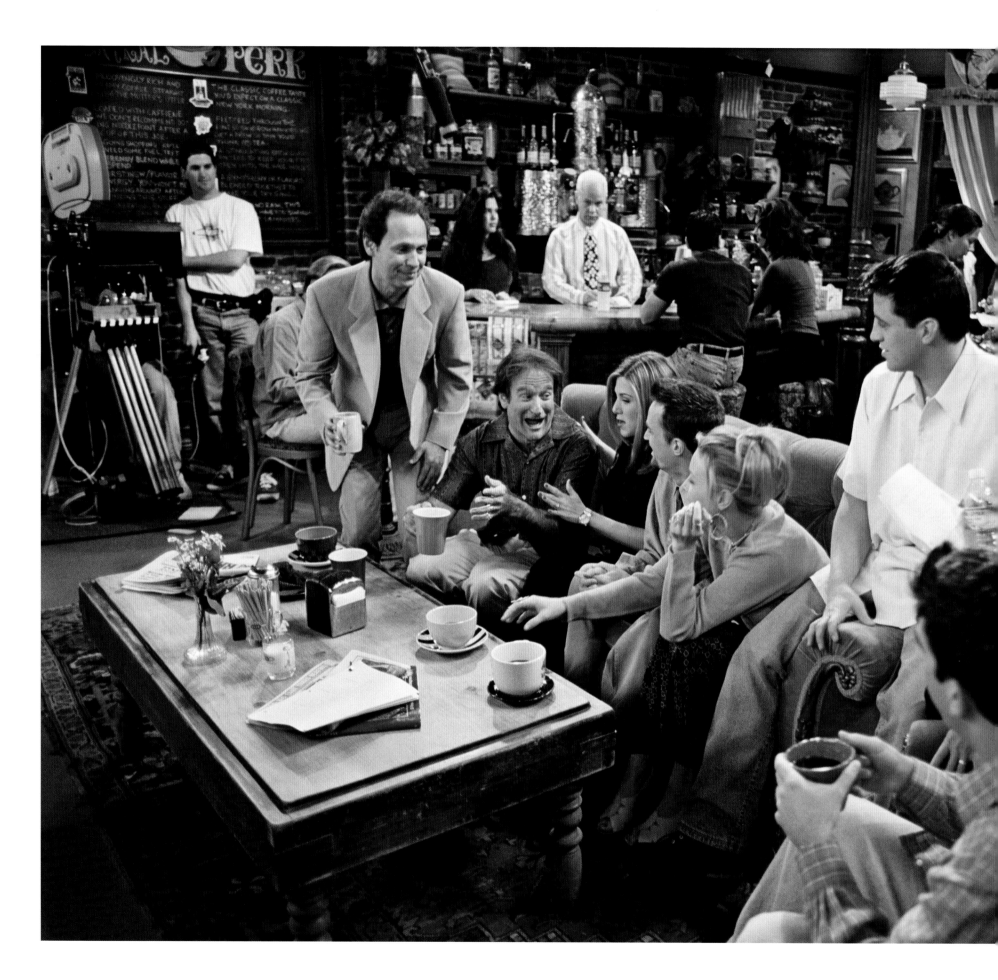

ROBIN AND BILLY CRYSTAL ON THE
FRIENDS SET, LOS ANGELES, 1997

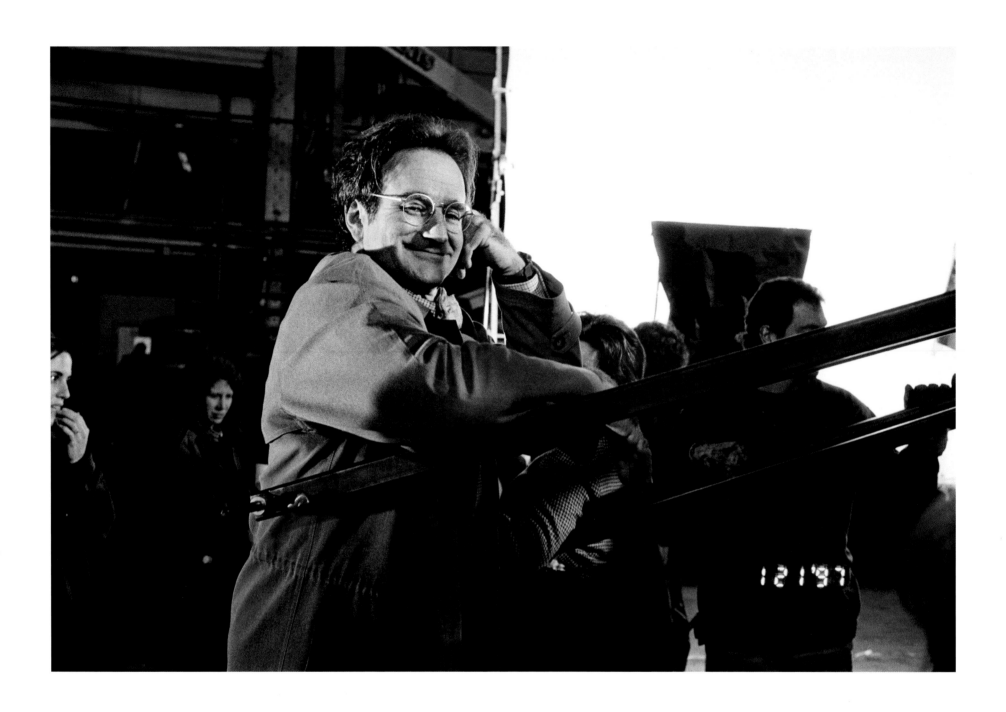

ON THE *FLUBBER* SET, TREASURE ISLAND,
SAN FRANCISCO, 1997 *(above)* AND GIANT *FLUBBER*
AD ON THE SIDE OF A BUILDING ON SUNSET
BOULEVARD, LOS ANGELES, 1997 *(right)*

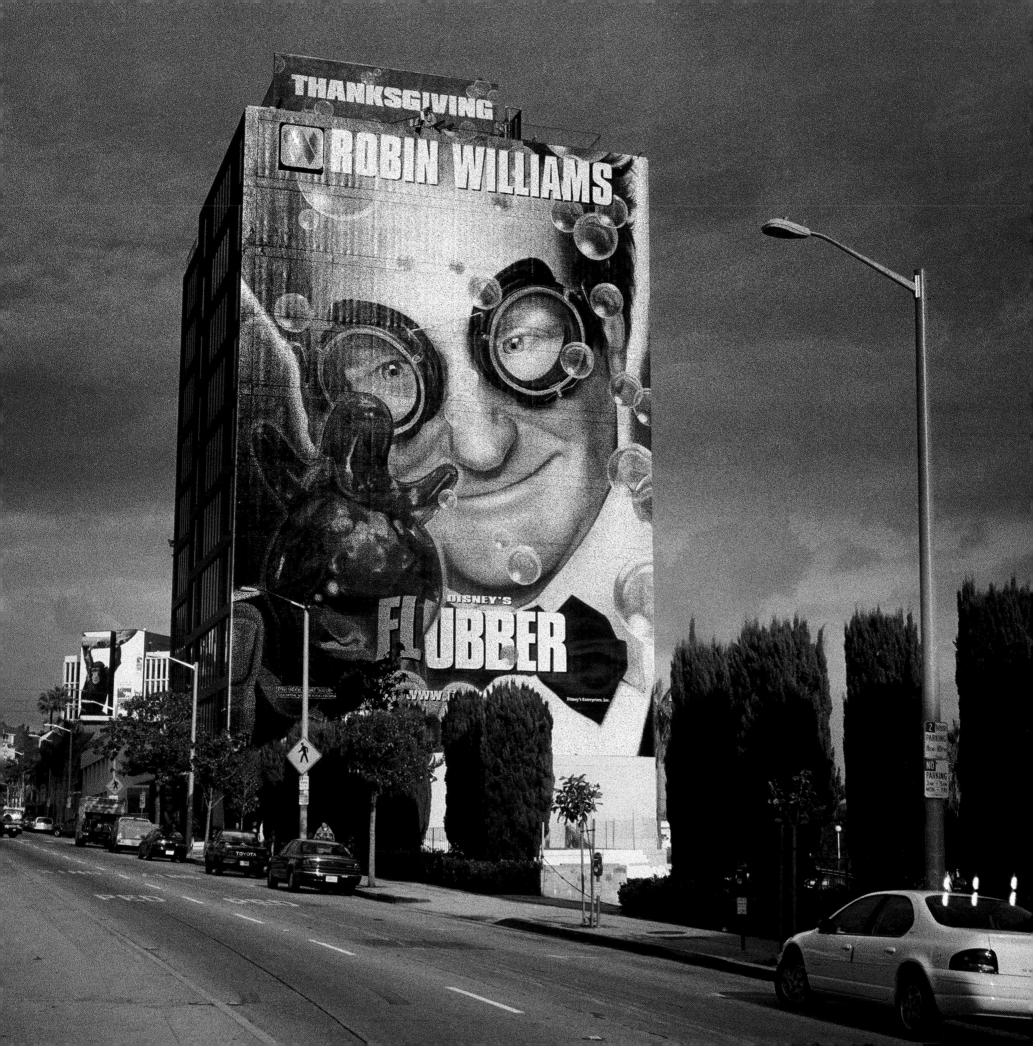

left and above
ROBIN AT MY FIFTIETH BIRTHDAY PARTY,
THE PALM RESTAURANT, LOS ANGELES, 1997

GOOD WILL HUNTING 1997

Almost from the moment I met Robin, there was an ongoing buzz from people in the know that he had serious acting chops, and it was only a matter of time before he was going to win an Oscar, if only the right part came along. He'd already won a Grammy and an Emmy and like any self-respecting, ego-driven entertainer in a hypercompetitive business, I'm sure he had his eye on the Holy Grail of awards that few ever attain—an EGOT (Emmy, Grammy, Oscar, and Tony).

As his movie career unfolded, I would hear over and over again that such and such film that he was about to do was going to be his Oscar movie—"can't miss," "did you hear who's directing?" "incredible script," "what a role"—always the same litany from rosy-minded prognosticators. And of course, as in any business that's totally unpredictable, disappointment is the name of the game—that is until *Good Will Hunting* came along.

Not many people actually know how Robin became involved with the film. It was complete serendipity. Marsha's young niece, Jen Garces, happened to be working in Memphis as a production assistant on Matt Damon's first starring film, *The Rainmaker*. One day on set Matt happened to tell her about his *Good Will Hunting* project and the troubles he was having getting anyone interested in funding the film. She agreed to help him out and get his script to Robin, which she eventually managed to do. Robin read the script, agreed to do the film, and with Robin attached, Miramax stepped in with the financing. As it turned out, Robin's gamble on a screenplay by

two unknown writer/actors—Matt Damon and Ben Affleck—was one of the more fortuitous decisions he ever made and resulted in all parties being richly rewarded.

When I arrived on set in Boston in May 1997 for the ad shoot on the movie, it didn't take long to sense that something special was going on. Robin was absorbed with the role and was especially happy with the film's talented director, Gus Van Sant. I saw the easy rapport he had with the young cast when everyone went out for bowling and beers at a local alley one night to celebrate a cast member's birthday. As usual, Robin had all of them, or whoever he focused on, laughing whenever he wanted. As they all found out, there was nothing quite like being around Robin when he was relaxed, letting loose and riffing away.

Late in the afternoon on my second day, my assistants and I were getting everything set up at a nearby gym for the gallery shoot of the cast as well as the ad shots that had been sketched out by Miramax's marketing team. Out of the blue I was informed by a production assistant that one of the producers wanted me to get right over with my cameras to the outdoor location where Robin and Matt were shooting a scene together.

By the time we arrived, an already gloomy overcast day was getting even darker. The producer thought that the area they were in, a lower-middle-class, neighborhood with row houses, was perfect for a poster try. After a brief back-and-forth where I expressed my

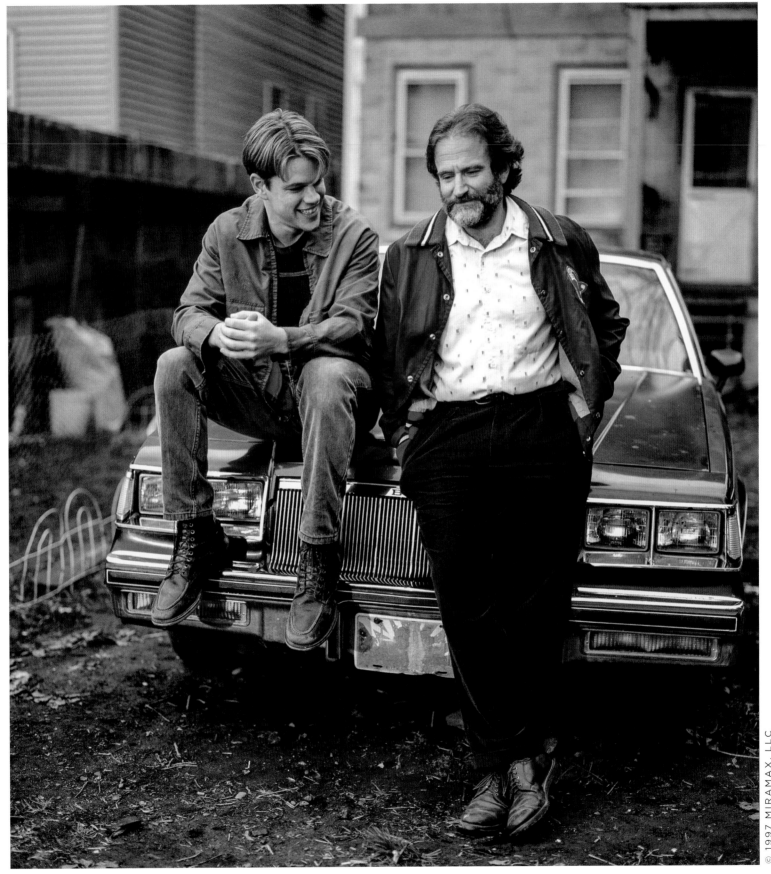

ROBIN AND MATT DAMON ON LOCATION DURING POSTER SHOOT FOR *GOOD WILL HUNTING*, BOSTON, 1997

At times like this it really helps if your friend just happens to be one of the leads in the movie. A lot of actors, including Robin, didn't like these kinds of surprises, especially when you're shooting an ad poster. Any number of things could cause a problem for them: the right hair and makeup people weren't there; nobody had explained the concept of the ad to them; they didn't have their publicists overseeing what was going on; or a dozen other complaints depending on where the actor happened to be on the "diva" scale.

But none of that happened. Even though it was the end of a long shooting day and they were both ready to head for their trailers, Robin and Matt listened patiently while I explained the producer's idea of an informal, seat-of-the-pants, casual shot with the local housing in the background and that all the two of them had to do was sit on the hood of an old beaten-up car and talk about anything that came to mind, not deliver lines from the script.

Robin couldn't have been more cooperative and at ease with the plan. He knew right away that this wasn't the ad concept he'd been told about, but more importantly for me, he realized that I was in a bind to please the producer and that this wasn't exactly what I had been expecting either. Matt graciously followed Robin's lead, and the shoot went off without a hitch. It really helped that the two of them genuinely liked each other so their banter came easily, and of course, on cue, Robin could get Matt laughing whenever he felt the time was right for some variety to their expressions.

[As it turned out, a frame from that session, albeit with a manufactured gold colored autumn background in lieu of the gritty working class neighborhood, was the poster Miramax went with for the film. For the record, there was never a scene like that in the movie, not that anybody seemed to notice or care.]

When we finished shooting, Robin walked back out to the neighborhood street and found a small crowd of fans waiting for him. As was always the case every time I witnessed this happen, Robin said hello to everyone and took the time to sign autographs and have his picture taken by anyone who had a camera ready to go. What I didn't know at the time was that the previous day Robin had paid

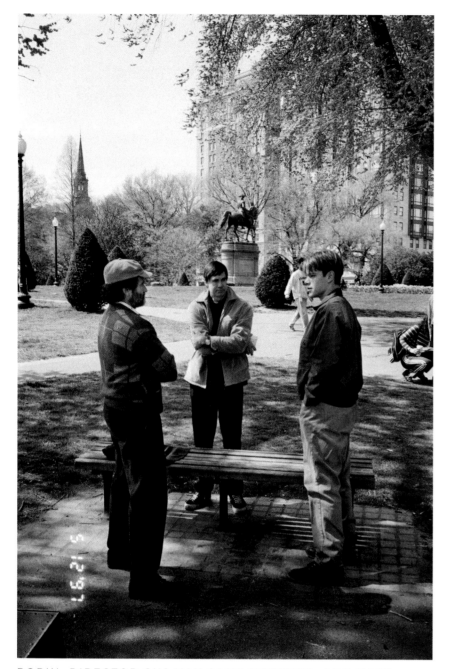

ROBIN, DIRECTOR GUS VAN SANT (CENTER), AND MATT DAMON (RIGHT) DISCUSS KEY SCENE BEFORE FILMING, BOSTON, 1997

concerns over the quality of the lighting available, it was showtime. While my assistant hustled off to get some extra lights put into position by the nearby crew, I went over to talk to Robin and Matt about what we were going to shoot.

ROBIN AND MATT DAMON (BOTH FAR LEFT) AND DIRECTOR GUS VAN SANT (ON DOLLY, FAR RIGHT) WAIT TO SHOOT THE PARK BENCH SCENE, BOSTON, 1997

a visit to a center for at-risk kids in that very neighborhood, and afterwards, made arrangements to buy new computers for their facility. This was very typical of Robin and his wife Marsha, quiet generosity without fanfare or publicity.

Over the weekend, Robin was holed up with his dialect coach perfecting his Boston patois for his big park bench scene with Matt scheduled for Monday morning. He did me a favor though, and agreed to pop out for a few hours and have dinner with me and my sister who was a big admirer of his work. From the minute he sat

down at the restaurant, he was all things Robin Williams—erudite, earthy, intellectual, political, scatalogical, improvisational, philosophical, and above all, fall-down-can't-eat-your-food funny.

The next morning under a bright blue Boston sky, I witnessed an extraordinary actor at the top of his game sit on a park bench in Boston Common and flawlessly deliver two pages of dialogue that to this day many consider to be one of the most memorable monologues ever put on film.

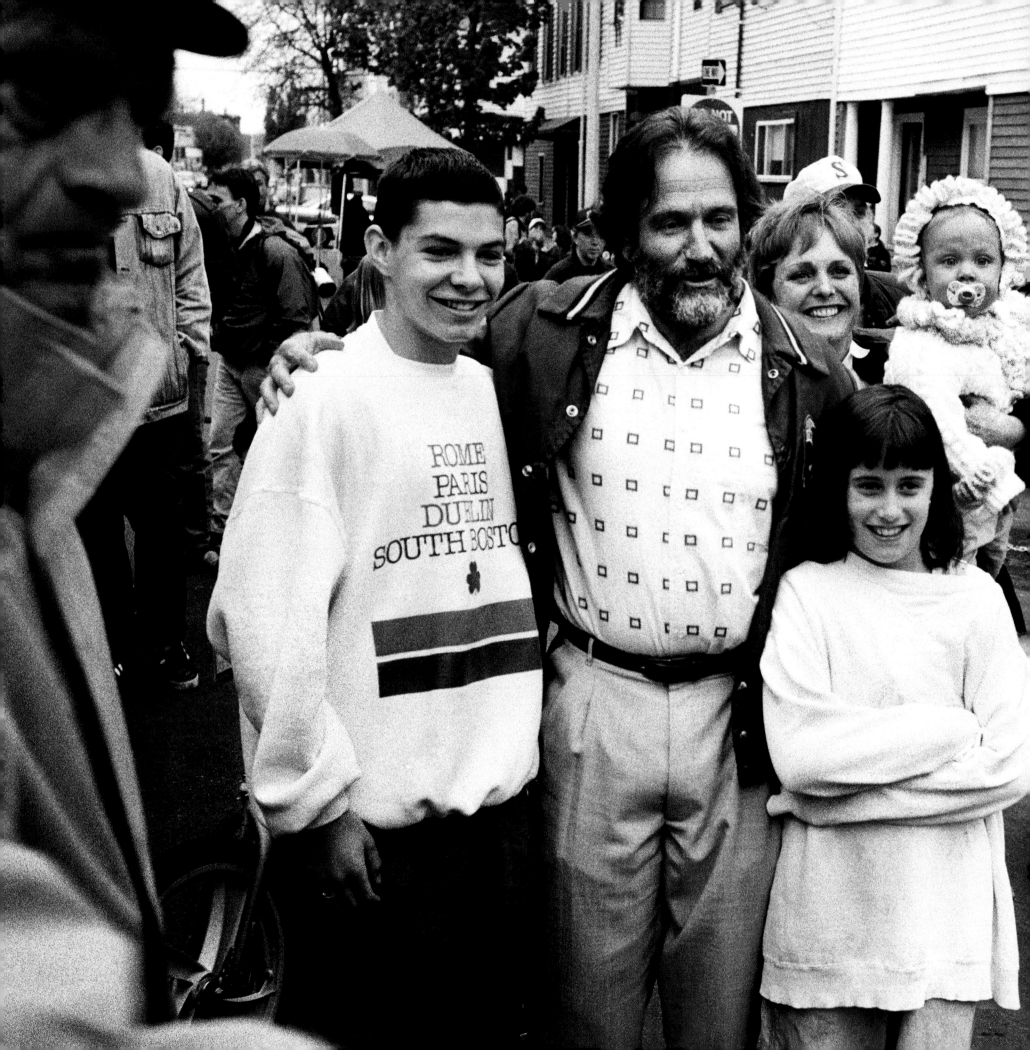

ROBIN POSES FOR PHOTOS WITH LOCAL
FANS DURING THE FILMING OF *GOOD WILL
HUNTING*, BOSTON, 1997

159

OSCAR NIGHT 1998

Oscar night, March 23, 1998, was arguably the biggest night in Robin's professional life. *Good Will Hunting* had been doing well in the awards sweepstakes that year, and Robin had already won a Screen Actors Guild award for best supporting actor for his role in the film. But he'd lost the Golden Globe in that category to Burt Reynolds for *Boogie Nights*.

Although everyone in Robin's camp was very upbeat about his chances, he was having none of it, other than offering polite thank yous to those offering positive predictions. Of course he wanted to win, but like most actors, insecurity was part of his DNA, so why trumpet himself or his chances, especially since that wasn't his style anyway. In fact, Robin was always humble and modest about accolades and awards coming his way, and he seemed especially so when it came to the possibility of winning an Oscar.

If Robin did win, it would be a milestone in his career that I definitely wanted to document just for him—no obligations to magazines or agencies or anyone else. I talked to Marsha the day of the ceremony, and she confirmed that he was more than a bit nervous about the outcome, so we didn't want to do anything that might add to his stress level, like telling him I was waiting in the wings to photograph his big night in case he won. We agreed to a simple plan: If he won, she would call to tell me where to meet them as soon as they left the Governors Ball.

That night I sat and watched the Oscars in jeans on my sofa, not knowing whether I'd be throwing on my tux and heading out for

a long night or sitting there for the entire show. As soon as Robin won and made his acceptance speech, I quickly changed clothes, loaded two small point-and-shoot cameras, and stuffed them in my tux jacket pockets. It was agreed that given the circumstances I couldn't appear to be a working photographer with cameras hanging off me. The idea was to blend in and stay close to Robin as part of his group. About twenty minutes later Marsha called and told me to meet them at their first stop, a party at the Beverly Hills Hotel.

When Robin arrived at the hotel, he had a look of disbelief on his face and kept smiling and waving, greeting fans and talking to a clamoring press. I didn't even get to congratulate him until right before we all piled into the limo: Robin, Marsha, Robin's mother Laurie, and his publicist, Mark Rutenberg.

On the drive over to the *Vanity Fair* party, he held on to his Oscar and kept beaming, making some small talk with his mother and Marsha and asking Mark where we were headed, but actually, for him, he was kind of quiet. I think he was still a bit in shock and somewhat disbelieving of what was actually happening. For me, it was like having a ringside seat to a very rare event—someone living out his dream in real time.

The next thing we knew, we were all thrown into the chaos outside the *Vanity Fair* Oscar party. I just stuck by Robin and photographed as the press called out his name, and he stopped to talk to everyone, being polite and cooperative as always. All the while, he never let his Oscar out of his right hand, sometimes clutching

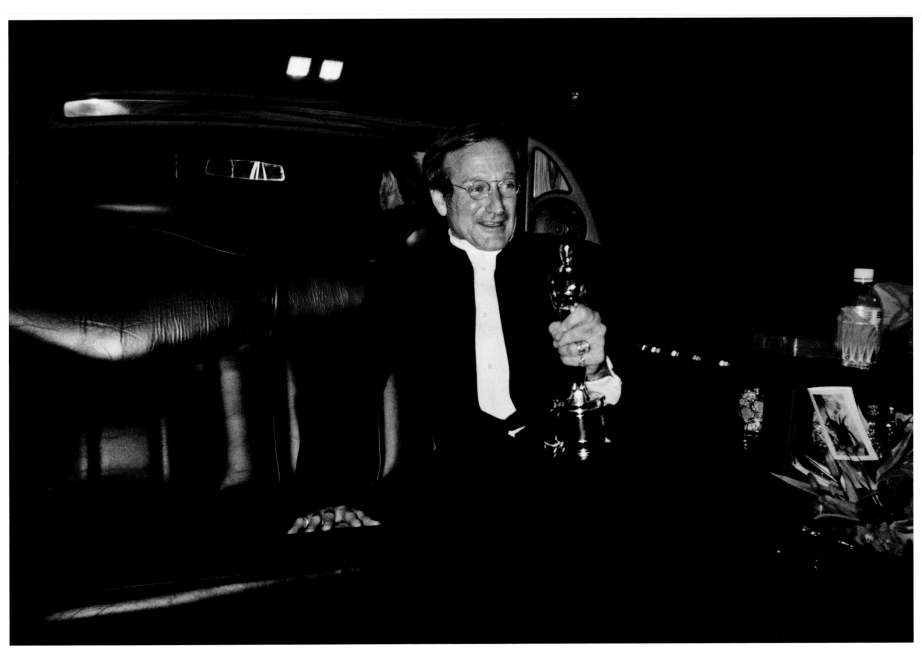

IN BACK OF LIMO AFTER LEAVING OSCAR PARTY AT BEVERLY HILLS HOTEL, LOS ANGELES, 1998

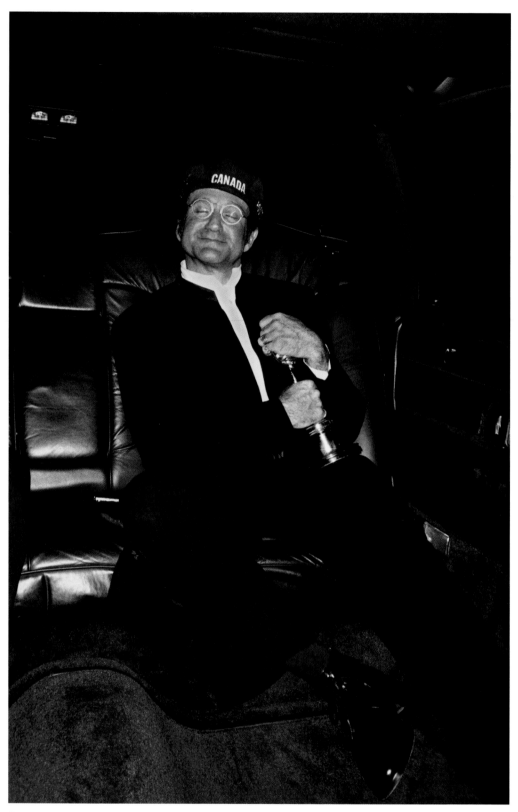

BEAMING HOLDING HIS OSCAR AND WEARING HIS ROOTS HAT AFTER
LEAVING THE *VANITY FAIR* PARTY, LOS ANGELES, 1998

it, sometimes cradling it, occasionally turning it, but mostly holding it firmly by his side.

With the press gauntlet behind him, Robin waded into the bedlam inside and was immediately swarmed by well-wishers—some were friends from his stand-up days, like Jay Leno; some were business associates, like his agent Mike Menchel; but most were your usual VIPs and minor celebs who had no personal connection to Robin but just wanted to latch onto an Oscar winner for a photo op. At times he seemed baffled as to who all these people were who kept grabbing his shoulder and arm to shake his hand, or yell congratulations in his ear, or touch his Oscar. When one of his real friends, like Eric Idle, made it through the crowd to him, that's when Robin's face would really light up and take in the genuine praise and congratulations being offered.

After about a half hour of nonstop commotion and noise, Robin headed for the door, and we all followed him outside to the restricted area for limousine drop-off and pickup. Another guest in a tux who was waiting nearby for his ride suddenly noticed Robin and rushed over. Before anyone realized what was happening, the man, who turned out to be one of the founders of Roots clothing company, placed one of his company's beret hats on Robin's head and turned him in the direction of his friend, who quickly took a few shots. Surprisingly, Robin, who never advertised anything at that point in his career, didn't seem to mind, either because he was in such a mellow mood that nothing could bother him, or because he was stunned that the guy had ambushed him with such a brazen publicity move. As expected, Mark made sure the hat wasn't on his client's head when Robin got out of the car at our next stop.

It was way past midnight and a few parties later when the limo driver dropped off Laurie and Mark, who were both ready to call it a night. As we pulled away headed

for our last post-Oscar soiree, Robin and Marsha explained that this one would be different. It was a very small, exclusive affair hosted every year by Dani Janssen, David Janssen's widow, at her penthouse apartment in Century City. Obviously, my name wasn't on the guest list, and it didn't sound like one of those parties you could just crash, so Robin and Marsha (who I think didn't want me to bail before the night was over) kindly had the doorman at the building call up and explain who I was. The next thing you know, we're all being whisked up in the elevator to the top floor.

Dani greeted Robin and Marsha warmly as we entered her spectacular apartment overlooking the city, then took Robin by the arm to receive congratulations from a small group of men standing having drinks in the middle of her spacious living room: Warren Beatty, Jack Nicholson, and Michael Douglas. To see the way all three Hollywood legends greeted and congratulated Robin with genuine respect and admiration is a picture I'll always remember, but unfortunately, only in my mind's eye. Party rule #1 was no photos allowed unless taken by the host. So I took it all in from a distance, watching Robin engaged in animated repartee with this triumvirate of Hollywood royalty. At that moment, standing high above Tinseltown, Robin had truly reached the summit of his profession, at least for that one incredible night.

When we finally made it back to Robin's suite at the Hotel Bel-Air, it was around three in the morning. The living room was filled with congratulatory flowers and bottles of champagne and wine. Robin plunked down in a chair exhausted while Marsha started to read him the cards that had come with the gifts. After listening for a few minutes, he decided to call it a night. He walked over to me and in typical fashion, thanked me for coming along when, of course, it was the other way around. As he headed off, I noticed that he'd left his Oscar sitting on the table alongside the champagne, the flowers, and an open bag from Junior's Deli. That was the last picture I took before I let myself out.

To this day, Robin's Oscar night stands out for me, not only for how surreal an evening it was, but because it was the happiest I ever saw Robin in his professional life in all the years I knew him.

AT THE END OF THE EVENING, ROBIN'S OSCAR SITTING ON THE LIVING ROOM TABLE OF HIS SUITE AT THE HOTEL BEL-AIR, LOS ANGELES, 1998

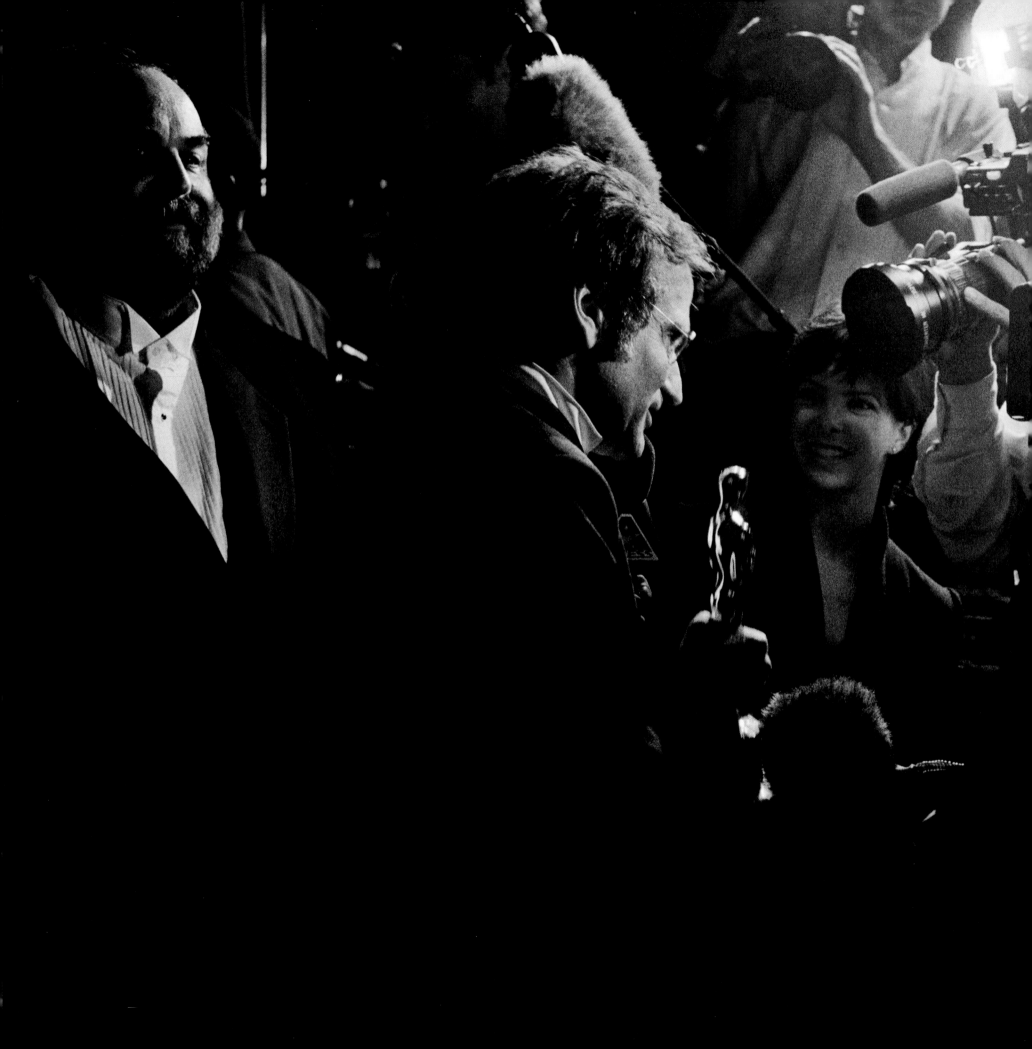

TALKING TO PRESS BEFORE HEADING IN TO THE
VANITY FAIR PARTY *(left)* AND WITH HIS GOOD
FRIEND ERIC IDLE (center) AND HIS MOTHER, LAURIE
WILLIAMS (left), AT THE *VANITY FAIR* PARTY *(above)*,
LOS ANGELES, 1998

VACATION WEEKEND, BIG SUR, CA, 1998

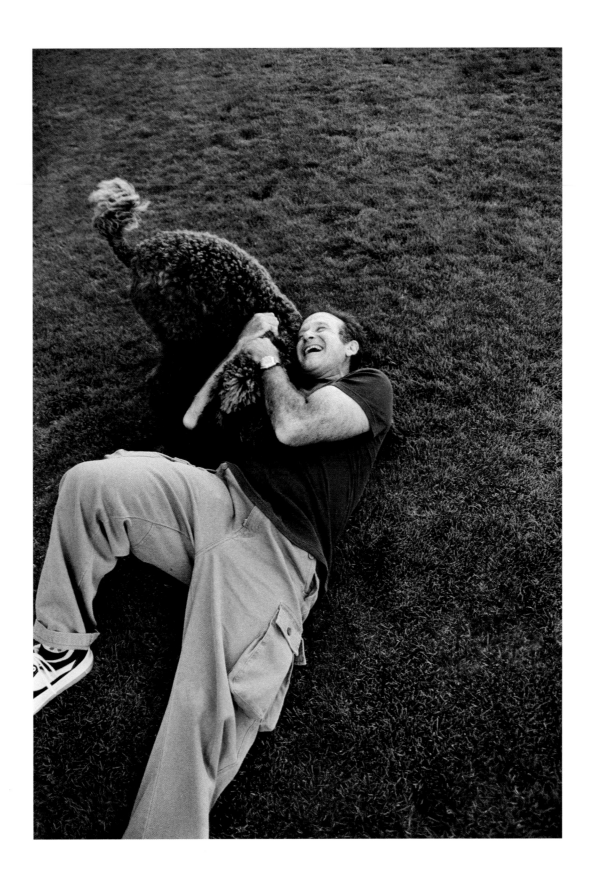

PLAYING IN THE YARD WITH HIS STANDARD
POODLE, KIWI, SAN FRANCISCO, 1999

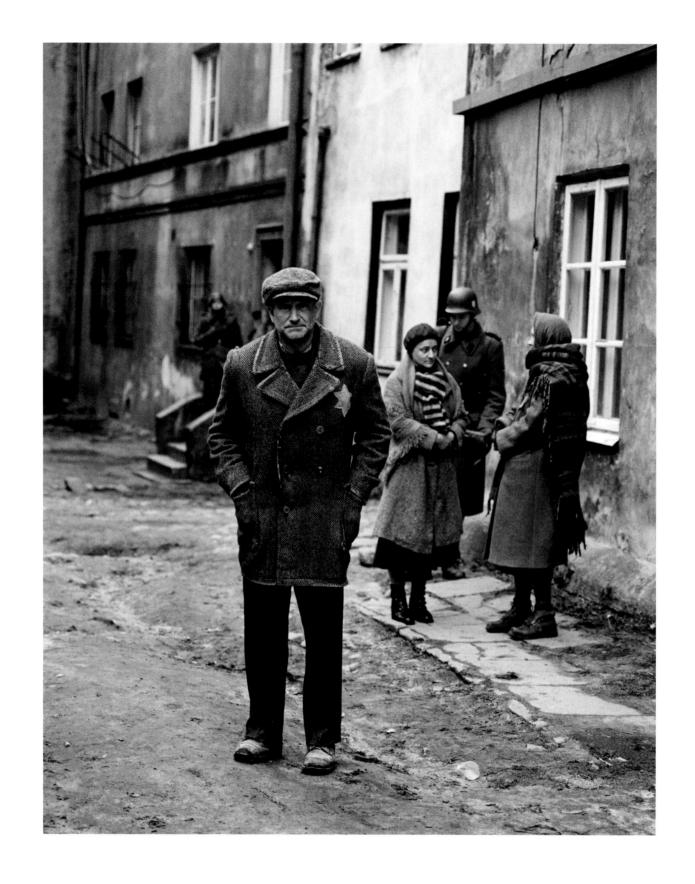

JAKOB THE LIAR SET, PIOTROKOV, POLAND, 1997

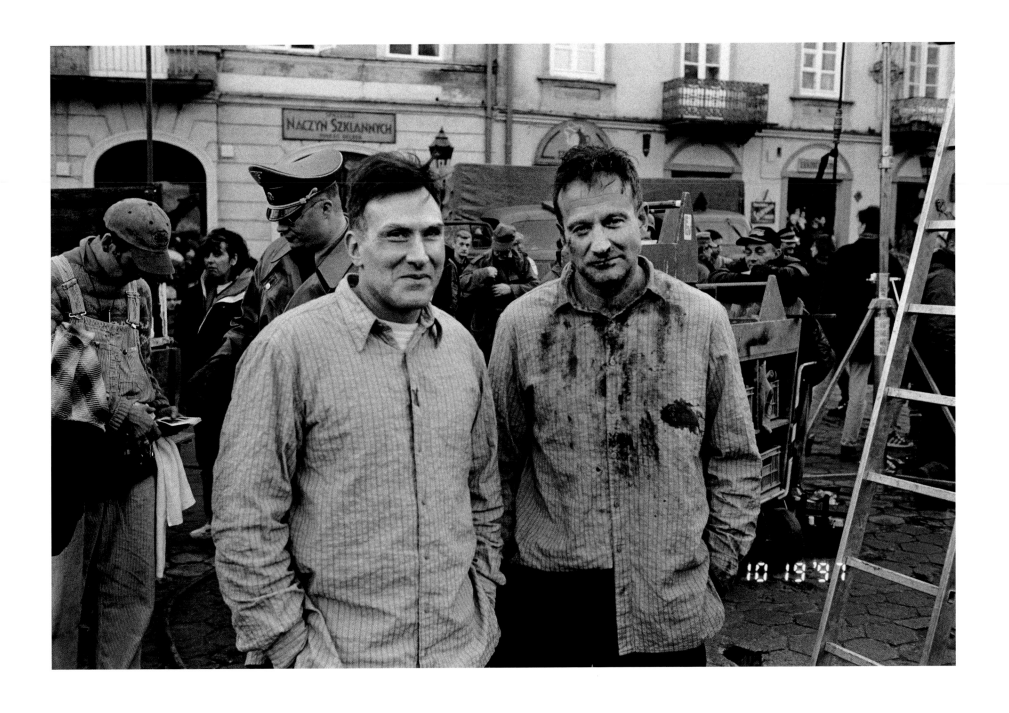

ROBIN WITH HIS VETERAN STAND-IN, ADAM BRYANT,
PIOTROKOV, POLAND, 1997

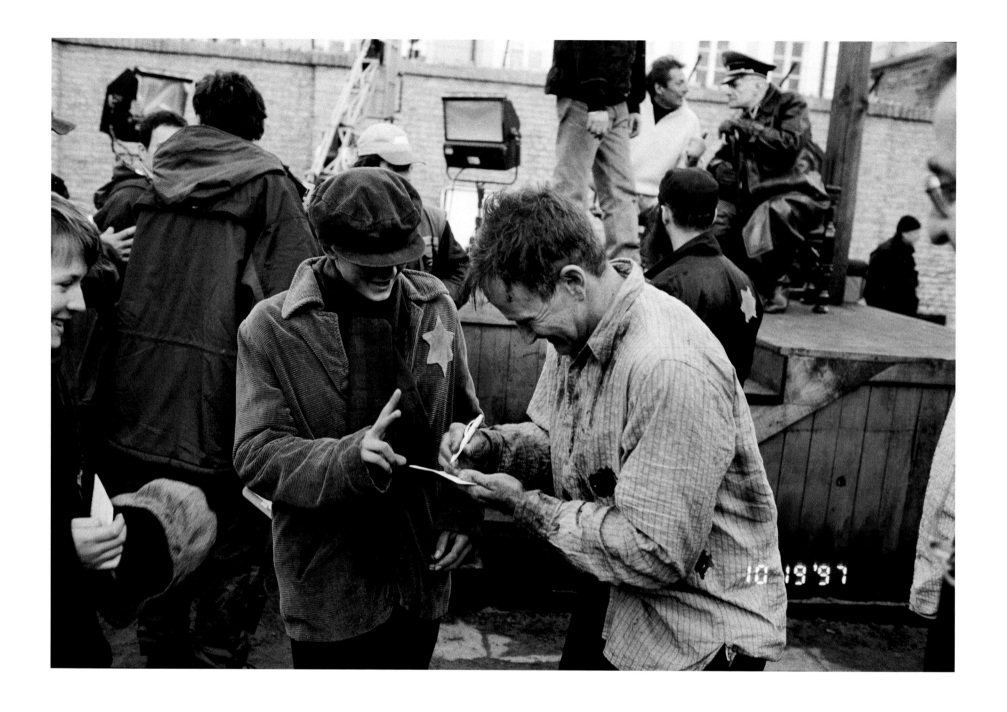

SIGNING HIS AUTOGRAPH FOR AN EXTRA ON THE SET
OF *JAKOB THE LIAR*, PIOTROKOV, POLAND, 1997

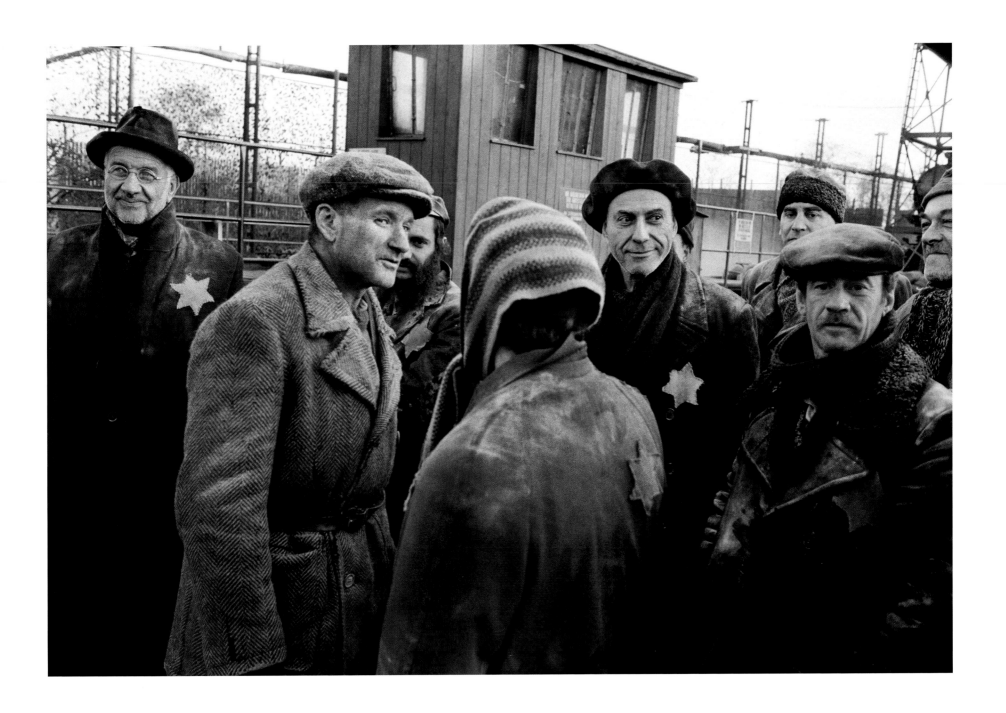

TAKING A BREAK WITH FELLOW CAST MEMBERS, (L to R: ARMIN
MUELLER-STAHL, ROBIN, ALAN ARKIN, AND MICHAEL JETER),
BUDAPEST, HUNGARY, 1997

this spread and pages 174–177
In 1999 Robin decided to do a podcast interview show for a start-up internet company called Audible, Inc., which would be offering audio downloads on the web of select newspapers and periodicals. The San Francisco agency that had the advertising account called me to do a special shoot with Robin, who had agreed to the ad campaign to promote the company and his new show. When I arrived at the photo studio a month later, the art director explained the concept to me. It couldn't have been simpler—let Robin be Robin. They had assembled racks full of special clothing and costumes and a floor full of props. As an eclectic mix of Robin's favorite music (hip hop, rock, salsa) blared from the speakers, Robin took off on a long flight of fantasy as he rapidly changed from one "character" to another in a remarkable tour de force of physical improv.

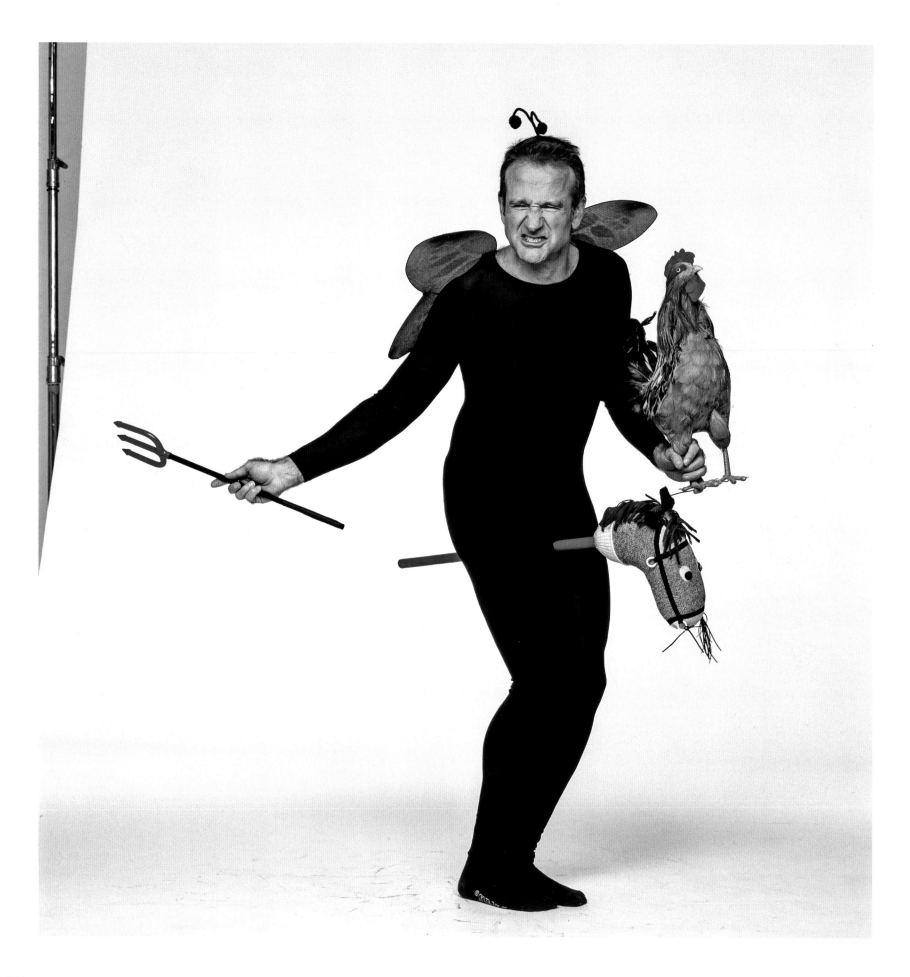

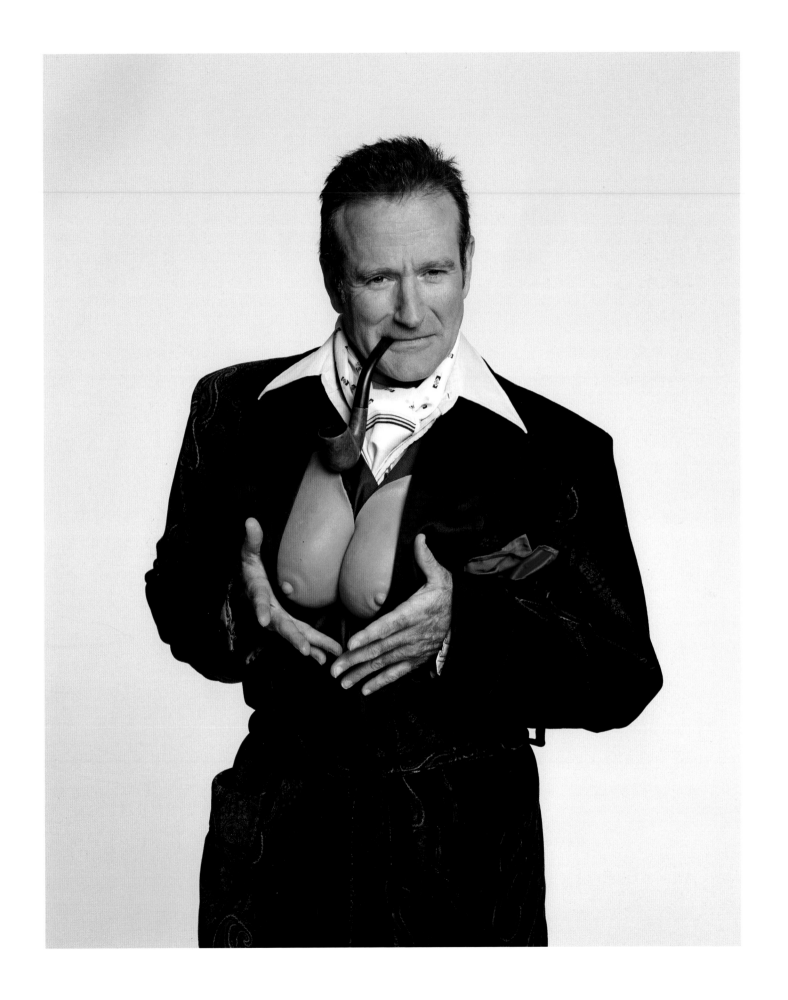

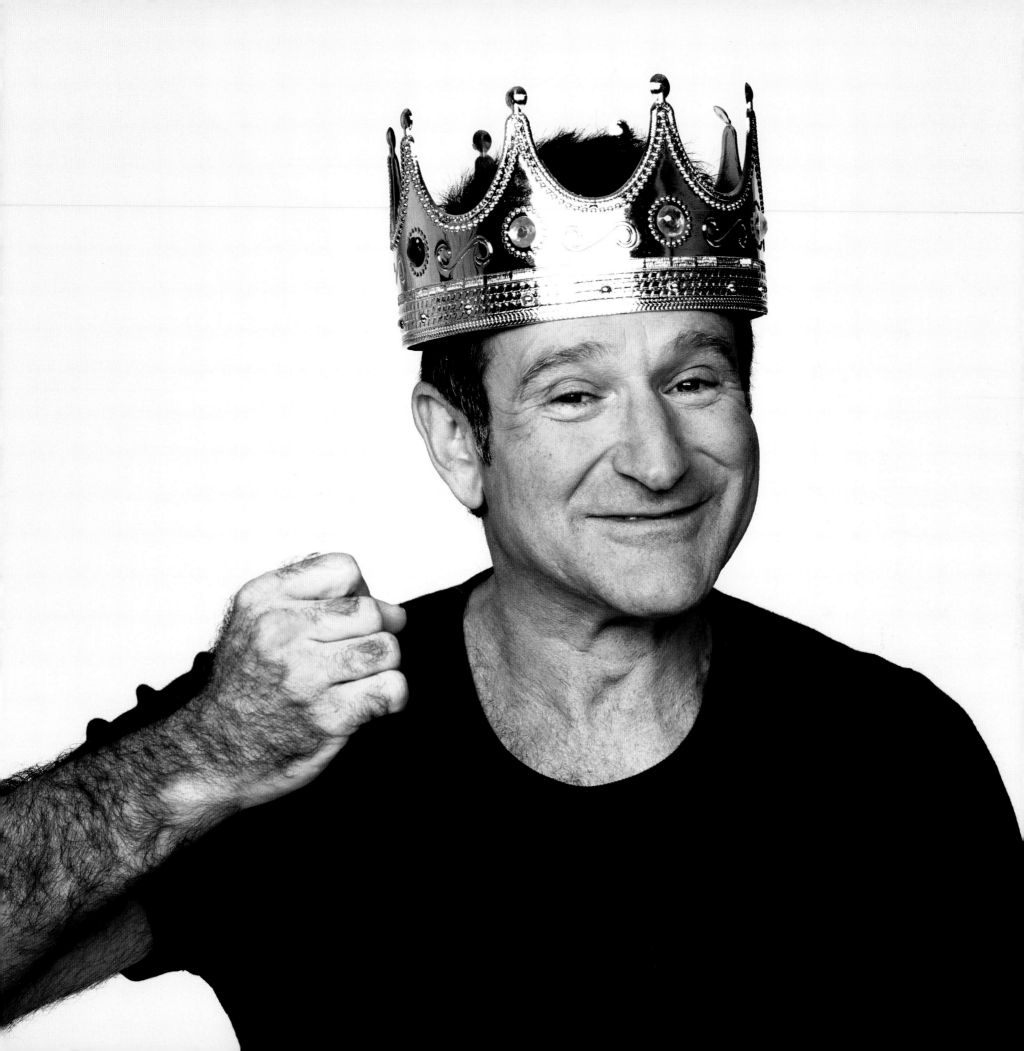

TESTING NEW VIDEO GAME AT
ELECTRONIC ARTS, RICHMOND, CA, 1999

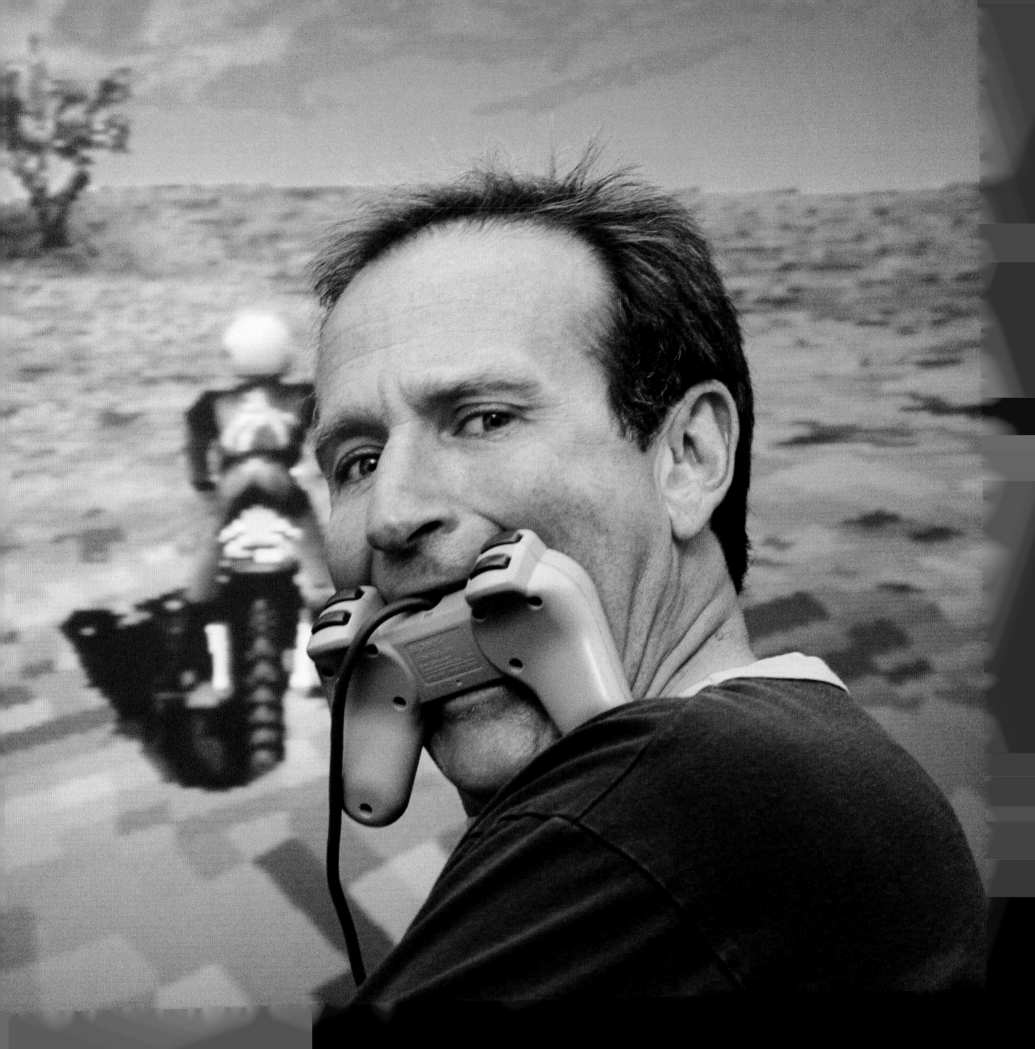

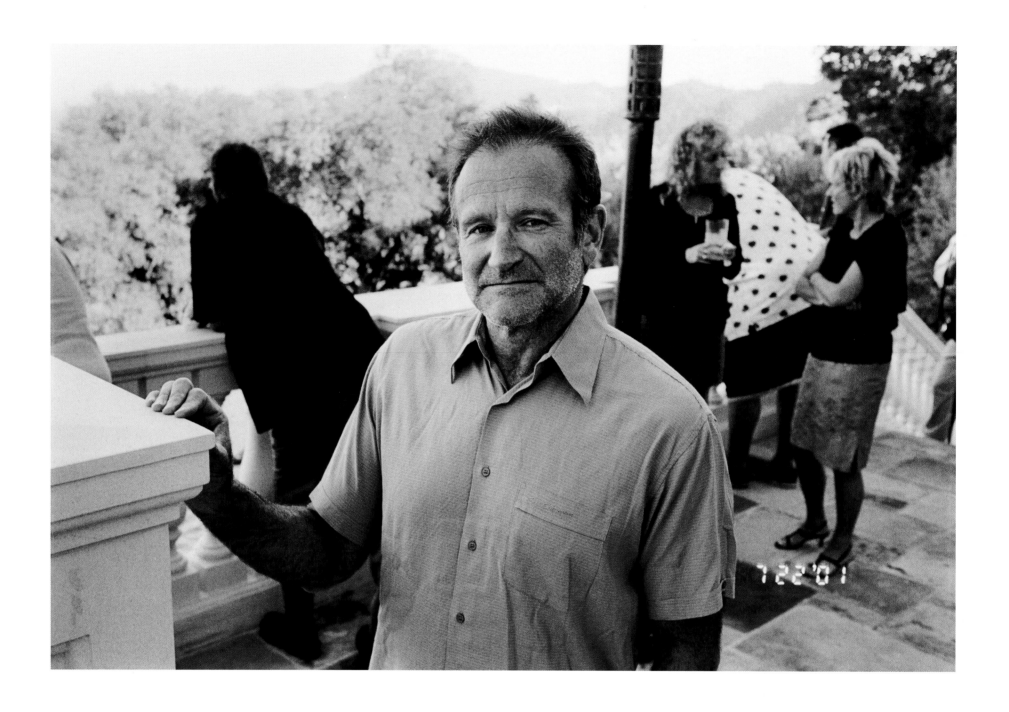

AT HIS FIFTIETH BIRTHDAY PARTY,
NAPA RANCH, 2001

BACKSTAGE AT BIMBO'S 365 CLUB MOMENTS
BEFORE GOING ON, SAN FRANCISCO, 2001

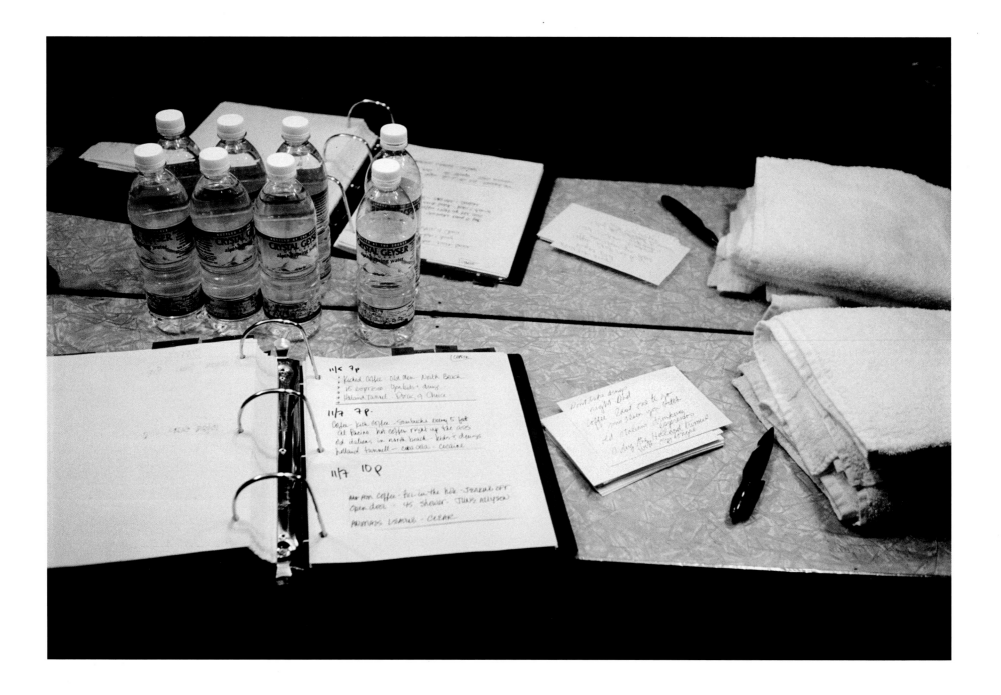

ROBIN'S STAND-UP NOTES ALONGSIDE HIS STANDARD
STAGE ACCESSORIES, WATER AND TOWELS,
SAN FRANCISCO, 2001

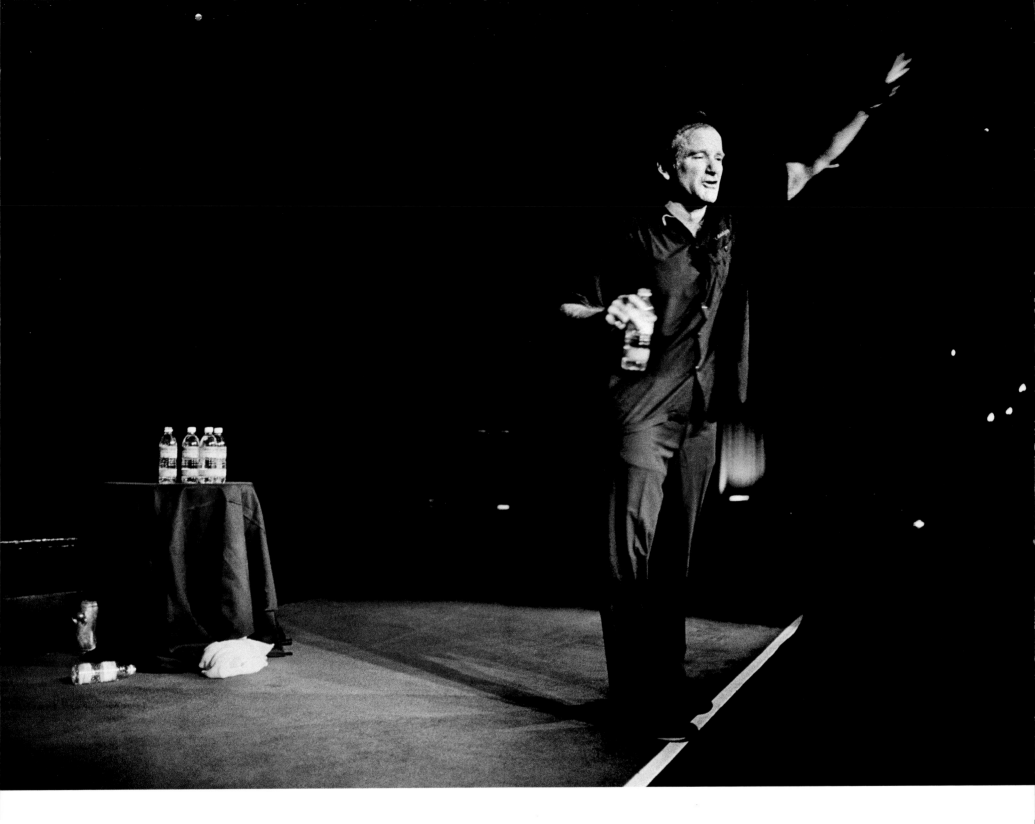

In December 2001 I went up to San Francisco to photograph Robin working on new material for his 2002 "On the Road" stand-up tour which culminated later in 2002 with his Robin Williams Live on Broadway HBO special in New York. He preferred working in an intimate supper club venue, Bimbo's 365 Club, to put his new act together. It was sold out every night I was there.

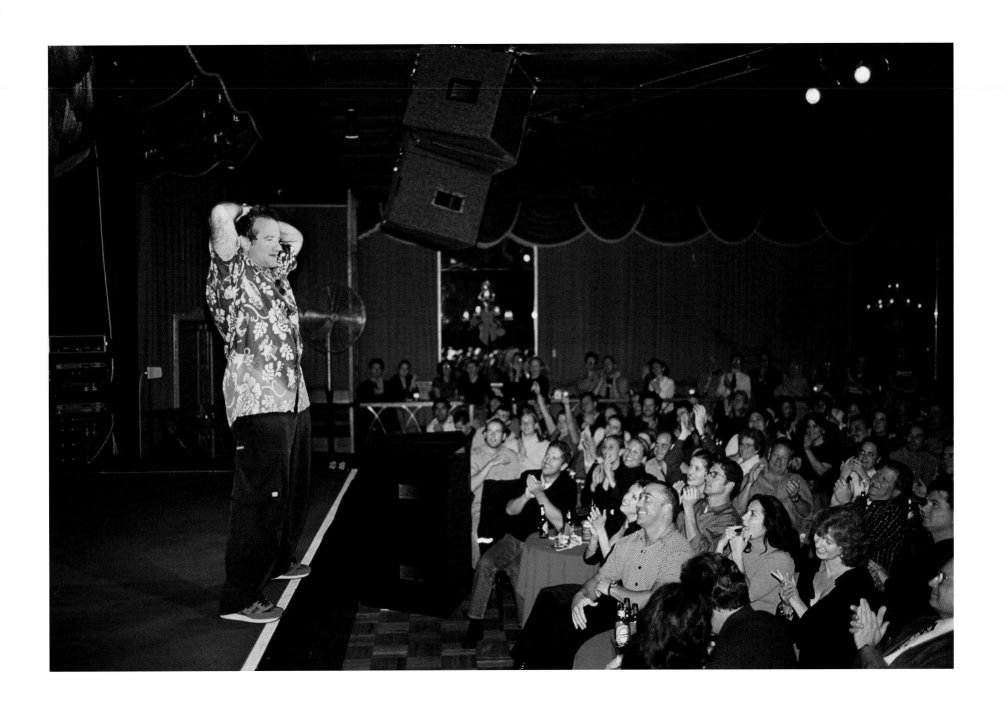

left and above
WORKING ON NEW MATERIAL,
BIMBO'S 365 CLUB, SAN FRANCISCO 2002

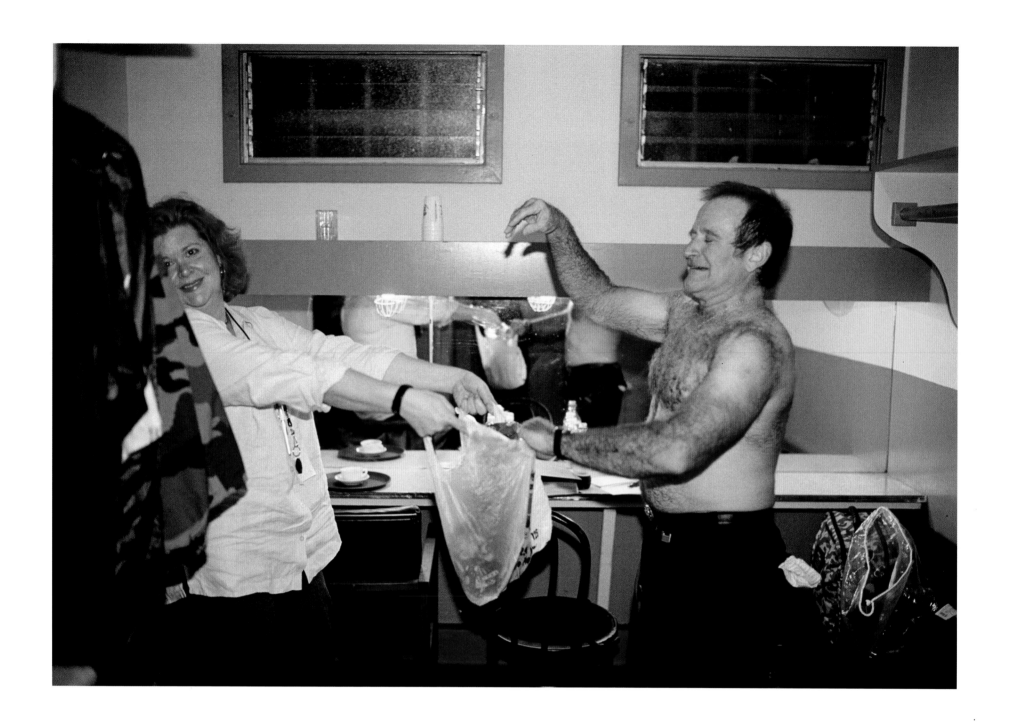

ROBIN'S PERSONAL ASSISTANT, REBECCA ERWIN SPENCER,
IN THE DRESSING ROOM HOLDING OPEN A PLASTIC BAG
FOR ROBIN TO DISPOSE OF HIS DRENCHED STAGE SHIRT,
BIMBO'S 365 CLUB, SAN FRANCISCO, 2001

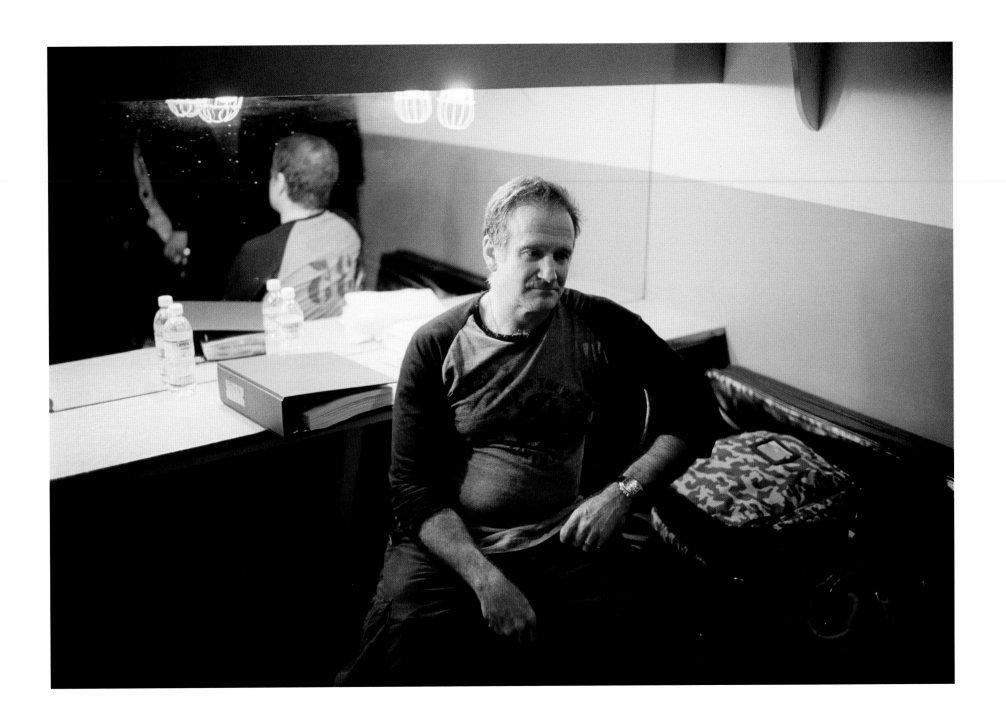

RESTING IN HIS DRESSING ROOM FOR A FEW
MINUTES AFTER HIS SHOW BEFORE LETTING
IN WELL-WISHERS, BIMBO'S 365 CLUB,
SAN FRANCISCO, 2001

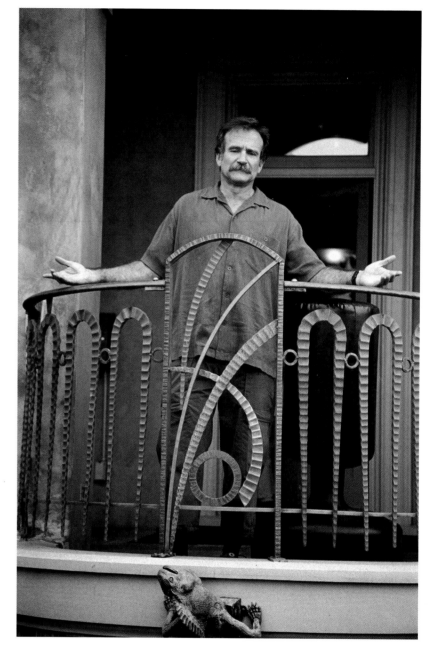

above and right
POSING WITH HIS POODLE KIWI AND RELAXING
AT HIS HOME IN SAN FRANCISCO, 2002

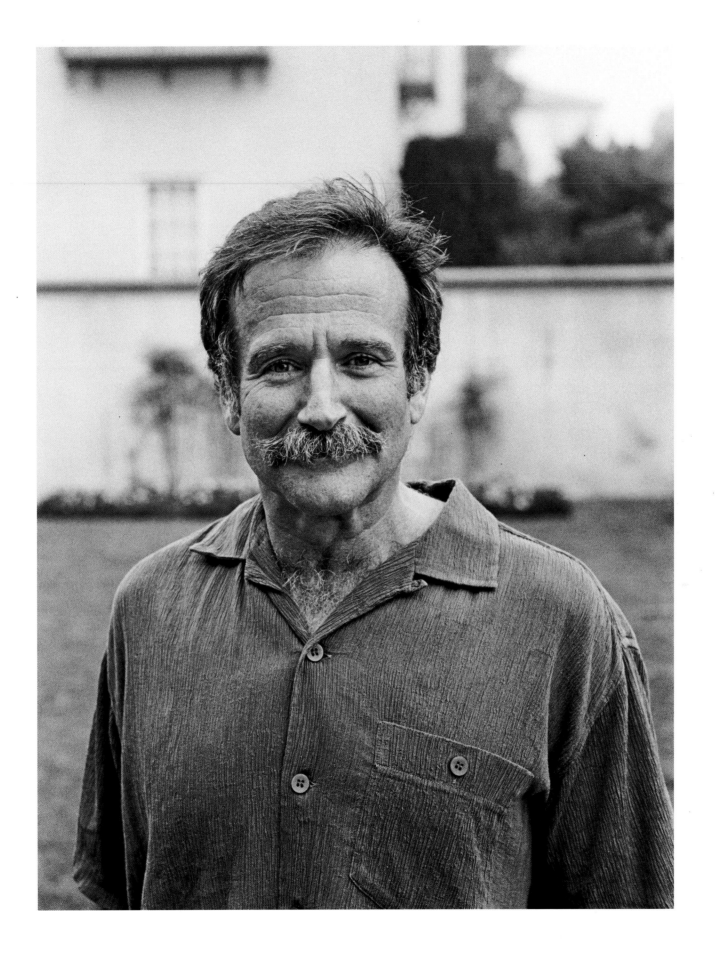

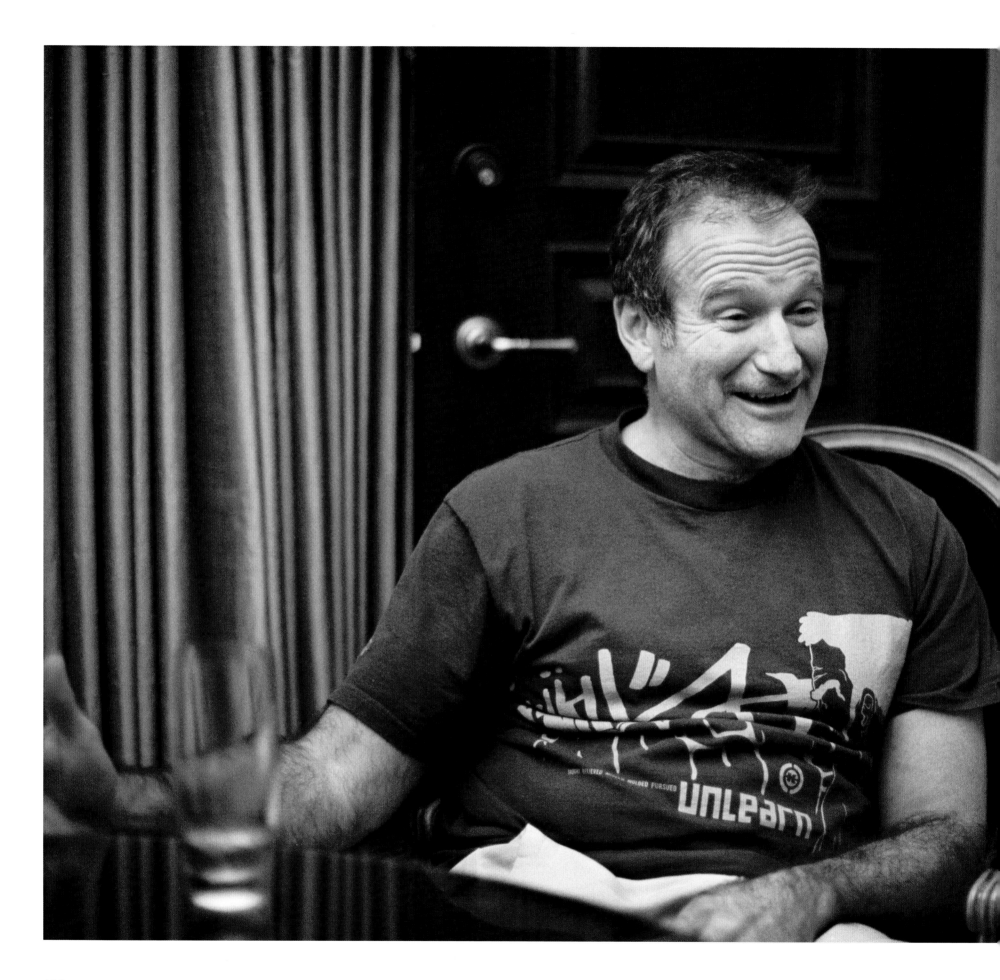

RELAXING IN HIS HARRAH'S HOTEL SUITE BEFORE
GOING DOWN TO THE THEATER TO GET READY FOR
HIS SHOW, LAKE TAHOE, 2002

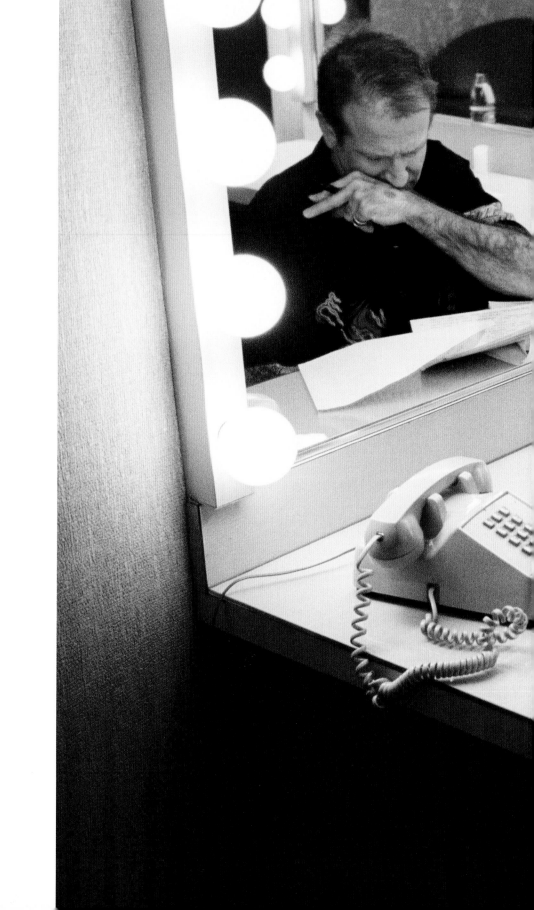

GOING OVER HIS NOTES IN HIS DRESSING
ROOM AT HARRAH'S, LAKE TAHOE, 2002

*Contrary to what some people may have thought,
Robin didn't go out onstage in stream-of-
consciousness mode and just wing it for ninety
minutes. His show was carefully planned and
structured with one bit or joke leading into the next,
with room for occasional detours whenever he felt
the urge.*

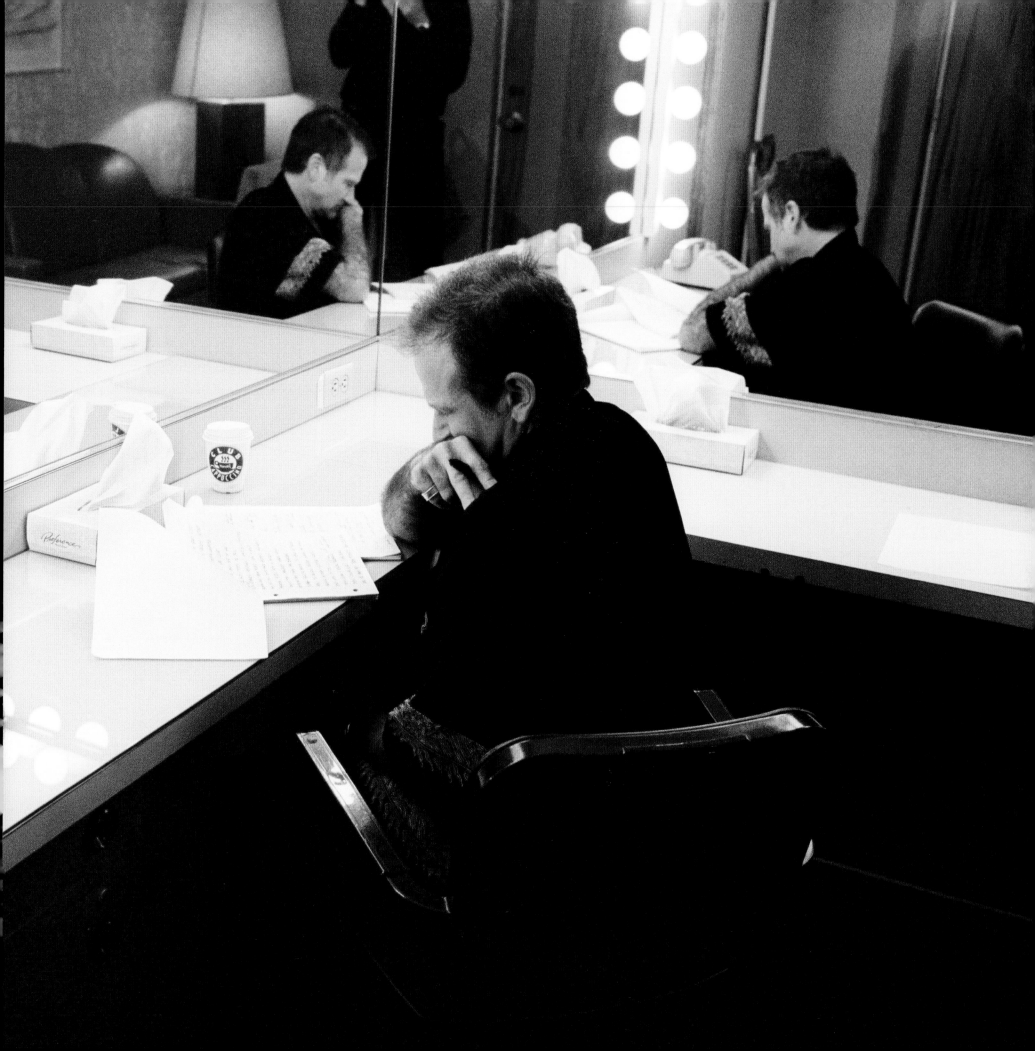

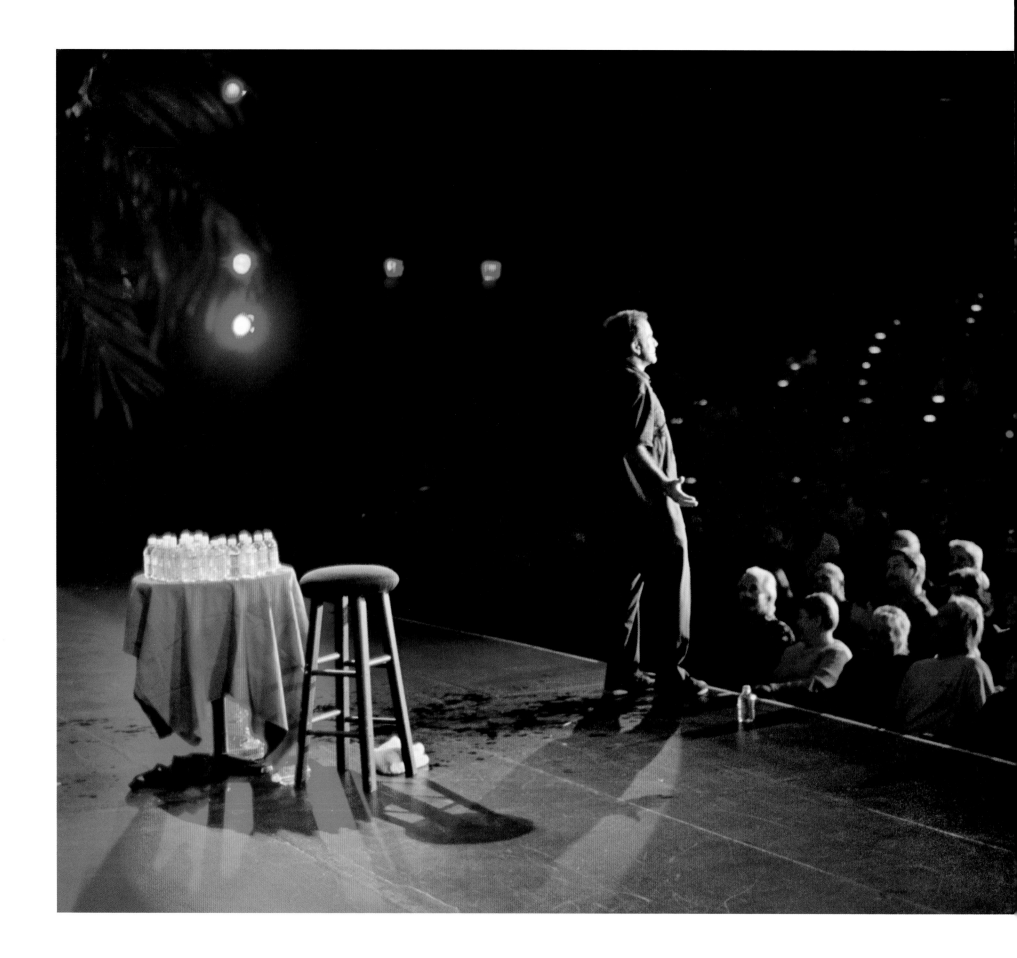

PERFORMING AT HARRAH'S,
LAKE TAHOE, 2002

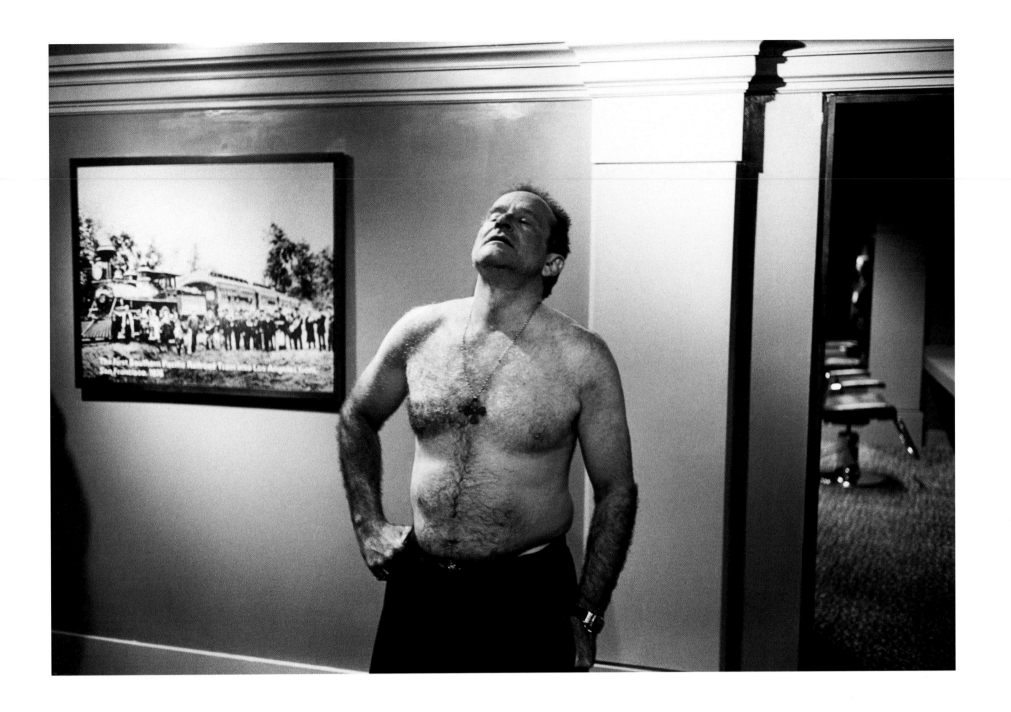

this and following spread
FROM BACKSTAGE TO THE DRESSING ROOM IMMEDIATELY
AFTER HIS NINETY-MINUTE SOLD-OUT PERFORMANCE AT
UNIVERSAL AMPHITHEATER AND BEFORE ANYONE WAS
ALLOWED IN HIS DRESSING ROOM, LOS ANGELES, 2002

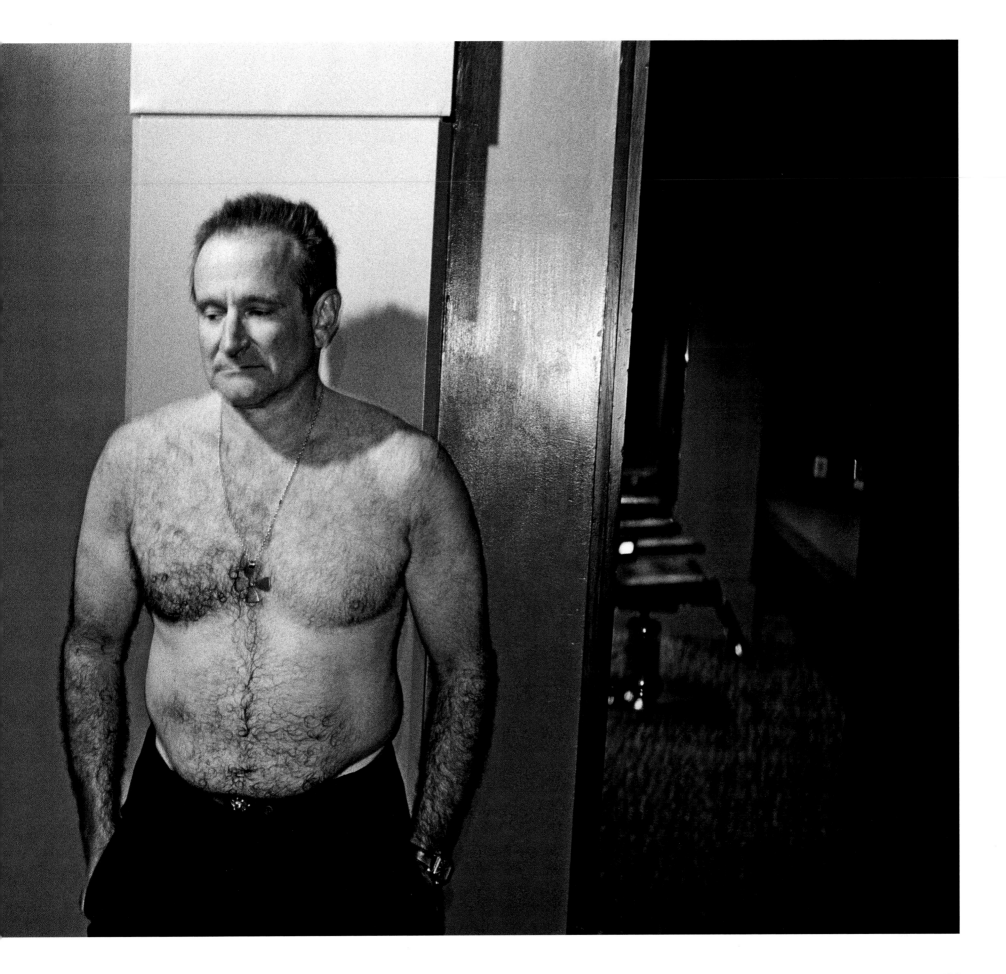

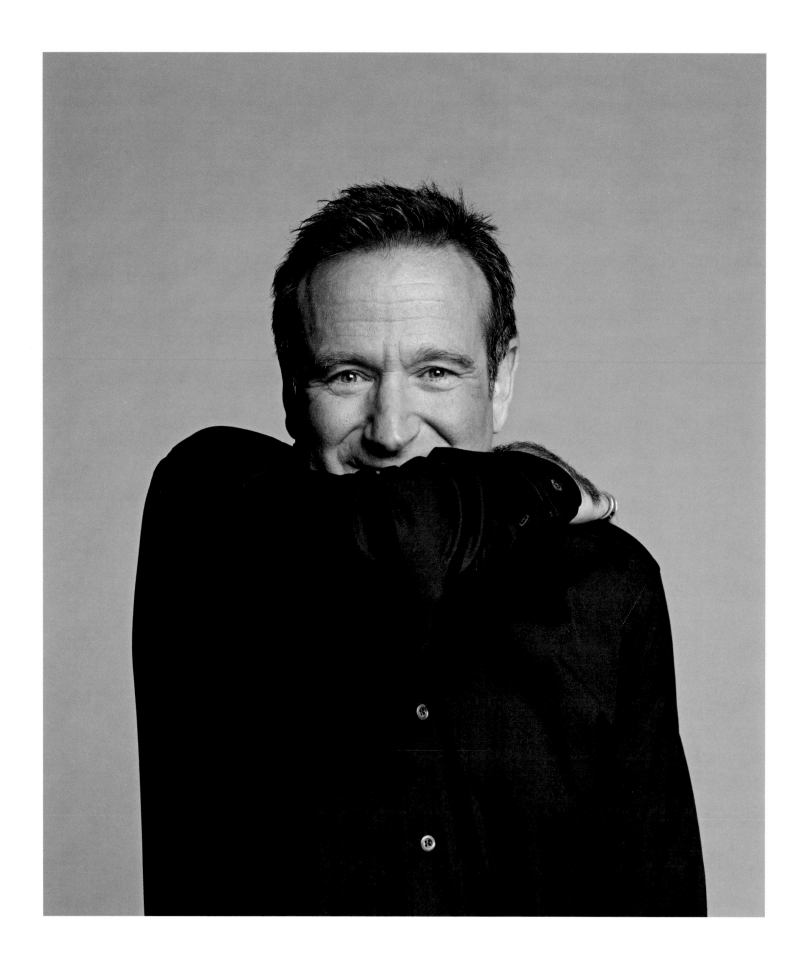

GIVING HIS "ON THE ROAD" TOUR "SALUTE" *(left)* AND
WITH HIS TOUR CREW AND FRIENDS GIVING THE
"SALUTE" AT THE MGM GRAND IN LAS VEGAS BEFORE
THE SHOW *(above)*, 2002

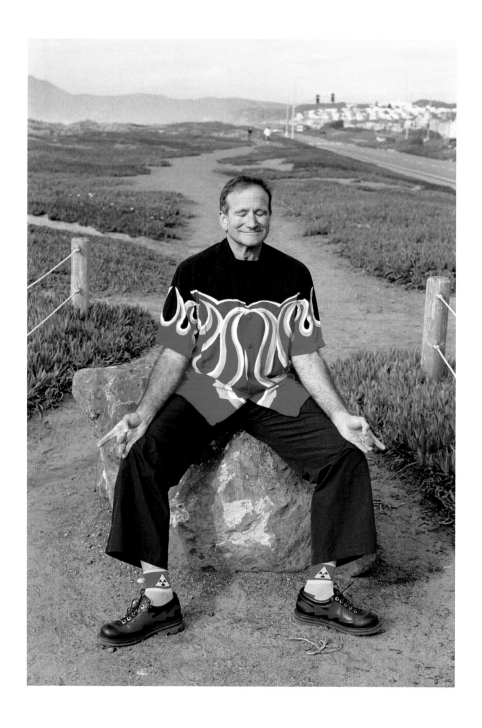 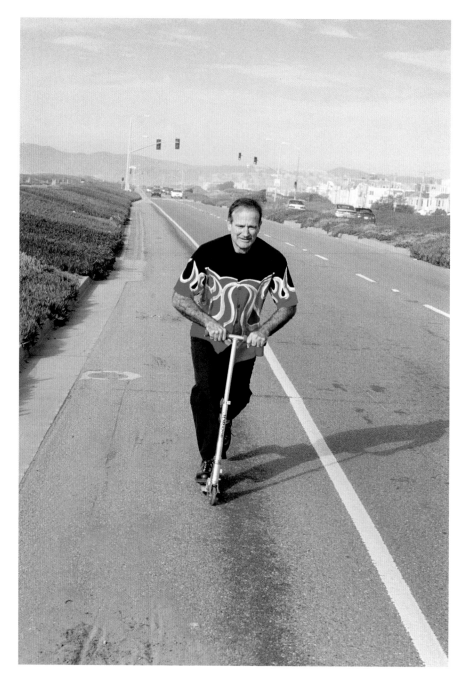

MEDITATING *(left)* AND RIDING A RAZOR *(right)* DURING A
PUBLICITY SHOOT, SAN FRANCISCO, 2002

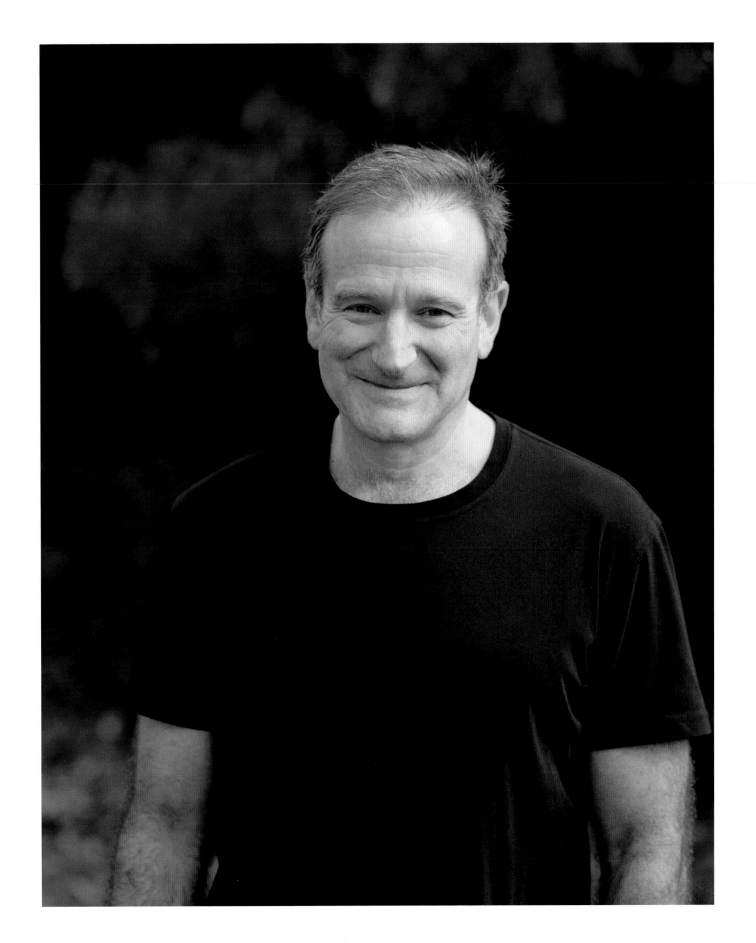

PUBLICITY SHOOT,
SAN FRANCISCO, 2002

following spread
THANKING THE
AUDIENCE AFTER
RECEIVING FLOWERS
AT THE END OF HIS
SOLD-OUT SHOW
AT UNIVERSAL
AMPHITHEATER,
LOS ANGELES, 1986

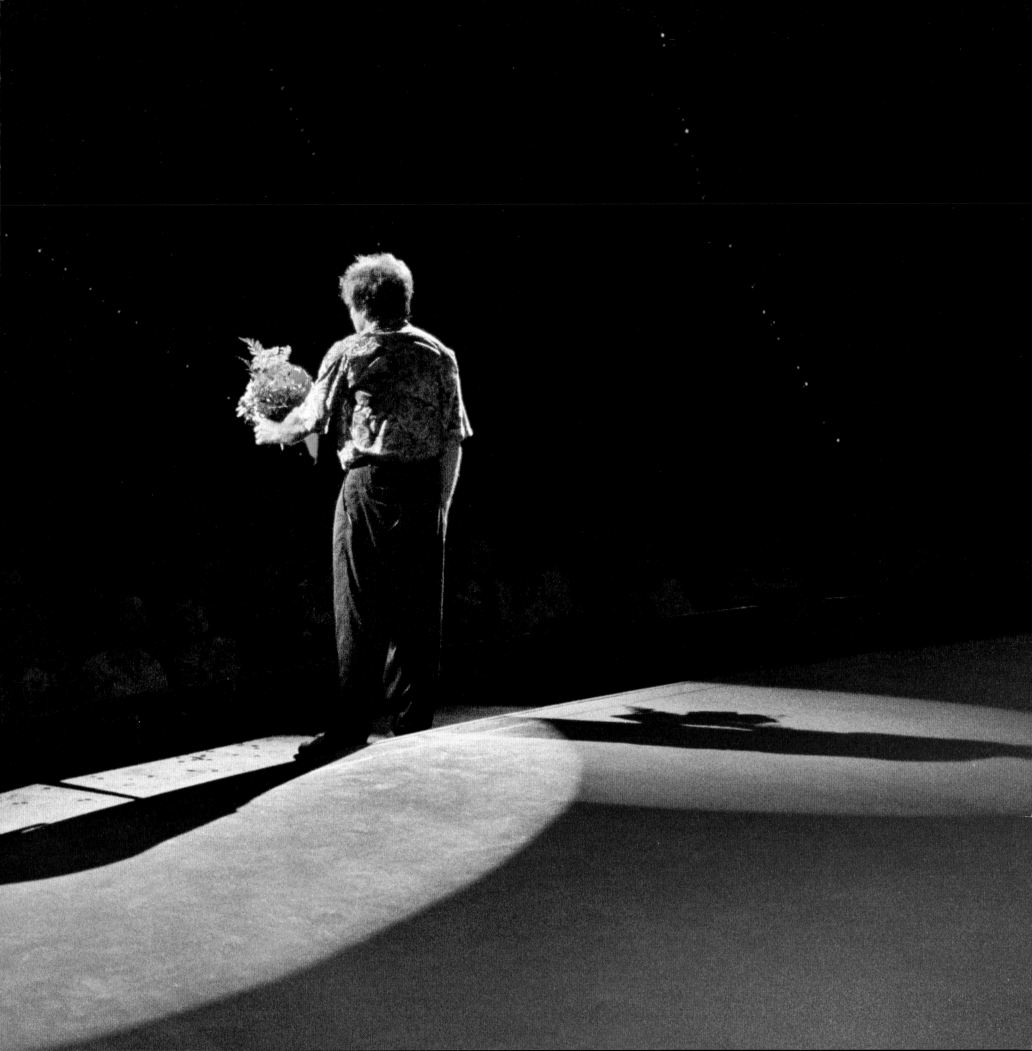

ROBIN'S INSCRIPTION IN MY FIFTIETH BIRTHDAY SCRAPBOOK: "ARTHUR, IT'S NOT HOW LONG YOUR LENS IS. IT'S WHERE YOU POINT IT. YOU ARE A *MENCH* AND A *MESHUGANAH KOPF*. MAY OUR FRIENDSHIP DEVELOP LIKE A PHOTOGRAPH; SHARP, COLORFUL, AND FULL OF WONDERFUL MEMORIES. ROBIN"

(mensch = good guy; meshuganah kopf = crazy guy)

ACKNOWLEDGMENTS

This book would never have been possible without my wife Debra, who was with me every step of the way with her encouragement and love.

And in memory of "Ben," who Robin riffed on more than once.

SPECIAL THANKS TO:
Paul Mahon (a.k.a. Paulie) for his wise counsel, calming influence, brilliant ideas, and loyal friendship. This book would still be an idea in my head were it not for his yeoman efforts on my behalf.

David Steinberg for his advice and guidance throughout the process of producing this book, and for his friendship over the last thirty years.

James Gilbert for his inspired work organizing, editing, and sequencing the photographs in this book.

Jeffrey Smith for his advice, editing skills, and business savvy in guiding this book.

Marsha Williams for her generosity and many years of friendship, and for allowing me to reproduce personal family images from her private collection.

Jack Shoemaker, Kelly Winton, Megan Fishmann, and the entire team at Counterpoint Press for their professionalism and support.

Arnold Kassoy for his cooperation and confidence in the book.

Larry Brezner for his advice and support, and for discovering Robin Williams.

Debbie Berne for her patience and impeccable book design.

Rebecca Erwin Spencer and Dan Spencer for their invaluable insight and help throughout the making of this book.

Karen Mullarkey, former Director of Photography at *Newsweek*, who assigned me to the Robin Williams cover story.

Patricia Bradbury for her artistic counsel during the latter stages of the project.

Joe Berndt, owner of BowHaus, Inc. in Los Angeles, for making my images look their best, regardless of their condition; Andrea Finninger for her digital expertise; and Chelsea Cota and Hillary Roberts for their organizational skills.

Alex Castro for his generosity with his time and for his keen eye in the initial editing of all the images.

Bill Pierce, the legendary photo maestro, for once again coming to the rescue with technical advice and support.

Tanner Gibson for her unflagging efforts on behalf of this book and her cheerful disposition throughout the project.